WHAT GOOD ARE THE ARTS?

John Carey has been at various points in his life a soldier, a barman, a television critic, a beekeeper, a printmaker and a professor of literature at Oxford. His many books include *The Intellectuals and the Masses* and Faber anthologies on the subjects of Reportage, Science and Utopias.

Further praise for *What Good are the Arts?*:

'Wrong-headed, self-contradictory and brilliant.' John Banville, *Guardian*

'Anyone who still insists on lecturing us about 'high' culture and its superiority to 'mass' culture should be made to read John Carey's *What Good Are the Arts?* – ideally as the educational component of a whole range of corrective measures, some of which would be much more painful. Carey (who wrote the equally brilliant and valuable *The Intellectuals & the Masses: Pride & Prejudice Among the Literary Intelligentsia, 1880-1939*) defines art, tells us what it's good for and has enormous fun dismantling the claims of aesthetic theorists, from Kant onward. It's been a long time since I've read a saner book.' Nick Hornby

'Blows the gaff on a lot of the received wisdom behind our culture.' Joan Bakewell

# WHAT GOOD ARE THE ARTS?

JOHN CAREY

# What Good Are the Arts?

*faber and faber*

First published in 2005
by Faber and Faber Limited
3 Queen Square London WC1N 3AU
This paperback edition published in 2006

Typeset by Faber and Faber Limited
Printed in England by Mackays of Chatham plc, Chatham, Kent

Verse and prose extracts from the following copyright material are
reproduced by kind permission of the publishers, Faber and Faber Ltd:
*Lord of the Flies* by William Golding, 'Ash-Wednesday' from *The Complete
Poems and Plays* of T. S. Eliot; 'An Arundel Tomb' from *Collected Poems* by
Philip Larkin; 'Lullaby' from *Collected Poems* by W. H. Auden

A CIP record for this book
is available from the British Library

ISBN 978-0-571-22603-0
ISBN 0-571-22603-5

2 4 6 8 10 9 7 5 3 1

# Contents

# Acknowledgements

An early version of the first part of this book was given as the Northcliffe Lectures at University College London in the spring of 2004. I am grateful to Professor John Sutherland for inviting me, and to him, Professor Danny Karlin, Dr Helen Hackett, and the other faculty members and their students for their enthusiastic welcome.

People whose writing or conversation has helped me are too numerous to list, but I should like to thank, in particular, Dinah Birch, Robert Ferguson, Peter Kemp, Šárka Kühnová and Adam Phillips for their ideas and encouragement. I have been lucky to be able to draw on such minds. Julian Loose of Faber suggested the title over lunch some five years ago, before a word of the book was written, and he has been a model of patient forbearance ever since.

For discussions of the potential of Magnetic Resonance Imaging for aesthetic enquiry I am indebted to Dr Joe Devlin at the John Radcliffe Hospital, Oxford, and Professor Matthew Lamdon Ralph of the University of Manchester. I greatly appreciated their friendly care in making themselves intelligible to a layman.

Julia Adamson and Lore Windemuth of the BBC forced me to clarify some of my ideas while we were making the mini-series *Mind Reading*, broadcast on Radio 4 in November–December 2004, and the book has benefited.

During my years of preparatory reading, my son Leo Carey helpfully alerted me to every relevant American publication that came across his desk at *The New Yorker*. It made the hours spent in libraries seem much less lonely. So did the ceaseless interest and attention of my wife, Gill, who read and criticized the book in draft.

# Introduction

People in the West have been saying extravagant things about the arts for two and a half centuries. The arts, it is claimed, are 'sacred', they 'unite us with the Supreme Being', they are 'the visible appearance of God's kingdom on earth', they 'breathe spiritual dispositions' into us, they 'inspire love in the highest part of the soul', they have 'a higher reality and more veritable existence' than ordinary life, they express the 'eternal' and 'infinite', and they 'reveal the innermost nature of the world'. This random clutch of tributes reflects the views of authorities ranging chronologically from the German idealist philosopher Georg Wilhelm Hegel to the contemporary American critic Geoffrey Hartman, and they could be multiplied ad infinitum.

Even those who would hesitate to classify the arts as holy often feel that they form a kind of sanctified enclave from which certain contaminating influences should be excluded – notably money and sex. The Australian critic Robert Hughes voices a general disquiet when he says that the idea of a Van Gogh landscape, the anguished testament of an artist maddened by inequality and social injustice, hanging in a millionaire's drawing room, is difficult to contemplate without nausea. For many, the pleasure of walking round a great public art collection is enhanced by the thought that they are in a space where the laws of economics seem to be magically suspended, since the treasures on display are beyond the dreams of private avarice.

That true art should banish thoughts of sexual arousal, as well as of commerce, has been a rule ever since our ideas about art started to be formulated in the 18th century. Currently the Internet is most commonly used as a supplier of pornographic images, which must mean that they are the most sought-after art objects in our world. However, we strictly exclude them from the category of true art, and, in the case of child pornography, criminalize them. We have revived the practice of sending people to prison for looking at the wrong kind of pictures, which had fallen into abeyance since the iconoclastic frenzies of the Protestant reformation, when you could be imprisoned, or even done to death, for possessing pictures of Christ or the Virgin Mary.

The arts have traditionally excluded certain kinds of people as well as certain kinds of experience. Writers on the arts have emphasized that their spiritual benefits, though highly desirable, are not available to everyone. 'The most excellent works of every art, the most noble productions of genius', Schopenhauer admonishes, 'must always remain sealed books to the dull majority of men, inaccessible to them, separated from them by a wide gulf, just as the society of princes is inaccessible to the common people.' For some art-enthusiasts, indeed, it is this very exclusiveness that makes the arts attractive. 'Equality is slavery', writes the French novelist Gustave Flaubert, 'That is why I love art.' A common 20th-century lament was that universal education had produced a semi-literate horde, 'insensible to the values of genuine culture', as the avant-garde American art-critic Clement Greenberg put it, whose vulgar clamour for the degraded kinds of art they could appreciate polluted the aesthetic atmosphere.

Quite what sort of spiritual influence genuine art should impart when operating correctly on the correct sort of person remains, however, largely unexamined. It is often said, by art-

lovers, that art-lovers have more 'refined sensibilities' than others. But this is a difficult thing to measure. Whereas there are tests for assessing intelligence, no objective computation of refinement is available, and partly for that reason claims and counter-claims in this area arouse passionate indignation. In his book *The Civilizing Process*, Norbert Elias tells of an 11th-century Doge of Venice who married a Greek princess. In her Byzantine circle table-forks were customary, but they had never been heard of in Venice. When the new Dogaressa was seen lifting food to her mouth by means of an instrument with two golden prongs, it gave fearful offence. Her excessive refinement was considered insulting to the Venetians, who ate with their fingers as nature intended, and she was rebuked by ecclesiastics who called down divine wrath upon her. Shortly after, she was afflicted with a repulsive illness, which the Italian theologian St Bonaventure (later nominated as one of the great doctors of the Christian church by Pope Sixtus V) did not hesitate to pronounce a judgement of God.

In our own culture the sacred aura that surrounds art objects makes imputations about superior or inferior artistic refinement particularly hurtful and disconcerting. The situation has been aggravated by the eclipse of painting in the 1960s and its replacement by various kinds of conceptual art, performance art, body art, installations, happenings, videos and computer programmes. These arouse fury in many because they seem, like the Dogaressa's table-fork, to be deliberate insults to people of conventional taste (as, indeed, they often are). By implication such artworks categorize those who fail to appreciate them as a lesser kind of human being, lacking the special faculties that art requires and fosters in its adherents. In retaliation, those who dislike the new art forms denounce them as not just inauthentic but dishonest, false claimants seeking to enter the sacred portals of true art.

In this book I shall try to answer some simple questions that, as I see it, bear on our present resentments and confusions. I shall ask what a work of art is, why 'high' art should be considered superior to 'low', whether art can make us better people, and whether it really can be a substitute for religion, as our belief in its sacredness and spirituality implies. In recent years scientists who work on the brain and the nervous system have increasingly turned their attention to art, clarifying what physical changes take place when we view art objects. I shall assess their results, as best I can, and explain why science cannot, in my opinion, make any useful contribution to debates about art's value.

The notion of artworks as sacred implies that their value is absolute and universal. This does not, as I shall make clear, seem to me a plausible claim. Value, it seems evident, is not intrinsic in objects, but attributed to them by whoever is doing the valuing. However, though this makes aesthetic choice a matter of personal opinion, it does not, I argue, reduce its significance. On the contrary, aesthetic choices resemble ethical choices in their decisive importance for our lives. But since they cannot be justified by reference to any fixed, transcendent standards, they must be justified, if at all, by rational explanation. In the second part of this book I make out the case – admittedly personal and subjective – for the superiority of literature to other arts, by considering how it works on us, and by reference to documented cases of its power to change people.

PART ONE

CHAPTER ONE

# What is a work of art?

'What is a work of art?' is a simple question, but no one has yet found an answer to it, and perhaps finding a single answer that will satisfy everyone is impossible. However, it is what I shall try to do in this chapter.

I should explain, at the outset, that I shall assume a secular viewpoint in what follows. That is, I shall exclude considerations of religious faith – not out of disrespect for religion, but because the assumption of a religious faith would alter the terms of the discussion fundamentally and unpredictably. If you believe in a God, or gods, the answer to the question 'What is a work of art?' will depend on what your God or gods decide – supposing, that is, that they have artistic interests. I add that rider because some gods, it seems, do not. The Catholic critic Jacques Maritain predicts that the Christian God will burn the Parthenon and Chartres cathedral and the Sistine Chapel and the Mass in C on the last day, so as to demonstrate that we should not seek eternal life in art. That is hardly the behaviour of an art-lover, and the biblical God's prohibition of all graven images and 'likenesses', recorded in Exodus 20:4, suggests a marked antipathy to the visual arts. However, the biblical God must know beyond any doubt what a genuine work of art is, since he is by definition omniscient. Consequently Christian discussions of art can assume that there are certain absolute, eternal artistic values, even if God has not vouchsafed knowl-

edge of them equally to all mortals. In what follows I shall not take the existence of such divinely sanctioned absolutes for granted.

I have said that 'What is a work of art?' is a simple question, and the answer, you may say, is simple too. A work of art is the *Primavera* and *Hamlet* and Beethoven's Fifth, and things of that kind. But the problem, rather, is what is *not* a work of art? What *cannot* be? For unless we know what art is *not* we cannot draw a boundary around what it is. Again, you may reply, that's easy. There are plenty of things that are not works of art – for example, human excrement. Although that sounds a convincing answer it would in fact be an unfortunate choice. The Italian artist Piero Manzoni, who died in 1963, published an edition of tin cans each containing 30 grams of his own excrement. One of them was bought by the Tate Gallery and is still in its collection.

Very well, you may concede, excrement was a bad choice, but what about space, what about absolute emptiness. That obviously can't be a work of art, because it's nothing. However, that too seems questionable. Yves Klein, one of the forerunners of conceptual art, once held an exhibition in Paris consisting of an entirely empty gallery. So space can be art.

I am sure I do not need to go on multiplying examples. The rather simple-minded respondent I have been imagining, with his conviction that some things cannot possibly be works of art, could be thwarted indefinitely and at every turn. He might protest that works of art must at least be things that the artist has made. But modern sculptors like Tony Cragg or Bill Woodrow, who create their art out of found objects and junk, or Carl André with his 125 fire bricks, another Tate Gallery acquisition, would quickly dispel that illusion. He might insist that nevertheless these sculptors have *chosen* the materials they use, and arranged them in a certain way, so a work of art must

4

reflect choice. It can't be just chance. Against that we could cite the work of Dadaists like Jean Arp, who tore up and dropped scraps of paper, fixing them where they fell, or Tristan Tzara who created poems from arbitrarily scrambled sentences drawn randomly from a bag.

In desperation, our respondent might concede that a work of art can be random. But he might insist that it is at least something the artist does. The artist must be the agent. But that is wrong too. Starting in 1990 the French artist Orlan underwent a series of surgical operations to reconstruct her face to conform with historically-defined male criteria of female beauty – the mouth of Boucher's Europa, the forehead of the Mona Lisa, the chin of Botticelli's Venus, and so on. The operations were broadcast live to art galleries throughout the world. You could also buy videos, and relics of Orlan's flesh left over from surgery. The whole artistic event was titled 'The Reincarnation of St Orlan', and clearly part of its point was that the artist was no longer agent but passive victim.

I hope the reader will not suspect at this point that this book is going to deteriorate into a harangue against the enormities of modern art, of the kind the tabloids indulge in each year when the Turner Prize shortlist is announced. In fact, the opposite is true. In reply to anyone who splutters that this or that recently unveiled installation is certainly not a work of art, my instinct is to ask 'How can you possibly tell? What are your criteria? Where do you derive your convictions from?' True, such questions are best left unvoiced, since they can lead to physical violence – which shows how seriously people take criticism of their artistic taste, even if they don't much care about art.

In this connection I should like to draw attention to a recent court case. In October 2003 Aaron Barschak, the so-called comedy terrorist who gatecrashed Prince William's twenty-first birthday party, appeared before Oxford magistrates' court on a

charge of criminal damage. Barschak, the court learned, had interrupted a talk by Jake and Dinos Chapman at the Modern Art gallery in Oxford. The Chapman brothers were discussing their exhibit *The Rape of Creativity* at the gallery, which features cartoon heads superimposed on a series of etchings by Goya. Barschak had splashed red paint on the walls of the gallery, on one of the artworks, and on Jake Chapman, shouting 'Viva Goya'. He claimed in his defence that he was creating his own artwork, made out of another's art just as the Chapmans had adapted Goya, and that he intended to enter his work for the Turner Prize. Finding him guilty, District Judge Brian Loosley said, 'This is a serious offence of wanton destruction of a work of art and I will be considering a custodial sentence. I feel that this was a publicity stunt . . . Even by modern standards and even stretching the imagination to incredulity this was not the creation of a work of art.'

I confess that I do not have complete faith in District Judge Brian Loosley as an aesthetic theorist. How he decided that Barschak's protest could not be a work of art, whereas the Chapman brothers' construct certainly was, is not clear to me. Possibly he felt that since Barschak was committing a crime he could not simultaneously be creating a work of art. But it is easy to find theorists who have argued that, on the contrary, art and crime are intimately linked, both being protests against social norms. When a bomb was thrown into the French parliament in 1893 the French dandy anarchist poet Laurent Tailhade, a friend of Wilfred Owen, proclaimed that the victims were of no importance so long as the gesture was beautiful. Shortly after, another bomb deprived him of his right eye, much to the amusement of Paris. André Breton, the leader of the Surrealists, declared that the simplest Surrealist act would be to shoot a revolver at random in a crowd. Fifty years later the Californian artist Chris Burden took him at his word, and fired a revolver at

an airliner taking off from Los Angeles, but missed. If District Judge Brian Loosley had taken these artistic precedents into consideration he might have concluded that Aaron Barschak was by comparison both witty and harmless. At all events, Barschak's claim that he was creating his own work of art does not seem to me to be disproved by anything the judge said.

The question 'What is a work of art?' is of course a modern one. It is the emancipation of the art scene in the 20th century and the public bewilderment it has caused that has given it prominence. Nowadays works of art regularly provoke anger or ridicule. For most of the 19th century the situation was quite different. Aesthetic theorists then, as now, puzzled over how to define a work of art, and everyone knows about the fuss caused by Impressionist painting. But the kinds of thing – the pictures, books, sculptures, symphonies – that the definition of a work of art would have to cover were not in doubt.

Equally you might say that the question 'What is a work of art?' could not have been asked before the late 18th century, because until then no works of art existed. I do not mean that objects we now regard as works of art did not exist before that date. Of course they did. But they were not regarded as works of art in our sense. Most pre-industrial societies did not even have a word for art as an independent concept, and the term 'work of art' as we use it would have been baffling to all previous cultures, including the civilizations of Greece and Rome and of Western Europe in the medieval period. These cultures would find nothing in their experience to match the special values and expectations attached to art that make it into a substitute religion, the creation of a spiritual aristocracy called geniuses, and the arena for the display of a refined discriminatory accomplishment called taste. On the contrary, in most previous societies, it seems, art was not produced by a special caste of people, equivalent to our 'artists', but was spread through the whole

7

community. Bodily ornamentation, using paint, tattoos, amulets and hair-treatments, was apparently a universal artistic practice among early humans. The same is true of dancing, which some consider to have been the earliest form of art, and which has never, it seems, belonged exclusively to humans. Adult male chimpanzees perform a 'rain dance' during torrential downpours, in which they stamp and slap the ground. But in none of these cases, so far as we know, has the activity been regarded as a subject for anything resembling academic study, or as one where unusual proficiency or agility is accorded spiritual value. The word 'aesthetics' was unknown until 1750, when Alexander Baumgarten coined it, and it was Kant in the *Critique of Judgment* who first formulated what were to remain the basic aesthetic assumptions in the West for two hundred years.

Kant was in several respects a curious person for the West to have chosen as its artistic mentor. His life was passed in a backwater of East Prussia, and he had little knowledge or appreciation of the arts. Music, in particular, struck him as an inferior pastime. Since it was incapable of communicating ideas, and depended on 'mere sensations without concepts', he felt that it should be classified as at best an 'enjoyment', rather than an art. Besides it was, he observed, guilty of 'a certain want of urbanity', since, when played loudly, it could annoy the neighbours. This was a sensitive issue with Kant, as he had himself been inconvenienced by the hymn-singing of the prisoners in the jail adjoining his property, and had been obliged to write to the burgomaster about it.

His *Critique of Judgment* was not merely about art but about beauty and our response to it, and it quickly established itself as a basic text in Western art-theory, respectfully invoked by innumerable aestheticians. For the modern reader it is a confusing document, for it seems to contradict itself, to make

assertions that run counter to common experience, and to depend on religious assumptions that few now share. Kant begins by conceding, reasonably enough, that judgements of taste 'can be no other than subjective'. Like pleasure or pain, they relate to the individual's personal experience. However, this unobjectionable position soon starts to change. Whereas judgement of whether things are 'pleasant' or not is indeed a matter of personal taste (so that we can say 'that is pleasant for me', realizing it may not be for others), judgements of beauty are, apparently, different.

> The case is quite different with the beautiful. It would (on the contrary) be laughable if a man who imagined anything to his own taste thought to justify himself by saying 'This object (the house we see, the coat that person wears, the concert we hear, the poem submitted to our judgement) is beautiful *for me*'. For he must not call it beautiful if it merely pleases him. Many things may have for him charm and pleasantness – no one troubles himself at that – but if he gives out anything as beautiful, he supposes in others the same satisfaction, he judges not merely for himself, but for everyone, and speaks of beauty as if it were a property of things.

To a modern reader this seems patently untrue. When we say a thing is beautiful we generally mean it is beautiful for us. It is a statement of personal taste. A very elementary knowledge of how standards of beauty have changed across ages and cultures would prevent us from demanding that others should agree with us about what is beautiful. Yet for Kant, anyone using the word 'beautiful' correctly must require others to agree: 'He *demands* it of them. He blames them if they judge otherwise.'

This is because for Kant, standards of beauty were, at the deepest level, absolute and universal. There existed, he believed, a mysterious realm of truth, which he called the 'supersensible substrate of nature', where all such absolutes and universals resided. The fact that we (in Kant's curious version

of reality) think everyone ought to agree with us when we call something beautiful, is an indication (for Kant) that we are dimly aware of this mysterious realm. Kant's belief in absolutes still persists today, at any rate in some people, if only at a sub-liminal level. It is this that feeds the conviction that some things just are, and some just are not, works of art. District Judge Brian Loosley is, it will be clear by now, a Kantian in this respect. It is not possible in his mental universe for someone to say, 'That is a work of art for me, though it may not be for you.' On the contrary, there is a correct answer, and if you get it wrong you may go to prison.

Another crucial component of Kant's doctrine was the separation of art from life. Art in previous cultures, so anthropologists and historians have found, is always bound up with everyday occupations and concerns, with the making of weapons or canoes or cooking vessels, with rituals to ensure rainfall or good harvests. Kant, on the other hand, posited a pure aesthetic state of mind that art objects should evoke. In this pure state all emotions, desires and practical considerations must be transcended. 'That taste', Kant decreed, 'is always barbaric which needs a mixture of charms and emotions, in order that there may be a satisfaction.' It is quite incorrect to think of beauty as something that stirs the emotions, according to Kant. 'Emotion', in the aesthetic realm, 'does not belong at all to beauty.' Any considerations of utility or practicality are similarly base and unworthy. The beautiful object must be admired in and for itself. Further, it is its pure form that we must admire, not its colour or, even worse, its smell, for these are mere sensuous pleasures (which is what Kant means by 'charms'). So for Kant the pleasure we take in the sight of a rose is aesthetic, but pleasure in its smell is not, and he denies that tone in music or colour in painting can give aesthetic pleasure. Colour is a mere accessory. Modern aestheticians who take

Kant seriously have continued to agonize over what may or may not correctly be called beautiful. Harold Osborne in his book *Aesthetics and Art Theory* cites a professor C. W. Valentine who decided that the colour of wallpaper or the sound of a bell could count as beautiful, but the taste of toffee could not.

For Kant beauty was, in addition, essentially connected with moral goodness. All aesthetic judgements are, consequently, ethical as well. 'Now I say the beautiful is the symbol of the morally good, and that it is only in this respect', Kant admonishes, 'that it gives pleasure.' In other words, when you look at a truly beautiful object you can tell it is truly beautiful because you realize that it is good. You feel it appealing to your better nature. 'The mind is made conscious of a certain ennoblement and elevation above the mere sensibility to pleasure.' Needless to say, Kant attributed this feeling to some fundamental bond between goodness and beauty in that 'supersensible' realm where all truth resided. 'In this supersensible ground' the moral and the aesthetic are bound together 'in a way which, though common, is yet unknown'.

Since beauty, as interpreted by Kant, turns out to be so closely related to whatever mysterious principles underlie the universe, it is not surprising that in his view its creators must be very special people indeed. He calls them 'geniuses', the special property of genius being that it allows access to the supersensible region. It is only among artists that genius occurs. Men of science, Kant stipulates – even highly intelligent ones like Sir Isaac Newton – do not deserve the name 'genius', because they 'merely follow rules', whereas artistic genius 'discovers the new, and by a means that cannot be learnt or explained'.

It is strange that this farrago of superstition and unsubstantiated assertion should have achieved a position of dominance in Western thought. Nevertheless, that is what occurred. As Kant's ideas were developed by his followers, his special aes-

thetic state came to resemble a quasi-religious ecstasy in which the art-lover's soul gained access to a higher realm. Hegel, in *The Philosophy of Fine Art*, teaches that through art 'the Divine', and 'spiritual truths of widest range', are brought to consciousness. The arts are 'the sensuous presentation of the Absolute itself', showing God in 'the actual sphere of spiritual existence and knowledge'. Art is better than life or nature. Its creations have 'a higher reality and more veritable existence than ordinary life', and nature is 'not a mode of appearance adequate to the divine being', whereas art is. Hegel is inclined to share Kant's lowish opinion of music. It has, he agrees, sadly little to do with intellectual conceptions, and 'for this very reason musical talent declares itself as a rule in very early youth, when the head is still empty'. Unfortunately, too, we often see musical talent 'hung together with considerable indigence of mind and character', whereas with poets (so Hegel believes) 'it is quite another matter'. Hegel also follows Kant in excluding the sensuous from art as far as possible. The true function of art is 'exclusively to satisfy spiritual interests, and to shut the door on all approach to mere desire'. Only the more 'theoretical' senses of sight and hearing can be admitted in art. Smell, taste and touch are all excluded, because they 'come into contact with matter simply as such', whereas in art 'the sensuous is spiritualized'. The notion that whether something is beautiful or not depends on one's personal taste is dismissed by Hegel with a sneer:

Every bridegroom regards his bride as beautiful, very possibly being the only person who does so; and that an individual taste for beauty of this kind admits of no fixed rules at all may be regarded as a bit of luck for both parties.

It emerges, too, that for Hegel 'the Divine' reveals itself only in European art:

> The Chinese, Hindoos, and Egyptians . . . in their artistic images, sculptured deities, and idols, never passed beyond a formless condition, or a definition of shape that was vicious and false, and was unable to master true beauty.

European art, on the other hand, being genuine, makes you a better person. It is 'in truth the primary instructress of peoples', and it educates by 'fettering and instructing the impulses and passions' and 'eliminating the rawness of desire'.

Schopenhauer, another beneficiary of Kant's theories, made further additions to the West's notions of high art. In pure contemplation of the aesthetic object, he claimed, the observer would entirely escape his own personality and become 'a clear mirror of the inner nature of the world'. It was not even necessary for the object to be a work of art. A tree would do, or a landscape. By letting 'his whole consciousness be filled with quiet contemplation', the observer will cease to be himself and become indistinguishable from the object. Further, what he will see will no longer be the object. It will be the Platonic idea, 'the eternal form', of which the inner nature of the world is made. However, this remarkable accomplishment is not, Schopenhauer warns, available to everyone. You need special gifts. The common mortal, disparagingly described by Schopenhauer as 'that manufacture of Nature which she produces by the thousand every day', can never hope to attain the pure disinterested contemplation needed for seeing Platonic ideas. Schopenhauer seems to have thought that this was because the common mortal was too interested in sex. He is a 'blind, striving' creature whose 'pole or focus lies in the genital organs', whereas the 'eternal, free, serene subject of pure knowing' lies in the brain. Those beings who can attain a vision of the Platonic ideas in pure contemplation are artistic geniuses. They can be recognized by their 'keen and steady glance', whereas the glance of the common mortal is 'stupid and vacant'. Men of genius may

also be distinguished, according to Schopenhauer, by their dislike of mathematics, and their incapacity for earning their living or managing the affairs of daily life. As they are superior to the rational methods that direct practical life and science, they will, in addition, be 'subject to violent emotions and irrational passions'.

It is easy to identify the dictates of Kant and his followers in the notions about art that are still in circulation today. That art is somehow sacred, that it is 'deeper' or 'higher' than science and reveals 'truths' beyond science's scope, that it refines our sensibilities and makes us better people, that it is produced by geniuses who must not be expected to obey the same moral codes as the rest of us, that it should not arouse sexual desire, or it will become 'pornography', which is bad – these and other superstitions belong to the Kantian inheritance. So does belief in the special nature of artworks. For Kantians, the question 'What is a work of art?' makes sense and is answerable. Works of art belong to a separate category of things, recognized and attested by certain highly gifted individuals who view them in a state of pure contemplation, and their status as works of art is absolute, universal and eternal.

This belief naturally lent support to the supposition that all true works of art must have something in common – a secret ingredient – distinguishing them from things that are not works of art. Various theories about this ingredient were formulated, none of them plausible, though they yielded occasional interesting ideas. Investigation of numerical proportion, for example, led to the theory that the key to aesthetic value was the 'golden section', where the shorter of two lines bears the same relation to the longer as the longer bears to the sum of the two. This had attracted the attention of Euclid, and its claim to be the essence of all art was eagerly pressed in the 19th century. It was pointed out that it occurs in many paintings, as well as in the plans and

façades of buildings from Egyptian pyramids and Renaissance palaces to Le Corbusier. It is also found in vegetable and animal forms, such as the width and length of an oak leaf, and the successive diameters of spiral mollusc shells – a fact that might, according to your viewpoint, weaken or strengthen its claim to be a distinctive property of art. Gustav Theodor Fechner (1834–87) was the first to put the theory to experimental test, and he found that a rectangle closely approximating to the golden section was preferred by more of the people he questioned than any other. However, identifying the golden section in literature and music has proved problematic. Also it apparently lacks cross-cultural appeal. D. E. Berlyne found that Japanese high school girls did not react favourably to a 'golden section' rectangle, but preferred one closer to a square.

Meanwhile the attempts of theorists to define works of art grew more tangled and tautological as the true difficulty of the enterprise became apparent. Though generally reinforced with abstruse phraseology, their definitions are invariably reducible to the statement that works of art are things recognized as works of art by the right people, or that they are things that have the effects that works of art should rightly have. Harold Osborne, for example, proposes that works of art are objects 'adapted to sustain aesthetic contemplation in a suitably trained and prepared observer' – obviously a useless definition, since 'suitably' leaves all the arguing still to do. The definition offered by the once celebrated American aesthetician John Dewey is more verbose but equally worthless:

> When the structure of the object is such that its force interacts happily (but not too easily) with the energies that issue from the experience itself; when their mutual affinities and antagonisms work together to bring about a substance that develops cumulatively and surely (but not too steadily) towards a fulfilling of impulses and tensions, then indeed there is a work of art.

It is hard to imagine Dewey supposed this would help anyone understand anything. Despite its air of heroically effortful rigour, its vague modifiers ('not too easily' and 'not too steadily' for whom?) give it the precision of cooked spaghetti.

By the start of the 20th century hopes of ever finding art's secret ingredient were fading, and at the same time the art scene was exploding. The productions of modernism challenged all previous assumptions about what art was. That was deliberate. To get outside the system, to escape the 'bourgeois' embrace of museums and art galleries, was a modernist drive – one that has continued as an impulse behind the pluralism of contemporary art. 'Museums', said Picasso, 'are just a lot of lies.' Roy Lichtenstein declared that he wanted to paint a picture so ugly no one would hang it. The reasons for this rebellion seem to have been social and political. The world of galleries, dealers and patrons came to be seen as exclusive, the preserve of money and privilege. Museums were perceived as bulwarks of triumphal nationalism, as, in their inception, they were. The Musée Napoléon, later the Louvre, which set the pattern for other great European galleries, had been inaugurated to display the treasures Napoléon brought back to France from his conquests. The carnage of the First World War intensified the feeling that for art to associate itself in any way with institutions and official values was indecent. The notion of a museum of modern art has been called a contradiction in terms, and it is clearly one that exposes irreconcilable sets of values. For the keepers of the flame, the directors of art galleries, must gather into their temples of eternal verity works that openly flout, denounce and ridicule what those temples stand for.

The critic who has examined these developments in 20th-century art and their implications most searchingly is the American Arthur C. Danto. Historically, his work marks the end of the struggle to find separate, distinct, universal qualities

that distinguish works of art. Surveying the course of Western art, he divides it into two narratives. The first, from about 1400 to about 1880, was the narrative of representation. The aim in this period was to imitate nature with more and more accuracy. Gombrich in *Art and Illusion* has told this story. The second narrative was modernism. Here the aim, as defined by 'the great narrativist of modernism' Clement Greenberg, was to explore the potential of the materials – paint, canvas, etc. Illusion was no longer pursued; the painted surface was just a surface. Art was not about nature but about art. This movement climaxed in Abstract Expressionism and ended in the early 1960s with pop art – specifically with Andy Warhol's Brillo Box, which was the grain of mustard seed from which Danto's thinking about art grew.

For Danto, the exhibition of Andy Warhol's Brillo Box sculptures at the Stable Gallery on East 74th Street in April 1964 marked a watershed in the history of aesthetics. As he saw it, it 'rendered almost worthless everything written by philosophers on art'. For the point about Warhol's sculptures was that they were absolutely indistinguishable from ordinary supermarket Brillo boxes. They showed that a work of art need have no special quality discernible by the senses. Its status as a work of art does not depend on how it looks, or on any physical qualities whatsoever. Connoisseurs like Greenberg who believed that they could tell works of art just by looking at them were mistaken. Anything, Danto concluded, could be a work of art. His typewriter could become a work of art, though it could not become, say, a ham sandwich. What could make it a work of art was nothing in its physical make-up but how it was regarded, how it was thought of.

In fact, as Danto concedes, choosing Warhol's Brillo Boxes as the point of breakthrough was, to a degree, arbitrary, for there were other works that might have been preferred. When

Marcel Duchamp sought to exhibit a urinal at the 1917 Exhibition of the Society of Independent Artists, under the title 'Fountain', he was making the same point as Warhol. Duchamp also exhibited a bottle rack, a grooming comb and a bicycle wheel as works of art. For that matter, Warhol's Campbell's Soup cans would, strictly speaking, have been a better choice than his Brillo Boxes since, unlike the Brillo Boxes, they were not even made by him but taken straight from the supermarket shelves, so they were absolutely indistinguishable from cans not presented as works of art. However, it was the Brillo Boxes that, for Danto, clarified the philosophical situation, and they symbolized a moment of historical emancipation, coinciding as they did with the black civil rights and the feminist movements.

Danto's conclusion – that what makes something a work of art is merely that it is thought to be a work of art – was highly unacceptable to him. He would have liked to avoid it if he could. For it seemed to open the floodgates. It reduced art to chaos. Nothing, he feared, could now be considered 'beyond the pale'. By nature, he admits, he is an essentialist. That is, he wants to believe – does believe – that art is special, that 'there is a kind of transhistorical essence in art, everywhere and always the same'. Although he acknowledges that anything can become a work of art, he clings to the viewpoint that 'it is, after all, a matter of fact whether something is a work of art or not'. There must, he feels sure, be two distinct categories of objects, works of art on the one hand and, on the other, 'mere things, with no pretence whatsoever to the exalted status of art'. To reconcile these convictions with his equally firm conviction that anything can be a work of art was difficult. However, he found a compromise that offered a solution to his dilemma. The compromise entailed switching attention from the thing itself – the Brillo box, say – to the kind of people who regarded

it as a work of art. For their opinion to matter, these people must, Danto decided, belong to the 'art-world'. That is, they must be experts and critics with an understanding of modern art. 'To see something as art requires an atmosphere of artistic theory, a knowledge of the history of art.' Only the opinion of such people can turn an object into a work of art, and they are qualified to do this because they can understand its meaning. For Danto works of art are distinguished by having a meaning, and not just any meaning, but a particular meaning. This correct meaning is the one the artist intended.

To illustrate his emphasis on the artist's intention, he cites the case of a candy bar entitled 'We Got It!', produced by the Bakery, Confectionery and Tobacco Workers' International Union of America, Local No. 552, and exhibited at the 1993 Chicago Culture in Action exhibition. A candy bar that is a work of art, Danto comments, need not be a specially good candy bar, but it has to be one produced 'with the intention that it be art'. It is this intention that the experts and critics are, in his theory, qualified to recognize. Further, having recognized the intention, they can judge the work's success by deciding whether, in their view, it achieves it. An artwork 'must be counted as a success or failure in terms of the adequacy with which it embodies its intended meaning'.

He gives an example of his theory in action, which helps to clarify it and also, I think, exposes its failings. He asks us to imagine that Picasso, towards the end of his life, painted a necktie blue. At the same time a child, unknown to Picasso, and knowing nothing about him, also painted a necktie blue. The ties, when finished, are absolutely identical in every respect. By chance they both use the same brand of paint, and it is applied smoothly. In Picasso's case, however, the smooth paint is a polemical allusion to and a repudiation of the cult of rough brushstroke or drip, which defined New York painting of the

1950s, and culminated in Abstract Expressionism. In the child's case the smooth paint is just to make it nice for daddy. The question is, which, if either, of the ties is a work of art? Danto is in no doubt. Picasso's tie is a work of art, the child's is not. As he puts it 'the child's tie is not an artwork; something prevents it from entering the confederation of franchised artworks into which Picasso's tie is easily accepted'. What prevents it, in Danto's view, is that it does not have a meaning, or not a meaning that relates to the history of modern art as Picasso's tie does.

Danto's example is, I think, beautifully constructed not only to demonstrate its own fallacies but also to lead us into the fundamental issues that the question 'What is a work of art?' raises. In reply to his objection that the child's tie does not have a meaning, or not the right kind of meaning, we may reply that it can in fact have any number of meanings. Meanings are not things inherent in objects. They are supplied by those who interpret them. In order to preserve his theory, Danto is constantly at pains to evade, or obscure, this fact. In discussing Duchamp's urinal, for example, he insists that to see it as a work of art we must understand what Duchamp intended by it. Duchamp told Hans Richter that his intention had been 'to discourage aesthetics', and this, for Danto, is the only permissible way of interpreting the urinal as an artwork. It might be possible, he admits, to admire it aesthetically as a beautiful, white, glistening shape that one had never really noticed before. But this, for Danto, would be a sentimental irrelevance. It would be, he suggests, the aesthetic equivalent of Christ's teaching that 'the least of us – perhaps especially the least of us – is luminous in holy grace'. It would be a version of the Christian viewpoint that regards the whole world and everything in it as God's artwork. Danto dismisses these pious fancies unceremoniously: 'let us just suppose this false'. The abruptness is revealing, for Danto is skating round a weak point in his argument. Seeing

the urinal simply as beautiful need not have anything to do with Christian piety, and if it were related to Christian piety that would not make it ridiculous. Danto has no real answer to such approaches, beyond insisting that they differ from his own opinion and, for him, lessen the interest of Duchamp's urinal:

> This reduction of Duchamp's art to a performative homiletic in demo-Christian aesthetics obscures its profound philosophical originality, and in any case such an interpretation leaves quite in darkness the question of how such objects get to be works of art, since all that would have been shown is that they have an unanticipated aesthetic dimension.

But of course for some viewers discovering that an object has an 'unanticipated aesthetic dimension' may be precisely what turns it into a work of art, and Danto's bluster does not prove them wrong. 'Reality has no meaning', he insists, 'art does' – to which the answer must be that reality has as many meanings as we care to apply to it, even when – to return to Danto's imaginary episode – reality is represented by something as seemingly meaningless as a child's blue-painted tie. For it seems likely that viewers of the child's tie would interpret it in numerous different ways. Some might see it as a gesture of love, others (as Danto himself suggests) might see it as a revelation of Oedipal hostility to the father, exploiting the tie's sexual symbolism. Either of these, or more, might be not just a meaning but the intended meaning, and so would meet Danto's demand that the correct interpretation must match the artist's intention.

But the real objection to Danto's promotion of the artist's intention is that it is simply unworkable as a criterion. With the vast majority of the artworks that fill our museums and galleries we have no access whatever to the creator's intentions. In much early art even the creators' identities are unknown. Whether they intended to produce 'art' in our sense at all seems, as we have said, highly unlikely. Judging works by their

intentions is a purely circular exercise. The critic deduces the intention from the work and then, putting the process in reverse, decides whether the work matches the intention. Literary theorists effectively disposed of intentionalism as an evaluative procedure in the mid-20th century, and that Danto should still cling to it suggests a frantic desire for certainties.

Another flaw in Danto's theory is revealed if we suppose that the child's father insists that for him the tie *is* a work of art, as he very well might. Danto's reply would have to be something like: 'It just *isn't* a work of art, whatever you feel about it; and it isn't a work of art because the art-world would not consider it one.' This reply would probably not satisfy the fond father. But ought it to satisfy us? In effect Danto's reply is simply a version of the religious solution that I touched on at the start. The religious person, supposing he agreed with Danto, would say, 'God does not consider the child's tie a work of art.' Danto says, 'The art-world does not consider the child's tie a work of art.' This is essentially the same answer, in that it is an appeal to a transcendent authority whose verdict cannot be questioned, and whose decision automatically overrides all subjective and personal opinions. People with good taste are indeed, for Danto, congenitally superior – a separate breed. Good taste, he affirms, cannot be learned; it is a gift.

It is worth adding at this point that Danto's faith in the decisions of the art-world extends to other arts beside painting. Indeed, it applies to all the arts. There is a music-world that decides what is music and what is just noise, a dance-world that distinguishes dance from mere movement, and a literary-world that identifies literature. These distinctions, for Danto, are real and definite. 'The newspaper story', he affirms, 'contrasts globally with literary stories, not being literature.' In some cases more than one of these bodies of experts would have to adjudicate, it seems. Danto cites Robert Morris's 'Box with the Sound

22

of Its Own Making' (1961), which was a tall wooden box with a tape recorder that played hammering and sawing noises inside it. As a visual and aural phenomenon, this could qualify, presumably, either as music or as sculpture. The Manhattan telephone directory might also, Danto observes, become an artwork in a number of different categories. It might be seen as an avant-garde novel or a paper sculpture or a folio of prints. But, as in the case of the painted blue tie, only the art-world's validation could transform it into art

The painted tie may seem a trivial example. But the confrontation between Danto and the father can serve as a model for all disagreements about what a work of art is, and all arguments about the respective merits of 'high' and 'low' art. The Danto strategy, in the debate I have imagined, is to over-rule the father's personal feeling – to make his opinion of no account. When champions of high art dismiss or devalue the pleasures people get from so-called low art, the strategy is the same. Whatever the particular circumstances, the argument of the high-art champions will be reducible to something like this: 'The experience I get when I look at a Rembrandt or listen to Mozart is more valuable than the experience you get when you look at or listen to whatever kitsch or sentimental outpourings you get pleasure from.'

The logical objection to this argument is that we have no means of knowing the inner experience of other people, and therefore no means of judging the kind of pleasure they get from whatever happens to give them pleasure. A very little self-examination will tell us that the sources of our own pleasures and preferences are by no means apparent, even to us. In each of us there is an undiscovered country. Writers have known this, and have been telling us about it, for a long time. Here, for example, is Virginia Woolf: 'We do not know our own souls, let alone the souls of others. Human beings do not go hand in

hand the whole stretch of the way. There is a virgin forest in each, a snowfield where even the print of birds' feet is unknown.' This would make a good reply to Danto, supposing the fond father knew his Virginia Woolf and could call the quotation to mind.

Although we cannot access another person's consciousness, we can tell, if only by crude question-and-answer methods, that people's responses to the same artwork vary enormously. The most thorough examination of this problem that I know is Hans and Shulamith Kreitler's book *Psychology of the Arts*. This is a mammoth survey of all the arts, incorporating the results of over a hundred years of investigation in experimental aesthetics, sociology, anthropology and psychology. The bibliography runs to 1,500 items. What the Kreitlers find is that responses to art are highly subjective, and that personal associations play a major role in determining preference. Experiments show a variability in people's responses so great that the reported averages are virtually meaningless. In music, for example, despite the insistence of purists that a proper response should not carry the listener beyond the music itself, empirical studies have repeatedly indicated that a whole spectrum of emotions, associations, ideas and imaginings are actually present. Further, these studies have failed to uncover any common elements in the imaginings suggested by particular pieces of music, or any correspondence between these and the declared intentions of the composer.

As for the question *why* different people respond differently to the same work, the Kreitlers agree, in effect, with Virginia Woolf that it cannot be known, or rather that to answer it your knowledge would have to be virtually infinite. It would have 'to extend over an immeasurably large range of variables, which would include not only perceptual, cognitive, emotional and other personality characteristics, but also biographical data,

specific personal experiences, past encounters with art, and individual memories and associations'. This enormous amount of data would have to be collected before an investigator could even start to understand the response of a single viewer to a single artwork.

I have suggested that those who proclaim the superiority of high art are saying, in effect, to those who get their pleasure from low art, 'What I feel is more valuable than what you feel.' We can see now that such a claim is nonsense psychologically, because other people's feelings cannot be accessed. But even if they could be, would it be meaningful to assert that your experiences were more valuable than someone else's? The champion of high art would have to mean not just that his experiences were more valuable *to him*, for that would not prove the superiority of high art, only his preference for it. He would have to mean that the experiences he derived from high art were in some absolute and intrinsic sense more valuable than anything the other person could get from low art. How could such a claim make sense? What could 'valuable' mean in such a claim? It could have meaning only in a world of divinely decreed absolutes – a world in which God decides which kinds of feeling are valuable and which are not – and this, as I have said, is not the world in which I am conducting my argument.

In rejecting Danto's suggestion that he ought to agree with the art-world's verdict, the father might well point out, in addition to the objections I have outlined, that faith in the art-world is rather attenuated in contemporary society. Modern art, as seen through the spectrum of, for example, the Saatchi phenomenon, has become synonymous with money, fashion, celebrity and sensationalism, at any rate in the mind of the man on the Clapham omnibus, and his disillusionment is shared by more weighty cultural critics. Art's surviving role in our mass-media society, declares Robert Hughes, 'is to be investment

capital'. Effective political art is now impossible, because an artist must be famous to be heard, and as he acquires fame his art acquires value and becomes ipso facto harmless. 'As far as today's politics is concerned, most art aspires to the condition of Musak. It provides a background hum for power.' Hughes returned to the attack in a speech to the Royal Academy in June 2004, following the auction of an early Picasso for $100 million at Sotheby's the previous month. This sum, he pointed out, is close to the GNP of some Caribbean and African states, and 'something is very rotten' when the super-rich of the West can spend it on a painting. 'Such gestures do no honour to art. They debase it by making the desire for it pathological.' He quoted the friend and authorized biographer of Picasso, John Richardson, who said that no painting was worth so much, and that the buyer 'should instead have given the money to something much more worthwhile'. Alluding to Damien Hirst's shark in formaldehyde, Hughes also condemned the reliance of modern art on shock tactics. 'I know, as most of us do in our hearts, that the term "avant-garde" has lost every last vestige of its meaning in a culture where everything and anything goes.' The critic of postmodernism Fredric Jameson is as pessimistic as Hughes, and for broadly the same reasons:

Aesthetic production today has become integrated into commodity production generally: the frantic economic urgency of producing fresh waves of ever more novel-seeming goods (from clothing to aeroplanes), at ever greater rates of turnover, now assigns an increasingly essential structural function and position to aesthetic innovation and experimentation.

An index of the public's reaction to these trends was afforded in July 2002 when a celebrated modern artwork met with a fatal accident. The work was a bust of sculptor Marc Quinn's head made from nine pints of his own frozen blood, and titled *Self*. It had been bought in 1991 by Charles Saatchi, reportedly

for £13,000, and kept, as its nature required, in a refrigerator. Unaware of its contents, builders renovating the kitchen in Saatchi's Eaton Square house switched the freezer off, and did not notice until two days later that it was surrounded by a pool of blood. There was no mistaking the levity with which this incident was reported in the British press. Columnists smilingly reminded their readers that the Saatchi mansion also had a special room containing Tracey Emin's £150,000 unmade bed. *The Times* jokily recalled other accidents that have befallen modern artworks. A John Chamberlain abstract made from crushed and welded cars was taken away by dustmen when left momentarily on the pavement outside a New York gallery. Porters at an auction house removed the brown paper wrapping from a chair, without realizing that it was an integral part of a sculpture by Christo. In the *Evening Standard*, the art-world's comment on Saatchi's loss ('A spokesman for the Tate said today "Marc Quinn is a very important artist"') was quoted with apparent satirical glee.

This irreverence turned out to be merely a rehearsal for the explosion of humour that greeted the Momart warehouse fire in May 2004. The casualties included two of the most celebrated items from the Saatchi collection, Tracey Emin's tent, appliquéd with the names of everyone she had slept with, and the Chapman brothers' *Hell*, a tableau of mutilated toy soldiers bought by Saatchi for £500,000. The artist Sebastian Horsley voiced the common reaction, though in rather less guarded terms than most:

> My only regret is that the artists themselves weren't on the funeral pyre. That would have been really great . . . The artists play the well-remunerated role of court dwarfs . . . Why have they let it happen to them? Saatchi, Jopling, Turner prizes – these prizes are for turncoats, cardboard outlaws who go on bended knee for an award from a society they profess to despise. What has happened to defiance?

> Why have the punk generation become so tamed, so emasculated, shaking hands with the royalty of the art-world and moving in circles that their work is supposed to scorn?

Public comment in the press and phone-in programmes over the next few days repeatedly endorsed the opinion that Brit-Art was a confidence trick, an alliance of hype, money and talentlessness. Only in a culture where the art-world had been wholly discredited could the destruction of artworks elicit such rejoicing, and in this atmosphere Danto's injunction that we should accept the verdict of the art-world in deciding what is, or is not, a work of art is comically unrealistic.

Yet not so long ago – within living memory – it would have made sense, and would have seemed, to most people, quite acceptable. What has changed is not so much the art-world as us. An increased reluctance to accept authority of all kinds – medical, scientific, political – was a well-mapped trend of the later 20th century, and scepticism about the art-world's posturing is part of it. Improved access to higher education is one underlying cause – the number of university students in the population has increased fivefold since the mid-1960s. But another factor countering acceptance of art-world views is the advent of mass art. The forces that produced mass art were social as well as technological, and insofar as they were social they represented the rebellion of the many against the few. We can quickly glimpse what they rebelled against if we scan the pages of Ortega y Gasset's essay *The Dehumanization of Art*, published in 1925. Modernist art in every sphere – painting, music, sculpture, literature – is, Ortega observes, essentially unpopular, exclusive and elitist. That is its function. It acts 'like a social agent', segregating from 'the shapeless mass of the many', two different castes of men, those who understand it and those who do not. It implies that the first group 'possesses an organ of comprehension denied to the others – that

they are two different varieties of the human species'. Consequently modernist art will 'always have the masses against it', because it deliberately insults them. It forces them to recognize themselves as 'the inert matter of the historical process'.

What Ortega did not foresee was that the masses would retaliate, and would take possession of an art of their own that would eclipse elitist art. Within decades, the 20th-century technological revolution, tirelessly innovative, would be providing them day and night – on screens, through headphones, through amplifiers – with art on a scale and of a kind undreamed of by the official art-world, and greeted by that world with bewilderment and detestation. Classical music now occupies a tiny corner of the multi-million dollar recorded music industry. Poetry-readers and theatre-goers are as rare as practitioners of origami compared with the global hordes who live their imaginative lives through TV soaps. Painting has virtually died out, while the elephant dung and inflatable dolls of the art-world represent a desperate attempt to snatch some crumbs of publicity from mass art's endless parade of glittering, world-class celebrities.

I said at the start of this chapter that I would not only ask but answer the question 'What is a work of art?', and it is time to do that. Danto is right to argue, I think, that the answer cannot lie in the physical attributes of the object itself. Anything can be a work of art. What makes it a work of art is that someone thinks of it as a work of art. For Danto, that someone must be a member of the art-world. But no one, except the art-world, believes that any more. The art-world has lost its credibility. The electorate has extended, has, indeed, become universal. My answer to the question 'What is a work of art?' is 'A work of art is anything that anyone has ever considered a work of art, though it may be a work of art only for that one person.' Further, the rea-

sons for considering anything a work of art will be as various as the variety of human beings. So far as I can see this is the only definition wide enough to take in, on the one hand the *Primavera* and the Mass in C, and, on the other, a can of human excrement and a child's blue-painted tie.

It follows, of course, that the old use of 'work of art' as a term of commendation, implying membership of an exclusive category, becomes obsolete. The idea that by calling something a work of art you are bestowing on it some divine sanction is now as intellectually respectable as a belief in pixies. After the Momart warehouse fire and the light-hearted public reaction, Tracey Emin reported on the radio that friends abroad had sympathized with her for living in a country where works of art were so little valued. We can now see that her and her friends' indignation, though understandable, derived from a simple misunderstanding of modern thought. They assume the existence of a separate category of things called works of art (to which they believe Emin's productions belong), which are intrinsically more valuable than things which are not works of art, and which accordingly deserve universal respect and admiration. These assumptions, we can now see, belong to the late 18th century, and are no longer valid in our culture. The question 'Is it a work of art?' – asked in anger or indignation or mere puzzlement – can now receive only the answer 'Yes, if you think it is; no, if not.' If this seems to plunge us into the abyss of relativism, then I can only say that the abyss of relativism is where we have always been in reality – if it is an abyss.

My definition is, I believe, the one to which Danto's reasoning was always leading him. At many points in his writing, seemingly without realizing it, he leaves questions about the identity of artworks open to individual judgement. Discussing whether there is a limit to things that can be made into artworks, for example, he comments:

30

My own view is that there would be cases in which it would be wrong or inhuman to take an aesthetic attitude, to put at psychical distance certain realities – to see a riot, for instance, in which police are clubbing demonstrators, as a kind of ballet, or to see the bombs exploding like mystical chrysanthemums from the plane they have been dropped from.

Quite so. But there is no question, here, of the art-world making the decision. It is conceded that something may be a work of art for one person and not for another. If you think it is, it is. Danto's relentless reasoning forces him to the brink of this realization, though he cannot quite bring himself to jump.

A curious result of the definition I have proposed is that there turn out to be fewer art experts around than we imagined. The ignoramus's attitude to art used to be parodied as 'I don't know much about art but I know what I like.' But this, it seems, is all any of us can say. Of course, there are scholars and critics deeply learned in one or many branches of the arts. But we have seen that the responses of people to works of art are almost infinitely varied. We have seen, too, that to know even one picture or book or piece of music, you would have to know all these responses. A work of art is not confined to the way one person responds to it. It is the sum of all the subtle, private, individual, idiosyncratic feelings it has evoked in its whole history. And we cannot know those, because they are shut away in other people's consciousnesses. Yet if we do not know them, we cannot really know even a single artwork. So it seems that none of us knows much about art, though we know what we like.

# Is 'high' art superior?

Cultural commentators distinguish 'high' art (classical music, 'serious' literature, old-master painting, etc.) from mass or popular art, and generally assume its superiority. This chapter will suggest that there are no rational grounds for this. The metaphor of height is itself curious. It may originate in bodily shame – 'high' art being that which surmounts the 'low' physical appetites and addresses the 'spirit'. It may also carry connotations of social class – 'high' art is that which appeals to the minority whose social rank places them above the struggle for mere survival. Paradoxically, 'high' art is also generally assumed to be 'deep'. However, those who use these terms do not invest them with any real meaning. Advocates of high art take it for granted that the experiences it gives them are intrinsically of more value than low art gives others, although, as we saw in the last chapter, such a claim is not just unverifiable but meaningless.

The novelist Jeanette Winterson is a good example of a high-art advocate, deriving her ideals from Clive Bell and the Bloomsbury Group. Like them she scorns realism, and equates art with 'rapture' and 'ecstasy'. Like them she disdains 'mass education'. Her critical writings reveal that she lives in a world of absolutes. There are 'true' artists, like T. S. Eliot, Virginia Woolf and herself, and there are non-artists like Joseph Conrad, whom she contemns as 'a Pole who prided himself on

his impeccable and proper English usage'. True artists are spiritually superior and also, she implies, socially superior. They shun 'the language of shop assistants and tabloids'. Art is 'enchantment', and true artists have 'the right of spells'. This is not, it seems, mere whimsy on Winterson's part. Her belief that she is surrounded by magical presences strikes the ordinary observer as barely sane. 'I move gingerly', she confides, 'around the paintings I own because I know that they are looking at me as closely as I am looking at them.'

The rightness of her own artistic taste is a datum she never questions. By contrast, she regrets her mother's low inclinations in cultural matters:

> My mother, who was poor, never bought objects, she bought symbols. She used to save up to buy something hideous to put in the best parlour. What she bought was factory-made and beyond her purse. If she had ever been able to see it in its own right, she could never have spent money on it. She couldn't see it, nor could any of the neighbours dragged in to admire it.

The prejudices displayed here are securely traditional, though, of course, still just prejudices. Distaste for the 'factory-made' goes back via the arts and crafts movement to William Morris, and ultimately to Carlyle. The belief that anything can be seen 'in its own right' echoes Matthew Arnold, and ignores the modern understanding that all observations depend on observers.

Why Winterson considers her way of seeing superior she does not divulge, but it is apparent she does, and feels that her mother and her mother's friends would be better if they were more like her. Among advocates of high art these are common assumptions. They think of themselves as leading rich and happy lives, and are sure that if the benighted masses would only share their artistic tastes they would be rich and happy too. In fact the situation Winterson describes seems to be one that provides satisfaction both to herself and to her mother. It gives

33

Winterson a reason for feeling superior, which she clearly needs, and it gives her mother a way of sharing pleasure with her friends. If her mother and friends really became adept at Winterson's kind of art, then it seems probable that they would enjoy it, since they enjoy sharing. But Winterson would have to find some new reason for feeling superior. At all events, the striking omission from her account is any acknowledgement that she is in fact ignorant of the pleasure and satisfaction her mother and friends derive from their kind of art, since their consciousness is inaccessible to her.

Social and cultural divisiveness of this kind is inherent in the notion of high art. It can be 'high' only by comparison with other art, which is 'low'. As Ellen Dissanayake argues in her book *What Is Art For?*, this concept of art is not only relatively recent, it is also aberrant when viewed through the perspective of human evolution. Dissanayake's approach is ethological (that is, she is interested in how animals, including human animals, survive in their environments), and the question she addresses is how art has contributed to natural selection. She is not concerned with our post-Kantian cult of art as solitary spiritual contemplation, but with a whole miscellany of practices from skin-painting to weapon-decoration traceable in early human societies. All these early art forms, she observes, were communal, reinforcing the group's cohesion and helping to assure its survival. The divisive tendencies of high art are alien to them.

Finding a single principle uniting these various art-practices is difficult. But the behavioural tendency that Dissanayake suggests lies behind them all is 'making special'. To make something special is to place it in a realm different from the everyday. Making special is not confined to humans. The bower bird, building his little palaces to allure a mate, is making special in Dissanayake's sense. Her argument is that human

34

communities that made things special survived better than those that did not, because the fact of taking pains convinced others as well as themselves that the activity – tool manufacture, say – was worth doing. So art's function was to render socially-important activities gratifying, physically and emotionally, and that is how it played a part in natural selection.

Anthropological evidence bears out Dissanayake's theory. In his study of the North American Eskimos or Inuit, a Stone Age nomadic society that has survived into the 21st century, Richard L. Anderson finds that Inuit art is not usually just decorative. Nor is it competitive: the notion of excellence in art is uncommon. Art means preparing tools for the shaman or toys for children. Inuit women, it is true, decorate their clothes with leather, fur and sinew, and tattooing, created mostly by women, is by far the most widespread two-dimensional art form. But since these practices enhance sexual attraction they are not purely decorative either. In general, Anderson concludes, Inuit art renders something 'culturally significant', which seems close to Dissanayake's 'making special'.

Advocates of high art might well retort that Dissanayake's theory, though ingenious, is irrelevant. Why should our artistic choices take any note of the practices of Stone Age man? Because, Dissanayake would reply, that is where our basic human endowments come from. Our mentality and metabolism, our fears and longings, were laid down during our existence as hunter-gatherers. In the long-term history of the human race, nomadic hunter-gatherers are the norm. Only in the last 10,000 years has hunter-gathering been replaced by settled agriculture and clusters of population. As for modern city life, it started only yesterday. In effect, as anthropologists have often pointed out, we have Stone Age minds, and Stone Age needs that contemporary life cannot satisfy. Primarily, for Dissanayake, we are lonely. Whereas hunter-gatherer man lived

from birth to death in a tight-knit group, modern man is born into a diverse, stratified society of strangers, and this is something quite new in the human repertoire.

The implications of this for popular art are evident. Whereas high art is exclusive, popular art is receptive and accessible, not aimed at an educated minority. It emphasizes belonging, and so seeks to restore the cohesion of the hunter-gatherer group. It is preoccupied with romantic-sexual love to a degree unprecedented, Dissanayake believes, in any previous human society, and this is a response to the loneliness of the modern condition. Anthropological evidence suggests that romantic love is virtually universal across cultures. In evolutionary terms it binds hominid parents and so increases the chance of offspring survival. What is new is not its existence but its enormous prominence in popular art, which functions to counteract modern solitude.

The violence and sensationalism that critics of popular art deplore can likewise be seen as answering biological imperatives programmed into us by evolution. A need for novelty and excitement, and the evasion of monotony, are basic human attributes, and are also observable in non-human primates, particularly when young. We seek intense emotions, because the purpose of emotion, in evolutionary terms, is to give focus and direction to our activities. Cognition is, so to speak, freewheeling, until emotion (anger, fear, desire) selects something for it to home in on.

For intellectuals in the early 20th century, the relation of mass art to biological drives served only to discredit it. It was further proof of its 'lowness', and of the debased nature of its adherents. The only critic, so far as I know, to realize that, on the contrary, this primitive element in mass art connects it with art's historical roots was the Czech novelist, essayist and dramatist Karel Čapek. Uncovering ancient features in popular

art forms was a Čapek speciality – part of a lifelong campaign to bring art to the people, and remove the barriers between social classes. He identifies the detective story, for example, as essentially a hunt, and traces it to the hunting scenes in Stone Age cave paintings. Analysing the contents of newspapers, he shows that, though they appear topical, they continually recycle age-old motifs and plot-lines, and so convey not so much news as 'the eternal continuity of life'.

Literature, Čapek insists, should entertain. Its true mission is to abolish 'boredom, anxiety and the greyness of existence', and always has been:

> We speak of the democratization of literature, about the need to popularize the book. But try to find where the people are. They sit in movie theatres, because something's going on there, and because it thrills them. It's very easy to break out into harangues against this destruction of taste. But consider whether the people sitting in movie theatres aren't basically the same as those who twenty-five centuries ago sat by the fire around the Homeric bard and listened to heroic songs, to how the Achaeans and the Trojans chopped one another up, how Achilles dragged Hector three times round the walls, or how Odysseus jabbed Polyphemus's eye out. For film, despite all its flaws, has one primitive advantage: that it is epic, that there is always something going on, that life here reveals itself in its raciest and clearest form – in action . . . It is not necessary to 'descend to the level of the people' and fabricate some special, rougher goods for them. If we are to talk about popular literature at all, it doesn't mean there should be 'popular' literature on the one hand and 'high' on the other. I should like high literature to become popular.

With more conventional critics than Čapek, disapproval of popular art's violence and sensationalism often goes together with the charge that it is escapist. But escapism, like violence and sensationalism, seems to be a human necessity. As Adam Phillips has argued in his book *Houdini's Box*, we are all escape-

artists, since the lives we want depend on our avoiding what we do not want. In this sense escapism is fundamental to our sense of ourselves, and to condemn it reveals curious priorities:

> A person who is running away from something, the Hungarian psychoanalyst Michael Balint once remarked, is also running towards something else. If we privilege (as psychoanalysts and others do) what we are escaping from as more real – or in one way or another more valuable – than what we are escaping to, we are preferring what we fear to what we seem to desire.

This is not to deny that some means of escape are harmful. Dissanayake cites an ethnographic survey of 488 human societies which found that 89 per cent practised some form of dissociative experience, and that alcohol and hallucinogenic drugs were among the commonest means employed. It seems unlikely that popular art will ever entirely replace these, but obviously it would be wholesome and beneficial if it did. 'High' art, it should be added, is equally a form of escape, as the psychologist William James conceded when he wrote, of alcohol, that 'to the poor and unlettered it stands in the place of symphony concerts and literature'.

The attraction of Dissanayake's approach is that it lets us see art-practices in a wider spectrum than our own small cultural window. Under her analysis 'art' dissolves as a category, diffusing into activities that some might, and some might not, consider artistic. Of course, the definition of art we arrived at in the first chapter would lead us to expect this. If art is anything anyone has ever considered art, then it will include things other people would fiercely deny artistic status to. Dissanayake argues, for example, that the pains taken by modern women to decorate themselves and their homes should not be seen as vain or frivolous but as more in line with art-practices across times and cultures than anything 'high' art offers. Male aestheticians have routinely despised female interest in fashion, as the femi-

nist critic Karen Hanson has noted, and this may reflect the bodily shame inherent in the mystique of high art. But once this prejudice is overcome, fashion can easily be seen as art, and even hailed as transcendent in typically male terms. Hanson quotes Baudelaire:

> Fashion should thus be considered as a symptom of the taste for the ideal which floats on the surface of all the crude, terrestrial and loathsome bric-a-brac that natural life accumulates in the human brain . . . Every fashion is a new and more or less happy effort in the direction of Beauty, some kind of approximation to an ideal for which the restless human mind feels a constant titillating hunger.

Gardening is another activity that can readily be recognized as an art. Landscape gardens for the rich have been art objects since the Renaissance. But ordinary gardening-for-the-masses looks, from an anthropological angle, more like an art-practice. The garden centre is a modern temple, and on every scale, from the window-box up, it helps greater numbers of people to create beauty than any other contemporary institution. For most people the garden is the single tenuous thread still connecting them to the green world in which the human race grew up.

Dissanayake is particularly worried about young males who miss the comradeship of the hunter-gatherer pack. It often seems to her that they would be happier 'spearing woolly mammoths, or constructing a loghouse with their buddies', than attending high school or sitting in an office. From her anthropological perspective art and play shade into each other – some African societies, she notes, have the same word for art and play – and, bearing this in mind, we can see that the modern art form that comes closest to giving her estranged young males what they need is football. Watching football – better still, watching football and engaging in crowd violence at the same time – provides physical contact, loss of identity, a common aim, and opportunities for male bonding very much on the

hunter-gatherer pattern. It takes very little imagination to recognize the performance on the pitch as a tribal dance and mock battle, and the scoring of goals, with its obvious sexual symbolism, gives 'supporters' the illusion that they have achieved something, and a feeling of satisfaction arguably similar to the sense of 'closure' that aficionados of high art experience at the end of dramas or operas or symphonies. Seeing football as an art form does not, of course, confer any value on it – or not within the terms of this book, since we discarded the notion of art as an inherently valuable category in the last chapter.

The pretentiousness of 'high' art shows up when we compare it with other cultures geographically, as well as across time. By high-art standards it would seem ridiculous to call something as mundane as having a cup of tea an art. But in Japan the art of tea has serious significance. Like the discipline of Zen, it aims to eliminate all unnecessary attributes, including the intellect. The tea ceremony, with its thatched hut and simple utensils, offers release through renunciation, as Daisetz T. Suzuki explains:

> The morning-glory, lasting only a few hours of the summer morning, is of the same significance as the pine tree whose gnarled trunk defies wintry frost. The microscopic creatures are just as much manifestations of life as the elephant or the lion. In fact they have more vitality, for even if the other living forms vanish from the surface of the earth, the microbes will be found continuing their existence. Who would then deny that when I am sipping tea in my tearoom, I am swallowing the whole universe with it, and that this very moment of my lifting the bowl to my lips is eternity itself transcending time and space.

That last sentence may sound deceptively like Western claims for 'high' art. But the direction of the thought is quite contrary. The Western art-enterprise of creating immortal 'monuments' to the human spirit is, by implication, rejected.

Given the odds stacked against them, those who set out to

make a reasoned case for the superiority of 'high' art deserve credit just for trying. But the assertions they come up with are often staggering. Here is Iris Murdoch, in her book *The Sovereignty of Good*, explaining the difference between good art and bad:

> There is nothing mysterious about the forms of bad art, since they are the recognizable and familiar rat-runs of selfish daydream. Good art shows us how difficult it is to be objective by showing us how differently the world looks to an objective vision. We are presented with a truthful vision of the human condition in a form which can be steadily contemplated.

This is a bizarre claim. The dictionary definitions of 'objective' are 'existing independently of perception or an individual's conceptions' or 'undistorted by emotion or personal bias' or 'of or relating to actual or external phenomena as opposed to thoughts, feelings etc.' Can Murdoch really believe that these apply to art? Are the paintings of El Greco or Rubens or Turner objective? Or the poetry of Milton or Pope or Blake? Or the fiction of Swift or Dickens or Kafka? If artists' visions were objective wouldn't their productions be more like each other? Wouldn't they, indeed, be precisely the same, like chemical formulae, which really do represent an objective take on the world? Murdoch's proclamation seems the exact reverse of the truth. If we had to choose between objectivity and her term 'selfish daydream' as the principle behind art, then it would have to be 'selfish daydream', though we might want to rephrase it as 'individual imaginative vision'.

It is easy to see, though, how Murdoch has come to get things so spectacularly wrong. She is keen on art (provided it is 'good' art) and she is keen on unselfishness, so it is important for her to believe they are connected even if all the evidence points the other way. Unselfishness, she holds, is the basis of virtue, so surely that must mean that good art is untainted by self, i.e.

objective. The argument collapses the moment you give it the slightest prod, because it presupposes a correspondence between art and virtue that it is meant to be proving.

Murdoch believes that natural, as well as artistic, beauty can release us from our selfish preoccupations, and she instances catching sight of a kestrel from her study window:

> I am looking out of my window in an anxious and resentful state of mind, oblivious of my surroundings, brooding perhaps on some damage done to my prestige. Then suddenly I observe a hovering kestrel. In a moment everything is altered. The brooding self with its hurt vanity has disappeared. There is nothing now but kestrel. And when I return to thinking of the other matter it seems less important.

No doubt we have all felt something similar. But is this really an escape from self, as Murdoch supposes? The way she sees a kestrel is entirely dictated by her cultural circumstances. For her it is an emblem of freedom and splendour, rather like the bird in Gerard Manley Hopkins's poem 'The Windhover'. But let us imagine that Murdoch is not a well-fed academic, fond of poetry, but a Chinese peasant, watching over a batch of chicks that will soon be ready for market. The appearance of a kestrel now becomes sinister and alarming. The peasant hastens to get his chicks under cover or, if he is lucky enough to have access to some kind of firearm, tries to shoot the kestrel. This is not, of course, an unselfish response. But nor is Murdoch's. What she takes to be self-forgetfulness depends on the retention of cultural advantages which are so habitual that she is no longer aware of them. That she can escape herself, or the culture that has formed that self, by having pleasing thoughts about wild life, is an illusion.

Murdoch's kind of assumption is very widespread, of course. It derives, as we saw in the last chapter, from Kant's doctrine of the 'selfless' contemplation of beauty. Though illusory, it often

figures in arguments for the superiority of high art. Belief in this superiority is so embedded in our culture that even those who profess to deny it can be shown to adhere to it, without apparently being aware that they are doing so. An example is the Right Honourable Chris Smith, MP, who, as Secretary of State for Culture, Media and Sport, undertook to demolish the distinction between high and low art in his book *Creative Britain*. His definition of creativity covers not just the old 'high' arts but fashion, software, advertising, computer games and pop music. As for the function of creativity, he sums it up in a semi-grammatical flourish, typical of his style: 'Creativity is about adding the deepest value to human life.' If this means anything, it surely gestures towards a notion of 'value' that is not simply monetary. Yet the only kind of value he actually attributes to the 'creative industries' he surveys is financial. They earn £50 billion a year, and that, for Smith, is their justification. How they affect people's minds and lives he does not ask.

When he turns to high art, the difference is at once apparent. Tony Blair had recently been criticized for inviting Noel Gallagher to Downing Street. Smith loyally scrambles to his defence:

The Prime Minister did indeed invite Oasis to No. 10, but a few days later he was at the Cottesloe Theatre being deeply moved by Richard Eyre's production of *King Lear*. The deepest cultural experience will frequently come, for all of us, from the heights of fine opera or the sweeping sounds of a classical orchestra or the emotional torment of high drama. But we shouldn't ignore the rest of cultural activity at the same time.

It is hard to know what to object to most in this banal and evasive piece of claptrap. Clearly opera, classical music and Shakespearean drama are not listened to by 'all of us', and if they represent the 'deepest cultural experience' then it follows

that those who are ignorant of them, and depend on the 'creative industries' for their culture, are being deprived of that deepest experience, and are consequently, by comparison, shallow. Clearly, too, Mr Blair undergoing 'emotional torment' at the Cottesloe Theatre is presented by Smith as somehow meritorious. Being 'deeply moved' by Shakespeare shows that he is a properly cultured person despite his liking for Oasis. In other words, though Smith professes to 'loathe' the distinction between high and low art, he endorses it in a thoroughly conventional way.

As a result, although he is anxious to declare that art promotes social inclusion, bridges the gap between high and low, and stops people feeling isolated and rejected, he cannot actually think of any artworks that have this effect. In a moment of ill-starred inspiration, it occurs to him that the death of Diana, Princess of Wales was, or could be presented as, socially cohesive, and he rapidly cobbles this into his argument. The 'outpouring of genuine emotion' at Princess Diana's death, he urges, gave those who outpoured it 'a sense of shared identity through shared cultural emotion', and proved that 'culture helps to bind people together'. What 'cultural emotion' is; in what sense Princess Diana's death represented 'culture'; and how dying in a car crash could qualify as a contribution to creativity, are matters Smith leaves unexamined.

A far more intelligent investigation of the high-versus-low-art debate is offered by Noel Carroll in his book *A Philosophy of Mass Art*. Carroll is not without shortcomings as a cultural commentator. He tends to assume that there is mass art on the one hand and avant-garde art on the other, and nothing in between. Occasionally he concedes that there is a category he calls 'middlebrow art' which, he says, imitates the structures of past avant-garde art, and is designed to appeal to people of a 'certain educational background'. This looks like a standard

highbrow dismissal of a large and literate segment of the population, often loosely referred to as the 'middle class', which intellectuals, because they have mostly sprung from it, resent and despise. Carroll can also slip into vagueness when commending the works he approves of. He defends mass art because it has produced 'some works of the highest achievement', without revealing what that means, or how he measures it. Generally it seems to mean works that even mass art's foes can be counted on to admire, such as the films of Charlie Chaplin, Buster Keaton and Alfred Hitchcock.

However, set against Carroll's strengths these are mere blips. He offers a systematic breakdown of the various arguments used to discredit mass art, and a reasoned refutation of each. He defines mass art as art made and distributed by means of mass technology, for mass consumption, and he identifies it as the most pervasive form of aesthetic experience for the largest numbers of people from all classes, races and walks of life. Despite this global importance, he notes, it is dismissed or condemned by most philosophers of art. He does not deny that there are differences between mass and 'high' art. He admits, for example, that mass art tends to be formulaic. However, he insists, so is much 'genuine' art. Cubist or Impressionist artworks follow recognized techniques, for example, and ever since Aristotle's *Poetics* high art has tended to demand adherence to traditional, established genres and rules of composition.

He also concedes that mass art is easy to follow, by comparison with avant-garde art. It favours starkly defined oppositions between good and evil, rather than complex psychological dramas. It avoids enigmas. Easy comprehension could indeed be seen as a 'central design feature' of mass art. However, Carroll is far from granting that difficulty in art can be equated with value. If we think about what has been accepted as genuine art

in the past, including most pre-20th-century painting, it is apparent that enjoyment of it can be relatively effortless. Impressionist painting, for example, gives instant pleasure to many viewers. The critical insistence that high art is difficult and therefore superior can be interpreted, Carroll suggests, as an attempt to reconceive the appreciative response to art along the lines of the Protestant work ethic. It might be added that it often carries connotations of social criticism, implying that the audience of mass art is lazy, improvident, and addicted to instant gratification, whereas high-art advocates are energetic, industrious and successful.

The claim that high art is necessarily difficult is often presented as a justification for its being supported by public money. Since it cannot be made accessible to a large public, it is argued, everyone must help to pay for it, otherwise the minority who like it would not be able to afford it. John Tusa, Managing Director of the Barbican Centre, puts this case in his plea for increased government funding, *Art Matters: Reflecting on Culture* (1999). Tusa believes in absolutes. 'Absolute quality', he asserts, 'is paramount in attempting a valuation of the arts.' What this means, and how 'absolute quality' might be measured, remain mysterious, but apparently there is a link in Tusa's mind between 'quality' and difficulty. 'The fact is', he explains, 'that opera is not like dipping into a box of chocolates. It is demanding, difficult.' Despite this assurance, the association of opera with difficulty seems questionable. What sort of difficulty, it might be asked, do those attending operas encounter? What is difficult about sitting on plush seats and listening to music and singing? Getting served at the bar in the interval often requires some effort, it is true, but even that could hardly qualify as difficult compared with most people's day's work. The well-fed, well-swaddled beneficiaries of corporate entertainment leaving Covent Garden after a performance

and hailing their chauffeurs do not look as if they have been subjected to arduous exercise, mental or physical. No other single institution does as much as the Royal Opera House to perpetuate the association of high art in the public's mind with lavishness, grandeur and exclusiveness. The colossal injections of other people's money needed to maintain it are notorious. In 1996 alone it swallowed £78 million of lottery funding. It has been the principal beneficiary of public subsidy ever since the Arts Council's inception. As Tusa says, opera is not like dipping into a box of chocolates. It is very much more expensive.

The kind of 'difficulty' claimed for high modernist art frequently seems questionable from another angle. There are many intellectual tasks, ranging from mathematical problems to crossword puzzles, which can justly be called 'difficult' in that they have correct solutions that are hard to work out. To say that a modernist work of art – T. S. Eliot's poem *The Waste Land*, for example – is 'difficult' is to use the word in a quite different sense. There is no agreement about what *The Waste Land* as a whole means, and for some sections of it no explanation has been found that seems even remotely satisfactory. The idea that the poem has a solution, like a crossword puzzle, would, in any case, be treated with disdain by its admirers. However, if it has no correct solution then its 'difficulty' is quite distinct from the difficulty of soluble tasks. Our normal word for things that cannot be understood is 'unintelligible', and in descriptions of high art, particularly high modernist art, this might be more accurate than 'difficult'.

Another standard charge levelled against mass art is that the emotions it arouses are shallow compared with those of high art. The American philosopher R. D. Ellis, writing in the *Journal of Consciousness Studies*, claims, typically, that 'good art' is recognizable because it can 'disturb us, agitate us, or make us weep', whereas the low art favoured by 'hedonists' is

merely 'pretty' or 'pleasant'. Other high-art advocates, while agreeing that low-art emotions are shallow, argue that what distinguishes high art is emotional control. Carroll quotes a representative comment by Abraham Kaplan: 'Popular art wallows in emotion while art transcends it, giving us understanding and thereby mastery of our feelings.' Obviously these different assessments of high art's emotional effects cannot both be true. It cannot be simultaneously commended for agitating us and making us weep and for teaching emotional control. In fact the inaccessibility of other people's consciousness, and the variability of personal responses to artworks, makes all statements about art's emotional effects suspect. Carroll concedes that mass art seeks to engage emotional responses that are nearly universal, such as anger, disgust, fear, happiness, sadness and surprise. But, he argues, acknowledged works of high art are also dedicated to arousing nearly universal emotions, and this factor probably accounts for their cross-cultural appeal. Besides, it is a mistake, he contends, to conflate nearly universal emotions with shallow emotions.

These replies might, perhaps, be pressed further. Very little observation is needed to convince us that the emotions people feel in response to artworks – to tragedies, say – are evidently different from those they feel in real life. The sense of desolation and depression felt in real-life bereavement may last a lifetime, whereas death in a tragedy will cause sadness for, at most, the rest of the evening. Theatre-goers are unlikely to require counselling the next day, as the bereaved well may. If audiences really felt 'emotional torment' (Smith's phrase) no one would buy tickets. Emotional torment is what you feel if your child has borrowed the car, is hours late getting back, and cannot be reached on his or her mobile. It is a horrible experience and no one would willingly undergo it. Jeanette Winterson, championing high art, claims that 'the emotions art arouses in us are of

a different order to those aroused by experience of any other kind'. By 'different' she evidently means 'higher'. But the correct response to her assertion is, yes, the emotions art arouses are fake and transient, compared to those felt in real life. At all events, the claim that high art is distinguished by its access to 'deep' emotion looks questionable, if 'deep' is synonymous with 'genuine' or 'intense'.

Neuroscientists may, in the future, be able to bring some clarity to this topic. They have already found that particular emotion centres in our brain light up when we see a picture of an expressive face. The emotional intensity a subject feels on contact with an artwork will no doubt soon be measurable. But the wide variation in personal responses to the same artwork that current methods of investigation reveal suggests that emotional-intensity levels will prove similarly variable, and how to interpret the new evidence will probably remain a matter of dispute. Subjects who are easily moved ('shallow' or 'hysterical' in intellectual terminology) may well register intense emotion when confronted with samples of mass art, and, if they do, high-art advocates will have to find reasons to discredit their feelings. We can be sure they will succeed in doing so.

How other people feel and think is, I have suggested, not precisely knowable. But most of us can describe our reactions to some degree, and an astonishing fact about the history of art-criticism – including literary criticism – is that it has shown virtually no interest in this source of knowledge. It is standard practice for critics to assert how 'we' feel in response to this or that artwork, when all they mean is how *they* feel. Did Aristotle ever check out his theory of tragedy against a cross-section of the audience at Delphi? Apparently not; and criticism has remained resolutely blinkered ever since. The critics of mass art that Carroll dissects invariably base their pronouncements on whatever fanciful image of the masses they happen to favour.

Consequently their critiques are essentially a branch of imaginative fiction.

This is particularly apparent when they are driven by political ideals. The Marxist critic Theodor Adorno, for instance, believed that mass art is a capitalist conspiracy designed to keep the masses in subjection by preventing them from developing independent critical intelligence. To this end, he maintains, mass art 'automatizes and stupefies' their mental faculties, and prevents them from questioning the existing social order. Carroll has no difficulty showing that, in fact, many of the stories and stereotypes of mass art (science fiction, for example, and westerns) are about the possibility of social change. But such evidence would make little impression on Adorno, since his convictions about how mass art works bear no relation to any ascertainable facts. He asserts, for example, that film is such a rapid medium that it 'leaves no room for imagination or reflection on the part of the audience'. They cannot deviate from the precise details on the screen without losing the thread of the story. 'Sustained thought is out of the question if the spectator is not to miss the relentless rush of facts.' Consequently film, as a medium, 'forces its victims to equate it directly with reality'.

Film-goers will receive this news with surprise. Walter Benjamin, another critic who draws his evidence exclusively from his imagination, reaches conclusions about film almost diametrically opposed to Adorno's. He welcomes the advent of film and photography, since they make possible mass-produced art, and replace the semi-religious 'aura' of old-style artworks, which instilled respect for tradition. Films, Benjamin believes, encourage critical detachment in their audience. Their use of close-ups allows a penetrative scrutiny of the realities of capitalist society. It 'extends our comprehension of the necessities that rule our lives', and is ideally suited to develop working-

class consciousness and contribute to the proletarian revolution. Further, film does not hold the spectator in thrall as 'auratic' art does, but allows divided, intermittent attention. The result is a quite new way of seeing, 'symptomatic of profound changes in apperception', that will galvanize concerted criticism in the mass audience.

Evidence that watching film enhances an audience's cognitive and perceptual powers in the way he claims is entirely lacking from Benjamin's account, and that is typical of the kind of 'theoretical' criticism he is writing. Carroll classifies Benjamin's practice as a variety of 'technological essentialism' – that is, Benjamin assumes that a technology, in this case film, has a mode of consciousness or a political stance inscribed in it, so that the introduction of the technology will change the way people think and feel in definite and predictable ways. The belief that education will be improved by introducing computers into classrooms is an instance of the same mistake. The most celebrated 20th-century technological essentialist was Marshall McLuhan, who taught that the mass media were the pathway to utopia. He was less concerned with the content of the mass media than with their structures, and the viewing and listening habits they fostered. Briefly, his argument was that television would cure human isolation and individuality, making the earth a 'global village' and restoring a lost Eden of communal consciousness. Print culture, he argued, by promoting solitary reading, had divided man from man. It had also fostered logic, repressing the emotions, and had separated imaginative life from the life of the senses. But television would free us from the arid and silent page of print, which feeds only the eye, and give us back the richness of our other senses, especially our hearing, a 'hotter' sense than sight in McLuhan's opinion.

Another evil of print-culture, as McLuhan saw it, was that it forced the whole of experience into a linear, standardized form.

Whereas tribal cultures, innocent of literacy, had nurtured non-linear thought – metaphorical, mythic, imaginative – the tyranny of print, and the modes of attention inseparable from it, had paved the way to specialization, regimentation, mass production, nationalism and modern militarism. But television can reverse this process, and take us back to the tribal world of gesture, mime and dance. It addresses 'the whole human sensorium' including, McLuhan curiously believes, the sense of touch. Its effect has nothing to do with programme content. 'The medium is the message.' The beneficial results would accrue simply from the relationship between the technology and our senses, irrespective of what we were watching. So however 'high' the programmes' cultural content, the TV child 'encounters the world in a spirit antithetic to literacy'. Liberated from the old culture, he or she will join the gladsome society of the global village, decentralized, communitarian and fraternal, where people will be so involved in one another's concerns that scarcely a trace of individualism will remain.

McLuhan's is, of course, a beautiful theory, benign, optimistic, and particularly compelling to intellectuals who, having spent much of their lives reading books, are easily persuaded that they may have missed out on pleasures of a more sensuous nature, to which tribal dancing might well be an introduction. At the same time, as a prophecy of the effects of television it is somewhat flawed. In the 21st century, even the most ardent McLuhanites can scarcely be under the impression that they are living in a communitarian global village, or that, however the future is scanned, such a utopia is anywhere in sight. Arguably the effect of television has, on the contrary, been to reveal prosperous Western lifestyles and expectations to vast numbers of the deprived, and to foster, as a result, envy, outrage and religious hatred. However, to make that sort of assumption without evidence to support it would be to fall into precisely the

same trap as McLuhan. Technologies, as Carroll stresses, do not carry political and social agendas. The medium is not the message. Television does not necessarily promote illiteracy, and print is not restricted to the transmission of 'linear' thinking. It can convey poems or the writings of mystics or McLuhan's denunciations of print, as well as textbooks of logic.

Adorno's is a more usual case than Benjamin's or McLuhan's, in that wholly unsupported assertions about the effects of the mass media have usually come from those who denounce them rather than from their apostles. It is an educative experience to read early intellectual dismissals of radio, film and other technologies that most highbrows now regard as culturally respectable, or at any rate capable of respectability. Writing in 1936, R. G. Collingwood distinguished genuine art, which he considered 'intrinsically' valuable, from amusement, propaganda, 'sob-stuff' and other mass-aberrations, and he took it for granted that there was a close link between the shallowness of these forms and the technology that delivered them: 'the gramophone, the cinema and the wireless are perfectly serviceable as vehicles of amusement or propaganda, for here the audience's function is merely receptive and not concreative.' Carroll, who quotes this passage, observes that passivity is among the commonest charges brought against the audience of mass art. Whereas high art, it is claimed, encourages 'active spectatorship', mass art is consumed in a state of supine receptivity, so that in time its audience's powers of discrimination atrophy through lack of use. In countering this, Carroll selects popular art forms such as the mystery story and the thriller, which encourage active reader participation – following a plot, noticing clues, anticipating what may happen next. He notes, too, that the lyrics of mass-market music are often metaphorical, so require exegesis. This claim has been powerfully endorsed recently by Christopher Ricks in his book *Dylan's*

*Visions of Sin*, where the words of Dylan's songs are microscopically scrutinized, and judged worthy of comparison with Keats, Shakespeare and other greats of English poetry. Not everyone was wholly convinced by Ricks's arguments, but to have a critic of his stature giving Dylan's lyrics the close and sensitive attention that is normally reserved for classic texts should mean that we hear less in the future about the natural inferiority of mass-market music.

However, it will probably make no difference. Prejudices in these matters are hard to shift. Taste is so bound up with self-esteem, particularly among devotees of high art, that a sense of superiority to those with 'lower' tastes is almost impossible to relinquish without risk of identity-crisis. The real lesson to be learnt from the example of Adorno, Benjamin, McLuhan and their kind is that we need to know more about the audience of mass art. What pleasures and satisfactions they derive from it and how it affects their lives are questions that can be answered only by going out and asking. Staying at your desk and just using your imagination is not a substitute, though it has been the usual practice up to now.

Representative of the studies that have tried to alter this pattern is Dorothy Hobson's *Crossroads: The Drama of a Soap Opera*, which researched audience response to the long-running ITV soap set in a motel near Birmingham. Hobson was spurred to investigate the programme because critics were so uniformly contemptuous of it. It had an audience of 14–15 million, mainly women, and its popularity depended, Hobson found, on its raising problems that they saw as relevant to their lives. It showed strong women characters, which made it a progressive form from its viewers' perspective. Many of them were lonely or elderly, and, as with other soaps, a degree of timelessness was important. Nothing final must happen. Any attempt to introduce an 'ending' causes protest. In 1982 there was a pub-

lic outcry over the sacking of Noele Gordon, who played Meg Mortimer, after seventeen years in the programme. The *Birmingham Evening Mail* ran a poll and postbag on the issue, which came out overwhelmingly in favour of Meg's retention. The replies came from middle-aged or elderly women, predominantly working class, many of them pensioners. They saw Meg as a positive model, a working woman managing a business and bringing up children without a husband, and they equated the programme with a form of stability in society that they felt to be slipping away. Despite this, *Crossroads* was not 'escapist' in a socially irresponsible sense. It educated its viewers about the problems of the disabled, and about the need for kidney donors, and raised money for a child kidney-patient unit. Handicapped viewers said that Benny, an educationally subnormal boy, played by Paul Henry, helped them to a sense of identity.

The intellectual taunt that soap-watchers confuse fiction with reality seems largely unfounded. It is true that viewers occasionally wrote in trying to stay at or get jobs in the motel, and one actress who, in the serial, was considering an abortion was refused service in a Birmingham department store. But these were exceptions. Hobson found that viewers had a high level of critical awareness, based on a close knowledge of story lines, and rooted in their experience of everyday life. Discussing characters in the soap as if they were real was a 'game' they played with one another, well aware of what they were doing. The idea of the 'passive viewer' is, Hobson found, a myth. Viewers have a creative input, they add their own interpretation and understanding, and involve their own feelings and thoughts about how the situation should be coped with. 'There are as many different *Crossroads* as there are viewers.' In this sense *Crossroads* is 'popular art', with communal participation. Reasons given for watching varied, but curiosity ('I suppose I'm

nosey') was common. So was the companionship the programme offered to people living mainly solitary lives. The fact that it was *not* high art, that it was 'unassuming', was a strong element in its appeal, and could be seen as a moral as well as an aesthetic strength, for it implied a rejection of self-aggrandizement and pretentiousness. *Crossroads*, Hobson believes, provoked a straightforward clash of cultures. What the critics were saying was 'This programme offends me and my cultural values', but they operated from a position of ignorance because they made no effort to discover what its viewers thought. 'It is', she concluded, 'false and elitist criticism to ignore what any member of the audience thinks or feels about a programme.'

False and elitist criticism has, of course, carried on regardless. The Yale literary theorist Geoffrey Hartman's high-minded jeremiad *Scars of the Spirit: The Struggle against Inauthenticity* (2002) drags up yet again the charge that popular culture 'promotes the passivity of mere consumption'. Drawing on the speculations of the fashionable French critic Jean Baudrillard, Hartman presents the results of mass culture more alarmingly than ever before. His, and Baudrillard's, case is that modern life lacks authenticity. Bombarded with images by the media, we are unsure of our own existence. Videos, home movies, and the 'simulacra' of television have produced 'a visceral feeling of identity-lack', of being a mere phantom, an 'android' or 'replicant', rather than a real person. Because of this 'weakening of the reality principle', we suffer the delusion that 'all the world's a movie', peopled by 'electric phantoms'. Noticeably, critics who present this kind of doom-laden nonsense never include themselves in the ranks of the deluded. The severe personality problems described have always happened to someone else, indeed, to very many people – to almost everyone, in fact, except the critic and the like-minded minority battling to keep reality alive. Hartman gives no sign of having been out on

the streets asking people if they are androids or replicants, though that would, surely, be a first step towards responsible research.

The cure for our malaise is, according to Hartman, high art. We crave authenticity, which is related to the 'sacred' and the 'spiritual', and high art supplies this. It can save us from the shallow worldliness of our Western lifestyle and re-engage us with the real. While he was in the later stages of writing his book the terrorist attack on New York's twin towers took place. It was an event which, among all its other terrible and multiple consequences, raised serious problems for Hartman's argument. For the terrorists could be seen as reacting against just those aspects of contemporary culture that Hartman had been denouncing, and as seeking the spiritual authenticity that he prized. In a postscript, he acknowledges this. The hijackers, he speculates, may have been driven by radical Muslim contempt for Western materialism and a yearning for purity and dedication. They may indeed, he thinks, bear out his theory, in that their quest for authenticity may show the strain of living with a sense of 'the unreality of society, self, and world'.

Perhaps. The hijackers' motives are undiscoverable. But if, as Hartman supposes, they were driven by a quest for authenticity, for the spiritual and sacred, akin to that which he associates with high art, then they could also illustrate the disregard or contempt for other and 'lower' people, for their lives and meanings, that high art fosters. Of course the differences between advocacy of high art and terrorism are multiple. I am not suggesting an equivalence. But the assumption that high art puts you in touch with the 'sacred' – that is, with something unassailably valuable that surmounts human concerns – carries with it a belittling of the merely human which, when transposed to the realm of international terrorism, promotes massacre. The fatal element in both is the ability to persuade

yourself that other people – because of their low tastes or their lack of education or their racial or religious origins or their transformation into androids by the mass media – are not fully human, or not in the elevated sense that you are human yourself. Of course it is just this fatal element that makes the viewpoint so attractive. For it brings with it a wonderful sense of security. It assures you of your specialness. It inscribes you in the book of life, from which the nameless masses are excluded.

Hartman's argument comes down to saying that the experience he gets from high art is better than that others get from the mass media. The difficulties attendant on making such a claim should by now be apparent. In *What Sort of People Should There Be?*, Jonathan Glover examines these difficulties from a philosophical angle (though without reference to Hartman, who had not yet written his book). Glover would certainly like to find a reason for thinking a cultured life, such as he leads, indisputably superior. We can gather this from the way he refers to other people. He agrees, for example, that providing the world's hungry masses with food and shelter might seem more important than culture or philosophy. But, he asks, what is the point of giving them food and shelter 'if all that remains for them afterwards is life working in an insurance company'. The arrogance of this is breathtaking. By whatever right does Glover assume that a life spent working in an insurance company is less worthwhile than his own? But his arrogance serves, at least, to assure us that if there is any kind of rational basis for his sense of his own superiority, he will find it.

To aid the search he introduces a concept called 'the quality of life'. This looks promising as a way of showing that certain activities are preferable to others. For if they make your quality of life better – or worse – you will have a dependable basis for evaluating them. Unfortunately, what a better or worse quality of life would be like remains itself a subjective judgement.

Glover appreciates this, and appreciates, too, the impossibility of escaping from subjectivity. The quality of life of a mentally handicapped person would, he instances, seem low to an intelligent, cultured observer. On the other hand it might be 'internally adequate' – that is, it might seem to the person who lives it satisfactory, worthwhile, and even preferable to the lives of others. Who is to decide which view is correct?

Such decisions become a matter of life and death in regimes, such as that of Nazi Germany, where elimination of the mentally handicapped was a matter of state policy. The abortion of fetuses that will not grow into normal people is also sometimes justified by reference to the inferior quality of life they could enjoy. Though such judgements are made to appear clinical and objective, they are subjective in that they depend on arbitrary decisions about what the quality of a life ought to be. They are arbitrary too in that those destroying the life cannot have firsthand knowledge of how it seems (or, in the case of aborted fetuses, would seem) to the being who lives it.

Insofar as art and culture are concerned, Glover speculates that an objective criterion of how far they enhance the quality of life might be based on J. S. Mill's elimination test, put forward in *Utilitarianism* (1861). Mill's test depends on the idea of consensus. If all or most of those who have experienced two pleasures prefer one to the other, he reasons, then we are justified in calling it superior in quality. This seems to open up an attractive prospect of deciding, once and for all, which works of art we should value most. But it has drawbacks. For one thing, we cannot tell that two people have experienced the same pleasure when exposed to the same artwork. Even leaving that aside, though, the results of Mill's head-counting, if applied on a truly democratic scale, would be unacceptable to many. Pop music, for example, would emerge as superior to classical music; football as superior to, say, sculpture. Classical musi-

cians and sculptors would rightly protest at such a test of 'quality'. That a greater number of people prefer something shows, they would point out, that it is more popular, and nothing else.

A variant of Mill's consensus argument sometimes employed by advocates of high art is to restrict the suffrage. Though it is true, they grant, that pop music and football will emerge triumphant if you merely count heads, a different and more satisfactory result will be obtained if you consider only the opinion of refined and educated people, and if you boost the numbers by including the votes of refined and educated people in past ages. In this way, it is argued, you will discover the consensus not, admittedly, of all mankind, but of those who really matter. The Scottish Enlightenment philosopher David Hume attempts to widen the consensus argument in this way in his essay 'Of the Standard of Taste'. He concedes that the rules of art are not scientific, but there is, nevertheless, a true standard of taste, he insists, and it is 'what has been universally found to please in all countries and in all ages'. Unfortunately a moment's thought will tell us that there is nothing on earth that meets this criterion, except perhaps sexual intercourse and eating. Times, cultures and individuals have differed radically in their artistic preferences. Besides, as we read Hume's essay we soon find that he does not believe in 'universally' pleasing art himself. On the contrary, true appreciation of art is a highly elitist matter in his estimation, and large sectors of humanity are debarred from it. 'Few are qualified', he stipulates, 'to give judgement on any work of art.' You must have delicate discrimination, so as not to be susceptible to crude effects, for, he warns, 'the coarsest daubing' may be beautiful enough to impress 'a peasant or Indian'. You must also be 'free from all prejudice', and this will enable you to steer clear of the 'bigotry and superstition' which are 'eternal blemishes' in Roman Catholic art. You must also be rational and civilized enough to

see through the claims made by devotees of the Koran, who pretend to draw moral precepts from 'that wild and absurd performance'. So Hume's 'universally admired' turns out to mean, at best, 'not counting Catholics, Muslims, peasants and Indians'. Though Hume is prepared to concede that our judgements of writers and artists may change with time, there are some preferences that can, he believes, be regarded as absolutely sacrosanct. For example, he suggests, it would be unthinkable to prefer Bunyan to Addison. Almost all students of English literature would nowadays disagree.

Shakespeare is probably the writer that most high-art advocates would select as a universally acclaimed genius, whose reputation proves that there are indeed artistic values that surmount place and time. But even here the consensus argument breaks down, not only because there are clearly more people in today's world ignorant of Shakespeare's works than knowledgeable about them, but also because even among the intelligent and educated across the centuries there has never in fact been consensus about Shakespeare's greatness. The disparaging opinions of Voltaire and Tolstoy are well known. Charles Darwin found 'tremendous delight' in Shakespeare as a schoolboy, but his view changed when he grew older. 'I have tried lately to read Shakespeare and found it so intolerably dull that it nauseated me.' Norbert Elias, in his book *The Civilizing Process*, quotes from Frederick the Great's treatise *On German Literature* (1780):

> To convince yourself of the lack of taste which has reigned in Germany until our day, you only need to go to the public spectacles. There you will see presented the abominable works of Shakespeare, translated into our language; the whole audience goes into raptures when it listens to these ridiculous farces worthy of the savages of Canada . . . How can such a jumble of lowliness and grandeur, of buffoonery and tragedy, be touching and pleasing?

This, Elias stresses, was not an idiosyncratic view, but reflected the standard opinion of the French-speaking upper class of Europe in the late eighteenth century. For that matter, university-educated intellectuals in Shakespeare's own day such as Thomas Nashe and Robert Greene would have found the suggestion that he was a great writer utterly ridiculous. On the contrary they derided him as an 'upstart', semi-educated plagiarist, on the fringe of the literary world. The orthodox educated view in the seventeenth century, as represented by the contemporary cultural commentator George Hakewill, was that the only work by an English author that could possibly challenge comparison with the classics of Homer and Virgil was Sir Philip Sidney's *Arcadia*. It was certainly not *Hamlet* or *King Lear*, which Hakewill does not even mention. Shakespeare himself, it might be added, made no effort to publish his plays, or to correct or proof-read those his acting company had printed. Far from regarding them as a cultural treasure of which the human race must not be deprived, it seems he did not care whether they survived or not.

To dismiss the opinions of Voltaire, Darwin, Tolstoy and the rest as stupid and blind, and insist that our own estimate of Shakespeare's universal value is the correct one, is to fail to understand that cultures change, and that their most fundamental convictions fade and change with them. If we are intent on finding something of 'universal' significance in our culture, it is likelier to be in science than art. Richard Dawkins, in his book *A Devil's Chaplain*, imagines superior creatures from another star system (they will have to be superior, he notes, to get here at all) landing on our planet and acquainting themselves with our intellectual stock-in-trade. It is unlikely, he suggests, that Shakespeare, or any of our art and literature, will mean anything to them, since they will not have our human experiences and human emotions. Equally, if they have a liter-

ature or an art, they are likely to seem alien to our human sensibilities. But mathematics and physics are another matter. Though the star-travellers will probably find our level of sophistication in these disciplines low, Dawkins suspects, there will be common ground. 'We shall agree that certain questions about the universe are important, and we shall almost certainly agree on the answers to many of these questions.'

None of this, of course, is a reason for thinking less of Shakespeare. But it is a reminder that talk of the 'universal' value of his or any art is meaningless. Nor can Shakespeare's value be established by a 'consensus', whether it is organized on democratic, head-counting lines, or by restricting the ballot to intelligent and educated people across the ages. Well over a century after his death many such people did not consider his plays 'high' art at all. The fact that they were once popular art, despised by intellectuals, but are now high art, itself suggests that the differences between high and popular art are not intrinsic but culturally constructed.

Jonathan Glover's enquiry, which raised the consensus argument as a possible solution to the question of what sort of cultural experiences, or what quality of life, we should prefer, ends in indecision. He sees no prospect of finding reliable answers to these questions. All tests for 'quality' are inconclusive, he concludes. We are driven back on our own values and prejudices. The evidence I have collected in this chapter seems to support his scepticism. We have seen that, though high-art advocates have no doubt about their own superiority, their arguments, when they offer any, do not bear scrutiny. The artistic practices of the human race throughout most of its history served an evolutionary purpose because they were unlike high art. They were communal and practical. The characteristics of popular or mass art that seem most objectionable to its high-art critics – violence, sensationalism, escapism, an obsession with romantic

love – minister to human needs inherited from our remote ancestors over hundreds of thousands of years. Activities such as women's fashion, gardening and football can be shown to meet these needs in ways that high art does not. Consequently when commentators such as Iris Murdoch set out to construct a philosophical proof of the superiority of high art, the result is catastrophic and self-deluding. Claims that high art is better than low because it is more difficult or arouses deeper emotions, and that low art is inferior because it is formulaic and encourages passive consumption, are not, it turns out, sustainable. The most striking deficiency in the case against mass art is the complete lack of interest – illustrated by Adorno, Benjamin, McLuhan and Hartman – in finding out how such art actually affects its recipients. The weird and contradictory accounts such critics give of the effects of mass art bear no relation to the findings of those who carry out responsible audience surveys. Finally, the 'consensus' argument – that high art products are superior because they have always seemed so to a consensus of right-thinking people – proves difficult to apply in practice, even in the case of Shakespeare.

# Can science help?

The first two chapters of this book have tried to clarify some points about terminology and remove some misunderstandings. The only credible answer to the question 'What is a work of art?', I have suggested, is 'Anything that anyone has ever considered a work of art, though it may be a work of art only for that one person.' I have also argued that the absence of any God-given absolutes, together with the impossibility of accessing other people's consciousness, prevents us – or should prevent us – from pronouncing other people's aesthetic judgements right or wrong. In this chapter I want to ask whether science can change this situation, whether it can supply the absolutes that religion used to supply, whether it can allow us to access other people's consciousness, whether it can turn aesthetics from an area of opinion into an area of knowledge.

One modern thinker who believes that it can is the biologist Edward O. Wilson, who sets out his case in his book *Consilience: The Unity of Knowledge*. Wilson's argument is that since all human activities and ideas originate in the brain, and since the brain is a material object which brain scientists will hopefully one day understand, it follows that all human activities, including art and ethics, can be explained scientifically. 'Every mental process', Wilson insists, 'has a physical grounding and is consistent with the natural sciences.' He maintains, too, that there is such a thing as 'human nature', which is uni-

versal. It is an evolutionary product and is composed of a number of 'epigenetic rules'.

These are innate operations in the sensory system and the brain. They are laid down by the joint operation of two kinds of evolution, genetic and cultural. Genes prescribe certain regularities of sense-perception or mental development, and culture helps determine which of the prescribing genes survive and multiply. There are primary epigenetic rules and secondary ones. The primary ones determine the way our senses apprehend the world – the way, for example, our sight splits the wavelengths of visible light into the distinct units that we call the colour spectrum. The secondary epigenetic rules relate to our thinking and behaviour. They include the neural mechanisms of language, the smile as a sign of friendship, the human tendency towards binary oppositions (good, bad; up, down), and such matters as the incest taboo and fear of snakes.

Turning to the arts, Wilson proposes that works of art can be 'understood fundamentally with knowledge of the biologically evolved epigenetic rules that guided them'. By this he seems to mean that we can understand how particular works of art came into being by identifying the epigenetic rules that they obey. The epigenetic rules make certain thoughts more effective than others in arousing emotion. Consequently they have biased cultural evolution towards the creation of archetypes, and these are the 'widely recurring abstractions and core narratives that are dominant themes in the arts'. It seems from Wilson's account that they are quite limited in number. In myth and fiction, he estimates, as few as two dozen groupings cover most of the archetypes – for example, the hero, the monster, the seer, the nurturing woman, and their variants. Those works of art that 'prove enduring', he concludes, are the ones that incorporate these archetypes, since they satisfy the preferences that have been 'universally endowed by human evolution'.

There appear to be some shortcomings in Wilson's theory. It is not clear whether he believes that simply containing one or more of the archetypes will give a work the power to endure. This would seem an incorrect assumption, since there are many works containing heroes, monsters, nurturing women, and so forth, that have been forgotten. But if artworks need something else beside the archetypes to make them endure, what is that something else? Again, suppose that there are two artworks that satisfy the same epigenetic rule – suppose they both register fear of snakes, as, for example, do the many artistic and poetic treatments of the Genesis story – will they necessarily be equivalent in their enduring power? If not, why not? Yet again, it is evident that human beings respond to artworks very differently, not only across different ages and cultures but within the same culture. How can the epigenetic rules allow this, given that, according to Wilson, the rules apply to us all, and constitute our essential, universal human nature? He contends that the 'quality' of works of art 'is measured by their humanness, by the precision of their adherence to human nature'. If there were indeed certain identifiable works that appealed to everyone in every age and culture, then it would be reasonable to conclude that they corresponded to something universally human. But the reality is that no such works exist, except in Wilson's imagination.

Perhaps the most evident drawback to the evaluative procedure he recommends is that our discussions of art and literature habitually range into many subtle and recondite areas of interpretation that could not conceivably be reduced to identifying the epigenetic rules that a work obeys. Significantly, he never ventures to show how his theory would work in practice. He never, that is, selects an artwork that has proved 'enduring' over several generations – *Hamlet*, say or Rembrandt's *The Night Watch* – and explains how its success depends on obeying

epigenetic rules – and it is not hard to see why he hesitates to do this. Analysing a work of art or literature using his epigenetic rules would be like trying to do a jigsaw puzzle using a forklift truck.

He does, however, cite a number of experiments in bio-aesthetics that, he believes, may illustrate epigenetic rules in action. He refers to Gerda Smets's book *Aesthetic Judgement and Arousal*, in which Smets, a Belgian psycho-aestheticist, recounts her attempt to find a dependable scientific basis for aesthetic judgement. Smets was working in the field of Information Theory, a branch of psychology that takes as its basis the observation that uncertainty is unpleasant, and that information, by eliminating alternatives, relieves tension and gives pleasure. According to the theory, information must not have too high a 'redundancy' (for example, over-repetition of the same element or pattern) or it will become boring, whereas too low a redundancy will prove bewildering and chaotic. Smets planned her experiment with great care. She saw that three things were necessary. First, a large range of patterns with known redundancy-ratings. Second, a way of measuring what went on in the brains of people who looked at these patterns. Third, a comparison of their aesthetic judgement of the patterns with these measurements.

She solved the first problem ingeniously by arranging small black and white cubes in a large number of different patterns. These ranged in complexity from a simple repetitive pattern like a chessboard, using 64 cubes, to apparently random groupings of 900 cubes. The people she was using as human guinea-pigs were allowed to look at each pattern for two seconds. Then they were supplied with piles of black and white cubes and asked to re-create the pattern. As the patterns grew more complex – that is, less redundant – they made more mistakes. At the end the number of mistakes they had made were added up, and

averaged out, and this allowed a precise redundancy-rating to be allocated to each pattern.

In the next stage of the experiment an electroencephalogram (EEG) was used. This is a device that measures the electrical potential between two points on the skull on which electrodes are placed, and registers it as a wave pattern. While the subject is relaxed and looking into darkness, the EEG shows large, high-amplitude, low-frequency waves, called alpha waves. When the subject is aroused his or her EEG will show more irregular, higher frequency beta waves. Arousal can be calculated by measuring the time the subject's alpha rhythm is interrupted by beta waves. Smets showed a selection of her redundancy-rated black-and-white patterns to her human guinea-pigs, and calculated the arousal each pattern caused. She found that arousal was greatest for patterns with 20 per cent redundancy. If we bear in mind that a simple, repetitive pattern has something approaching 100 per cent redundancy, whereas a totally random arrangement has 0 per cent redundancy, we shall appreciate that patterns with only 20 per cent redundancy are very complex indeed, and the high brain-arousal they elicit reflects the subject's effort to find regularity in what is apparently random.

Wilson cites Smets's findings and concludes that a preference for 20 per cent redundancy is an epigenetic rule. However, there are good reasons for doubting this. In the first place, it is not true that Smets found that most of her subjects preferred patterns with 20 per cent redundancy. She found that they were maximally aroused (on EEG ratings) by 20 per cent redundancy. But when she asked them, in the third stage of her experiment, which patterns they thought most beautiful she got a far more varied response. Most of her subjects thought that patterns with 60 per cent redundancy (that is, much less complex, more regular patterns) were the most beautiful. But there was

no consensus. Subjects she classified as 'aesthetically more sensitive', or with 'a high degree of visual or aesthetical training', preferred more complex patterns (with 40 per cent rather than 60 per cent redundancy, though never with 20 per cent). In other words, whereas the brain-effort needed to try to puzzle out a pattern from seeming randomness appears to be fairly standard (at any rate among Smets's group of human guinea-pigs), aesthetic preferences, even within the same small group, vary very greatly. It follows that even if there were an epigenetic rule connected to 20 per cent redundancy it would be of no use whatever in judging between aesthetic preferences. Nor, it must be added, is Smets's discovery of a general preference among her subjects for patterns somewhere in the 40–60 per cent waveband of any use in that respect. For supposing you found that some people did not prefer patterns with between 40 per cent and 60 per cent redundancy, could you conclude that these people were unsatisfactory representatives of the human race, or that their aesthetic response was inferior? Neither conclusion could be justified scientifically. From a scientific viewpoint, nothing could be concluded except that they were unusual. The Smets experiment, that is to say, makes no progress towards establishing absolute standards for judging artworks.

Nor, by its very nature, could it do so. For Smets's experimental approach fails to take into account a very large number of factors that affect people's judgements of artworks. Redundancy, as defined in Information Theory, is the sole criterion she recognizes for distinguishing between her black-and-white patterns, but it is of very limited use for distinguishing between artworks. How could the difference, say, between the Dutch and Italian schools of painting, or, more specifically, between Leonardo's *The Virgin of the Rocks* in the National Gallery and Rubens's *Heads of Four Negroes* in

Brussels, be reduced to their level of redundancy? It is clear that individual preference for either of these pictures would involve a multiplicity of considerations that lie beyond the scope of Smets's black-and-white squares, and it is inconceivable that any amount of earnest experiment with the one could ever produce results relevant to the other.

The second experiment Wilson cites to illustrate an epigenetic rule is a study of optimum female facial beauty. Scientists prepared mock-up female faces, in which the features could be changed. The eyes could be made larger, the cheekbones higher, and so on. As they made these changes they asked a number of observers which faces they preferred. They found that when the faces' critical dimensions were exaggerated – big eyes, thin jaws, high cheekbones – they were judged more attractive by a wide range of viewers of different races and both sexes. The authors of the experiment explain this as an example of what biologists call, when it occurs among animals, supernormal stimulus. When a male silver-washed fritillary butterfly is shown a large plastic replica of a female silver-washed fritillary butterfly it follows it instead of a real female. When a herring gull is shown large painted wooden eggs it will prefer them to its own eggs even though they are too big for the gull to climb on top of. The human observers who prefer abnormally large eyes and abnormally high cheekbones are responding, Wilson suggests, in a similar way.

Applying this principle to art would lead to the supposition that art is equivalent to exaggeration, and this was indeed the theory put forward by two scientists, V. S. Ramachandran and William Hirstein, in a special issue of the *Journal of Consciousness Studies* devoted to Art and the Brain in 1999. They explained that if a rat is rewarded for discriminating a rectangle from a square, it will respond even more vigorously to an exaggerated rectangle, that is, one much longer and thinner than the

previous one. Biologists call this the Peak-Shift Effect, and Ramachandran and Hirstein think it explains many aspects of art. In effect, they suggest, all art is caricature. It selects and exaggerates certain features. For example, an evocative sketch of a female nude will accentuate 'those feminine-form attributes that allow one to discriminate it from a male figure'. Or it may be a caricature in 'colour space rather than form space'. A Boucher nude with its pink-flushed skin tones is, according to Ramachandran and Hirstein, a colour caricature of this kind. 'What the artist tries to do', they contend, 'is not only to capture the essence of something, but also to amplify it in order to more powerfully activate the same neural mechanisms that would be activated by the original object.'

Even abstract art, they speculate, may employ supernormal stimuli to excite form areas in the brain more strongly than natural stimuli. They cite a famous experiment on seagull chicks made by Tinbergen in 1954. Seagull chicks beg for food by pecking at the mother's beak, which has a red dot at the end. Tinbergen found that they will also peck at a stick with a red dot, and, much more vigorously, at a stick with three red stripes. This super-beak is, for Ramachandran and Hirstein, a caricature in 'beak-space', and in the seagull world would qualify as a great work of art. In the same way, they believe, some forms of art, such as Cubism, may tap into or caricature certain 'innate form primitives' we do not at present understand. So too may Van Gogh's sunflowers or Monet's water-lilies. They may be the equivalent 'in colour-space' of the stick with the three stripes, in that they 'excite the visual neurons that represent colour memories of those flowers even more effectively than a real sunflower or water-lily might'.

Ramachandran and Hirstein offer other science-based 'laws of artistic experience' in addition to their proposition that all art is caricature. Object-recognition in early human develop-

ment teaches the need to isolate a single visual modality, they explain, before amplifying the signal in that modality, and 'this is why an outline drawing or sketch is more effective as "art" than a full colour photograph'. So, too, cells in the visual cortex respond mainly to edges, not to homogenous surface colours, and this may explain why 'a nude wearing baroque (antique) jewelry (and nothing else) is aesthetically much more pleasing than a completely nude woman'. A preference for symmetry may, too, be hard-wired into our brains. Since most biologically important objects – predator, prey, mate – are symmetrical, symmetry may serve as an early-warning system to grab our attention. Other biologists have associated symmetry with sexual selection in a wide variety of species. The female scorpion fly prefers males with symmetrical wings; the female barn swallow prefers males with a symmetrical wishbone pattern of feathers on their tails. Such preferences may, it is thought, have evolutionary value, since symmetry may be a sign that the male's immune system is resistant to parasites that would cause uneven growth.

Ramachandran and Hirstein offer their findings as a 'universal rule or deep structure underlying all artistic experience'. Yet the objections to them seem obvious. Fellow scientists replying to their article in the *Journal of Consciousness Studies* pointed out with some embarrassment that many works of visual art are not remotely like caricatures, and that if distortion were the key to aesthetic success we would decorate the world with funhouse mirrors. A primary fact about human responses to artworks is that they vary enormously across times, cultures and individuals, so that comparisons with the automatic responses of rats or seagull chicks are obviously inappropriate. Psychologists have found that many people not brainwashed by art education detest Cubism, and are far from agreeing with Gombrich's assertion (which Ramachandran and Hirstein cite)

that a veiled nude is more attractive than an unveiled one. To explain personal preferences in these or other matters (such as the alleged superior 'effectiveness' of a line drawing compared to a colour photograph) by reference to biological imperatives linked to the operation of the neural system is to throw credibility to the winds. As for symmetry, whatever its value in natural selection, it is a matter of simple observation that very few paintings or sculptures are symmetrical, so any biological explanation of art needs to find a reason for symmetry-avoidance not symmetry-seeking. Before dismissing Ramachandran and Hirstein as the Laurel and Hardy of neuroaesthetics, however, we should remind ourselves that they are, in fact, highly distinguished academics: Ramachandran a Professor of Neuroscience and Psychology at the University of California; Hirstein, Philosophy Professor at William Paterson University. So their theory's hopeless ineptitude illustrates the difficulty of applying scientific research to art, even when fine minds attempt it.

The thinkers we have looked at so far have all been seeking a key that will 'explain' art scientifically. This is an ancient quest. That the universe is based on mathematical principles was a Platonic belief, quickly assimilated by Christianity. St Augustine taught that there is an immutable and eternal rhythm in all art, that comes from God. The rhythm may be in time, as in music, or in space, as in the visual arts. All natural objects, trees for example, share this same rhythm. 'Some deeply abstruse numerical system', Augustine believed, controls their growth and underlies all creation.

Attempts to discover this key factor scientifically came much later. Experimental aesthetics began in 1871 when Fechner displayed two versions of Holbein's *Madonna with Burgomaster Meyer* side by side in a Dresden museum and asked visitors to write down which they valued more highly. The experiment

failed because few visitors responded, and many of those who did misunderstood Fechner's instructions. His enterprise was, though, the forerunner of a huge body of behaviourist research in the second half of the 20th century which was devoted to recording spectators' reactions to various shapes, colours and sounds. Behaviourism is limited in that it can only record preferences, not explain them. Also, it is rudimentary. To progress from recording people's responses to shapes, colours and sounds, to explaining the effect that paintings or symphonies or operas have on them, would be inconceivably difficult, since artworks are not made just out of shapes, colours and sounds but, as we have seen, out of highly unstable meanings that differ with different recipients.

The impetus behind such experiments increased, however, as accurate ways were found of measuring the extent to which people are aroused by things they see and hear. Arousal in humans can be caused by various stimuli – loud noises, bright lights or colours, drives like hunger and sex, problem-solving, and also qualities sometimes associated with artworks such as novelty, complexity and ambiguity. A rise in arousal affects the electrical activity of the brain, causing changes in the electro-encephalographic waves that can be measured by placing electrodes on the skull. We have already come across these in the Gerda Smets experiment on 20 per cent redundancy. Another way of investigating what is going on in the brain is by Magnetic Resonance Imaging (MRI), which uses magnetic waves to pick up changes in blood-flow within the brain. When neurons are working they get hungry for sugar, oxygen and other nutrients. Because they need to get more energy when they fire, there is a local increase in blood-flow, and by locating and measuring this an MRI scanner can locate and measure brain activity.

There are other measurable bodily changes indicative of

arousal – increases in blood pressure and heart rate, changes in the rate and pattern of breathing, and a decrease in the electrical resistance of the skin due to sweating. Things we see and hear are continually causing these minute-by-minute changes in our bodies, though we are mostly quite unaware of them. E. B. Tichener, one of the founders of experimental psychology, affirmed that 'you cannot show the observer a wallpaper pattern without by the very fact disturbing his respiration and circulation'.

Naturally enough these methods of investigation fed the hope that people's responses to artworks could at last be scientifically measured. Another advance had come in 1954 with the discovery of the brain centres for rewards and punishments. It was found that if an electrode was placed in a particular part of a rat's brain, and if the electrode supplied electrical stimulation when the rat stepped on a pedal, then the rat would press the pedal repeatedly, often for hours on end. Earlier in the same year another group of scientists had found aversion areas in the brain where stimulation had the opposite effect. Cats with electrodes implanted in those areas would quickly turn off the switch that controlled stimulation.

The scientist who has tried to relate these breakthroughs most resolutely to how we respond to works of art is D. E. Berlyne. He found, experimenting on cats, that there came a point when pleasure turned to pain. The cat, suitably fitted up with an electrode in its head, would eagerly run to operate the lever that turned on pleasurable stimulation, but when this reached a particular level of intensity the cat would hasten to operate the lever that turned the stimulation off. From these observations Berlyne evolved his theory that there is a pattern of increase followed by decrease in all aesthetic pleasure, human as well as animal, that shows up as an inverted 'U' shape on a graph. He argued, plausibly, that this increase-decrease

pattern fits in with several previous aesthetic theories. The 'golden mean' theory of beauty – not too little, not too much – is one that Berlyne's cats seem to endorse. The cats could also be seen as neo-Aristotelians, since Aristotle's theory of catharsis tells us that pleasure in tragic art depends on certain emotions being first stimulated and then cancelled.

Admittedly Berlyne's theory does not help towards a definition of art, since the inverted 'U' formula apparently applies to all sources of pleasure – eating, sex, physical exercise, unwrapping a birthday present – just as much as it does to art. It does not tell us, in other words, anything distinctive about art. Obviously, too, humans responding to artworks are in several respects unlike cats with electrodes in their brains, not least because the amount of pleasure they get from any particular artwork varies greatly. Berlyne appreciates this and is much less intent than Wilson on finding blanket rules that cover all art. On the contrary, he is interested in the psychological factors that influence individual taste. He cites a study of high school students which shows that the ones with artistic interests are also the ones most prone to guilt, stress, anxiety and instability. These findings tally with the Freudian view that art provides substitute satisfactions when direct satisfaction is blocked by fear or moral scruples. But Berlyne is far from opting for any simple Freudian explanation. Also, by contrast with Edward O. Wilson's confidence that aesthetics will one day be reduced to scientific certitude, he seems to think that accounting for differences of taste lies beyond science's scope. It is 'impossible to say which, or which combination, of the many variables distinguishing two works of art may be responsible for any difference that may be discovered between reactions to them'.

This conclusion agrees with Hans and Shulamith Kreitler's recognition, quoted earlier, that if we were to answer the question why the same work of art evokes different responses in dif-

77

ferent people, our knowledge would have to 'extend over an immeasurably large range of variables'. The Kreitlers' own theory of art corresponds quite closely to Berlyne's, in that they believe the key to all art is tension followed by relief. The tension-relief sequence is found, they admit, in many activities they do not classify as art – for example, mountaineering, surf-riding and crossword puzzles. But art is distinguished from these, they contend, because it has emotional content and 'cognitive orientation' (i.e., ideas). The obvious answer to this, however, is that emotions and ideas do not reside in artworks but in the people responding to them, and since, as the Kreitlers recognize, their responses display infinite variation, some people may well find emotions and ideas in mountaineering, surf-riding and crossword puzzles as well as in art.

A remarkable feature of the Kreitlers' book is the honesty with which, as in this case, it demolishes its own theories. Another instance is its discussion of empathy. Many have claimed that encouragement of empathy is an important function of art, and the Kreitlers seem at first to favour this view. The word was coined, they point out, by Tichener to translate the German *Einfühlung*, and refers to the infectious nature of emotion, as when fear spreads in a crowd. Experiments show that there is a basic human tendency to empathize. When a group of experimental subjects observe other people apparently undergoing pain, from an electric shock, say, and when the administering of the pain is preceded by a light or bell, the observers will show signs of emotional distress when the light or bell is switched on. Similar experiments on rats and monkeys, who react in a comparable way, reveal that empathy is by no means a human monopoly. The fact that empathy is so widespread makes it difficult to claim that it has any special connection with art, and the Kreitlers appreciate this. Boxing matches, circus performances and many other spectacles may,

they grant, arouse empathy just as art does. But there is, they maintain, a difference, for such spectacles are not interpretable on multiple levels, as art is. Having introduced this new criterion, however, they immediately start to have doubts about it. 'Cheap novels, low-grade films, and sometimes even popular entertainment music', they concede, can be interpreted on different levels *and* arouse empathy. Hence, though the Kreitlers feel anxious about such pastimes, they admit that they may 'formally qualify as art'. So of course, we silently add, may boxing matches and circus performances, since the number of levels they can be interpreted on is not static, but varies with their infinitely various interpreters. Predictably, the legendary key to true 'art' has slipped through the Kreitlers' grasp once again.

Their illustration of their tension-followed-by-relief formula in action is similarly less than convincing. They describe an elaborate experiment, involving 60 people and 285 colour-combinations, which showed that for a majority of people complementary colours placed in opposition (green against red; yellow against blue) arouse the maximum tension. Colours similar to each other arouse the least. It follows, the Kreitlers conclude, that paintings ought to have both contrasting and non-contrasting colours, so as to provide both tension and relief. As a contribution to art criticism, this evidently falls some way short of usefulness. But despite such occasional banalities their book is valuable for its patient and persistent accumulation of evidence of the subjective, personal nature of artistic response, as confirmed by many surveys and questionnaires:

When people are confronted with the task of expressing the personal meaning which various forms have for them, responses vary along the whole range of symbolic meaning dimensions. These meanings include not only associations to objects and situations, but also sensations, moods and feelings, abstract concepts, metaphors and symbols . . . The understanding of a specific experi-

ence in a specific observer in the here and now would require a reformulation of all the discussed processes in terms of the context of that particular experiencing subject, with his idiosyncracies and uniqueness.

This virtually infinite variation in the experiences of those exposed to artworks necessarily undermines all endeavours to find a key or formula or scientific test for 'art', including the Kreitlers' own.

We have seen that Edward O. Wilson does not get round to applying his scientific theory to the explanation of a particular, selected artwork, and the Kreitlers' thoughts on colour-combinations give some inkling of why such attempts are best avoided. But a scientist who does take this courageous step is Semir Zeki in his remarkable book *Inner Vision: An Exploration of Art and the Brain*. Zeki works on the visual areas of the brain, and he has many fascinating things to say about how brain-science may help to clarify common human experiences. For example, we often feel that we cannot properly express our thoughts in words. Indeed, it is clear that we cannot. It is impossible, for example, to describe a face in words so that the person we are addressing will be sure to recognize it, however clear an image of it we may have in our minds. Showing the other person a photograph, on the other hand, will effect this instantly. The reason, Zeki suggests, may be found in the greater perfection of the visual system, which belongs to a part of the brain that has evolved over many more millions of years than the linguistic system. Language is a relatively recent human acquisition and belongs to a much younger part of the brain – a part that might still, perhaps, be evolving. This may explain why linguistic description is a laborious matter, whereas visually we can take in an enormous amount of information in a fraction of a second. Clearly this could have a bearing, though Zeki does not take the issue up, on discussions about textual and visual culture.

The book offers many other intriguing growth-points of thought relating to the arts and their scientific basis. Portrait painting, for example, has, Zeki observes, acquired its prominence in the history of art because the brain has devoted a whole cortical region, located in the fusiform gyrus, to facial recognition. This accounts for the otherwise strange fact that portraits of sitters entirely unknown to us, and lost in remote periods of history, attract our eager scrutiny and attention. Another instance of Zeki's clarifying exposition is his section on abstract and figurative art. Abstract colour compositions activate a more restricted part of the brain's colour-pathways, he notes, than figurative art does. Abstract art uses, in effect, less of the brain. Because it signifies nothing, it is handled by the brain without mobilizing areas that are important for visual stimuli that signify something.

Turning to the question of evaluation, Zeki points out that the purpose of the visual system is to acquire knowledge of the world, and it does this by being able to detect the constant, enduring features of objects. The visual system will recognize a tree, say, even when it is seen in different lights, at different distances, and with or without leaves at different times of the year. The visual system can, in other words, recognize the 'essence' of a tree. From its contact with innumerable trees in the past, it has built up a sort of Platonic idea of treeness, and when it sees any new object that might be a tree it compares it with its Platonic idea to decide whether it is a tree or not. This seems to Zeki to provide a clue to what gives certain works of art enduring power. He has read widely in the writings of artists, and he finds that they, or some of them, say that the visual system's essence-recognizing corresponds exactly to what they do. They strive to present the 'essence' of objects – to snatch, in Tennessee Williams's words, the 'eternal from the desperately fleeting'. Schopenhauer, too, said that painting should aim to

obtain knowledge of an object 'not as a particular thing but as a Platonic ideal', and Constable in his *Discourses* maintained that art should 'get above all singular forms' and present 'the abstract idea of their forms more perfect than any original'. Zeki takes these statements at face value – mistakenly, I believe. He concludes that what artists do is to depict representative or composite objects. An artist depicting a tree, say, will try to make it the sum of all possible trees, the essence of treeness. 'Great art can thus be defined, in neurological terms', he proposes, 'as that which comes closest to showing as many facets of the reality, rather than the appearance, as possible, and thus satisfying the brain in its search for many essentials.' When Zeki speaks here of the reality rather than the appearance, he means the Platonic idea of essential treeness, as opposed to the many individual trees, some large, some small, some with, some without leaves, that the visual system would have encountered in its lifetime.

This composite or representative quality applies, Zeki goes on to claim, not only to the objects artists depict but also to the situations. In painting, say, a festive occasion, a painter will strive to capture its 'common features' so that his painting will become representative of 'all, or a very large number' of festive occasions. Great artworks are those that succeed in fulfilling this representative function. The situations they depict will resemble many other situations of the same kind, and as an example of a great artwork that meets these requirements he selects Vermeer's *A Woman at the Virginal with a Gentleman* (also called *The Music Lesson*) in the Royal Collection. This picture, he points out, is ambiguous and mysterious. The brain cannot answer the questions it poses. We do not know the relationship between the two people or whether their meeting is happy or sad. Hence we can recognize in the painting an 'ideal representation of many situations', and that makes it great.

These do not seem to me convincing arguments. In the first place, it is surely untrue to say that Vermeer, in producing a painting that is ambiguous and mysterious, is working in the same way as Zeki describes the visual system working. The aim of the visual system, as he explains it, is to avoid ambiguity. It seeks to decide what is and what is not a tree. If it cannot decide, the result is anxiety. Ambiguity, whatever its value in art, is disturbing in life. In an experiment in Pavlov's laboratory in 1927 a dog was shown a circle to herald the arrival of food and an oval when food was not coming. When it was shown an oval that was only a very slightly flattened circle – an oval, that is, that occupied a region of ambiguity between a circle and an oval – the dog had a nervous breakdown. The creative process behind Vermeer's picture, insofar as it results in ambiguity, cannot be compared to the operation of the visual system, because the visual system seeks to eliminate ambiguity, whereas according to Zeki the picture seeks to cultivate it.

Secondly, works of art are unique, and people value them for that reason – because, that is, they are unlike other depictions even of the same subject. Admirers of Vermeer speak and write about his art in this way. They acknowledge that there are other painters – Pieter de Hooch and Gerard Terborch, say, both of them painters Vermeer knew and shares themes with – whose work can resemble Vermeer's, but his remains unique. It is hard to reconcile this uniqueness with the composite function, representative of many other similar situations, that Zeki says he finds in Vermeer's painting. Indeed, the one seems to debar the other. If artists did indeed paint not objects but Platonic ideas of objects their paintings would presumably all look exactly the same, since there cannot be more than one Platonic idea of anything. Of course, to paint the visual system's Platonic idea of anything would, in any case, be impossible, since to paint it you would have to give it a definite form,

whereas the Platonic idea is an abstraction holding in suspension a multiplicity of possible forms, any one of which, if depicted, would instantly displace all the others.

Zeki's neurological key to the arts leads him, also, to the questionable conclusion that unfinished works of art are better than finished ones. He notes approvingly that Michelangelo left three-fifths of his marble statues unfinished. The advantage of an unfinished work of art, in Zeki's reasoning, is that it does not tie the visual system down to a single definite form. It leaves the visual system free to supply multiple forms from its almost infinite store of memories. One can see how Zeki's theory drives him to this conclusion. If works of art are good because they resemble Platonic ideas, and if Platonic ideas contain innumerable possible forms, then an unfinished artwork must be best because the viewer can imagine it being finished in innumerable possible ways. On the other hand, if the criterion of a great work of art is the extent to which it leaves the visual system free to supply images from its own store of memories, then presumably the greatest work of art would be no work of art at all, for that would leave the visual system completely at liberty. Indeed, this seems to be the conclusion that Zeki himself comes to. Michelangelo, he notes, turned away from art altogether in his later years and espoused religion, which means, as Zeki interprets it, that he came to see the futility of works of art when compared with the almost infinite range of the brain's stored record.

A final misgiving one might have about Zeki's Vermeer example is that Vermeer's reputation as a supremely great painter is in fact very recent. For two centuries after his death no one thought of him as particularly outstanding. He had been praised by his Delft contemporaries, but then he slipped from view. His pictures changed hands for small sums and were often attributed to other artists. Eighteenth-century histories of

Dutch painting hardly mention him. The great Swiss critic Jakob Burckhart, lecturing on Dutch art in 1874, dismissed him as a depicter of 'women reading and writing letters and such things'. Lack of recognition brought financial stringency. Vermeer died suddenly in a fit of depression in 1675, and his wife put it down to worry about money. The local Delft baker received two Vermeers, the *Lady Writing a Letter with Her Maid* and *The Guitar Player* – now worth unguessable millions – in payment of the Vermeer family bread bill. These historical facts are a handicap for anyone who believes in timeless genius, and they also make it improbable that Vermeer's success can be directly related to the neurology of the human visual system, since no one supposes that that has changed over the last three centuries.

From his explanation of Vermeer's greatness, Zeki proceeds to the case of Cubism which, by neurobiological standards, scores less highly. The way artists such as Juan Gris spoke of Cubism persuades Zeki that it was an attempt to overcome the limitations of a single perspective, by showing how an object would look when viewed from different directions simultaneously. Gris said that it revealed 'the less unstable elements in the objects', by depicting 'that category of elements that remains in the mind through apprehension, and is not continually changing'. This sounds very like Zeki's account of how the visual system does its job of recognition – memorizing the 'constant, enduring features' of objects and ignoring fleeting appearances. But the visual system ends up with something recognizable, like a tree, whereas Cubism ends up with something unrecognizable, like Picasso's *Man with a Violin*, which, Zeki complains, is not identifiable by an ordinary brain as what its title declares it to be. He evidently thinks less of Cubism as a result: 'The attempt by Cubism to mimic what the brain does was, in the neurobiological sense, a failure.' Equally one might say that the

encounter illustrates the inadequacy of neurobiology as a critical tool. For clearly some people do value Cubism, and it is not conceivable that they value it because they are under the impression that Picasso's *Man with a Violin* actually looks like a man with a violin. Their criteria, in other words, are entirely different from Zeki's. In his defence it should be added that he cites defenders of Cubism who do seem to think it represents objects 'as they are', and he quotes K. Malevich's claim that Picasso 'grasped the essence of things and created enduring, absolute values'. Set against nonsense of this kind, the neurobiological approach to Cubism seems almost justifiable.

The argument of Zeki's book, essentially, is that successful art owes its success to being particularly well adapted, in some way, to the human visual system. Thus Vermeer's 'representative' quality approximates – so he believes – to the visual system's memory store, whereas Cubism fails because it does not integrate different views of an object as the visual system integrates them. A third example he discusses is art that comprises vertical and horizontal lines, like that of Piet Mondrian, or coloured squares, red in Malevich's *Red Square*, blue in Theo van Doesburg's *The Cow*, and yellow in Josef Albers's *Homage to the Square: Yellow Climate*. Art of this kind is, he argues, particularly well adapted to the visual system, because each cell in the visual brain has a receptive field. It responds, that is, to a limited part of visual space – a red square, say, or a line of particular orientation. So there is a correspondence between art made of lines or coloured squares (which Zeki dubs 'art of the receptive field') and the physiology of single cells in the visual brain. Moreover, cells that respond to lines of particular orientation predominate in the visual cortex, and are found in many areas of it. Physiologists consider them the building blocks that allow the nervous system to represent more complex forms. So when Mondrian defended his use of vertical and horizontal

lines by saying they 'exist everywhere and dominate every-thing', his observation was, Zeki suggests, neurobiologically correct. When we view one of his abstracts, or some of the paintings of Malevich or Barnett Newman, large numbers of cells in different visual areas of our brains will be activated. Similarly, coloured squares are, Zeki observes, 'admirably suit-ed to stimulate cells in the visual cortex'. Malevich's *Red Square* could almost be a diagram of the receptive field of a visual cell.

Zeki is careful to disclaim any aesthetic judgement in all this. He is not suggesting, he protests, that art made of vertical and horizontal lines or coloured squares is better, simply because it activates specific groups of cells. Nevertheless, by describing such art as 'well adapted' to appeal to cells in the visual cortex he does seem to imply that it has an especially dependable neuro-biological base. Further, the claim that such art represents 'essentials and constants' – a claim borne out, he says, by its relationship to the physiology of single cells – certainly sounds like praise. Besides, if Zeki is not claiming that line-and-square art is better because of its special relationship to the neural sys-tem, it is hard to see the point of his investigation. To say that such art is 'admirably suited to stimulate cells in the visual cor-tex' makes no sense. Everything we see is admirably suited to stimulate cells in the visual cortex, otherwise we should not see it. On the other hand, if Zeki is, despite his disclaimer, trying to suggest some special merit for line-and-square art, then it must be said that his proposal looks shaky. Line-and-square art acti-vates specialized cells that respond to lines and squares. Similarly curves must activate cells that respond to curves – though no one, Zeki tells us, has yet discovered where in the visual cortex these cells are located. Everything visible activates cells that make it visible. To maintain that it is in any respect 'better' to activate one kind of cell rather than another would be strange, and would, if the claim could be substantiated, have

revolutionary consequences for aesthetics. It would mean that it was biologically right or natural to respond to one kind of artwork rather than another. But Zeki denies that he is trying to do any such thing.

Yet he persistently seems to be doing it. Following the lines-and-squares discussion, he points out that lines that move activate cells in the visual cortex even better than stationary lines, and he praises the kinetic art created by Tinguely and Calder because it takes advantage of this. Their mobiles, he explains, are better tailored than non-mobile artworks to the physiology of cells in the cortex, because many orientation-selective cells respond poorly to lines until they start to move. In a particular area of the cortex that he has investigated, an overwhelming majority of the cells are selective for motion but unresponsive to stationary lines and to colour. By cutting colour out of his mobiles, and reducing his palette to black and white, Tinguely seems to have known how best to activate the cells in this area, Zeki concludes. He seems to have adapted them to the physiology of this area of the brain without even knowing it. Again, Zeki's reasoning is hard to follow. If Tinguely had made his mobiles coloured rather than black and white, brain cells that respond to colour would have allowed us to see them just as well as we see black and white. If he had created artworks that were stationary, not mobile, we should have seen them as well as we see the stationary artworks of Mondrian or Malevich, and Zeki could have praised them for being precisely adapted to activate the cells they happened to activate.

So far the answer to our question 'Can science help?' does not seem very hopeful, at any rate if the aim is to discover absolute standards by which works of art may be judged, and dependable reasons for deciding that one thing is a work of art and another not. Neither Edward O. Wilson's epigenetic rules, nor Gerda Smets's 20 per cent redundancy, nor Ramachandran

and Hirstein's caricatures, nor D. E. Berlyne's inverted 'U', nor the Kreitlers' tension-relief sequence, nor Semir Zeki's adventures among the brain cells, seem at all promising. The experimental psychologists trying to find what shapes and colours most people respond to do not venture on the question of value judgement at all. They do not, that is, suggest it is aesthetically right or wrong to respond in a certain way. They merely try to find what is usual. Zeki himself is careful to say at the start of his book that his neurological research does not allow him to say anything at all about the aesthetic experience or the emotions that a work of art arouses. Through what processes an art critic reaches conclusions about a work 'remains', he acknowledges, 'totally unknown, and is indeed a question unaddressed by neurology'. Yet these are just the things we need to know about if we wish to find out what a work of art is.

However, if science cannot answer these questions, it can, I think, help to dispel misconceptions. For example, scientific ways of measuring arousal force us to rethink assumptions about art's emotional effects. To talk of a particular work of art's power to move becomes meaningless, since it refers to a factor that differs almost infinitely with different people. Another misconception that, I should like to argue, science can dispel is the theory of significant form elaborated by Clive Bell in the early 20th century and eagerly embraced by the Bloomsbury Group and others. Bell was, of course, a firm believer in absolute standards. The feelings 'great art' awakens are, he taught, 'independent of time and place'. 'All sensitive people agree', he reported, 'that there is a peculiar emotion provoked by works of art'. This emotion is available, however, only to those who have learnt to look at art in the right way. The crucial property in all visual art is, according to Bell, 'significant form'. This is a matter simply of lines and colours. It has absolutely nothing to do with representation or subject matter.

Indeed, to be interested in representation and subject matter is a sign that you are a member of what Bell calls 'the gross herd', who can never taste the 'thrilling raptures of those who have climbed the cold white peaks of art'. When you look at a painting you must, therefore, deliberately not see it as representing anything. You must see it only as lines and colours, 'combined according to certain unknown and mysterious laws'. You must expunge that part of your brain that knows about life. 'To appreciate a work of art', as Bell puts it, 'we need to bring with us nothing from life, no knowledge of its ideas and affairs, no familiarity with its emotions.'

Bell's theory had social aims. It was designed to distinguish himself and those like him, with their exquisite sensibilities, from what he regarded as the semi-educated masses with a debased appetite for human-interest stories, newspapers and photographic realism. This social function had obvious attractions for the class-conscious, and it still has adherents today. However, advances in brain-science since Bell's time cast an interesting light on his recommendations. It has been found that when damage is sustained in particular areas of the brain, it results in the patient being unable to recognize objects. The world is seen only as patterns of line and colour, obeying unknown and mysterious laws, precisely as Bell required. Sometimes the condition affects the ability to recognize only particular objects. Damage to the fusiform gyrus leads, for example, to prosopagnesia, or a failure to recognize faces. But the disability can be more general, as in the case Oliver Sacks reports in his famous essay *The Man Who Mistook His Wife for a Hat*, where a profound visual agnosia causes all powers of representation, and the ability to identify objects in the real world, to be destroyed. Such conditions are, of course, acutely distressing to the patient. Far from being, as Bell claims, the ultimate aim of art, they are a tragic deprivation. Those who

choose to look at paintings as 'significant form' remain, of course, free to do so, but they should recognize that their aesthetic is that of the brain-damaged.

I have left to the last the question of whether science might enable us to access another person's consciousness. Of course, there are those who believe that it is perfectly possible to do this even without the help of science. A simplistic theory of the artistic process assumes that the artist feels an emotion and then puts it into an artwork in such a way that the eventual viewer or listener or reader will take the same emotion out at the other end, rather like someone opening a parcel, and feel what the artist felt. T. S. Eliot's idea of the 'objective correlative' is a theory of this kind. Clive Bell believed that transmission of the same emotion could happen between remote historical periods. Looking at some Sumerian figures in the Louvre, Bell says, one is 'carried on the same flood of emotion to the same aesthetic ecstasy as, more than four thousand years ago, the Chaldean lover was carried'.

Those who doubt Bell's position would rightly object that he cannot possibly know he is experiencing the same emotion as a Chaldean 4,000 years ago. To such doubters it will seem that Bell, and those who take his line, simply do not understand what it would mean to have the same feelings as someone else. To have the same feelings you would have to inhabit the same body, to share the same unconscious, to have undergone the same education, to have been shaped by the same emotional experiences – in short, to *be* the other person, which is impossible, even for lovers in bed together, let alone for two humans from different cultures separated by 4,000 years. To those, myself included, who do not think it possible for two people to share the same consciousness, it seems that to assert you have the same feeling as someone else indicates a strange absence of imagination, an inability to grasp the differences between peo-

ple, and a refusal to grant to others the same inexpressible inwardness that you feel you have yourself.

Since all artistic judgement comes down to how people feel, this question of whether we can know how others feel is obviously crucial, affecting all the issues we are considering, and we might hope that science could help to answer it. Edward O. Wilson argues that it can, and that the answer is yes. Scientists, he predicts, will in the future be able to watch the physical functioning of the brain with more and more precision, observing how different areas light up as different faculties are activated. Will this allow the watching scientist to know how the possessor of the brain is feeling? In a strict sense, Wilson admits, it will not, any more than we can know what it feels like for another person to see a colour, or how a honeybee feels when it senses the earth's magnetism, or what an electric fish thinks as it orients by an electric field. Subjective experience is inaccessible.

But having conceded this Wilson puts the opposite case. Surprisingly he turns first not to science but to art. In the arts, he asserts, people 'transmit feeling' to others:

> But how can we know for sure that art communicates this way with accuracy? We know it intuitively by the sheer weight of our cumulative responses through the many media of art. We know it by detailed verbal descriptions of emotion, by critical analyses, and in fact through data from all the vast, nuanced, and interlocking armamentaria of the humanities.

Readers who listen carefully will detect a faint rasping sound behind this proclamation – the sound of Wilson clutching at straws. For a scientist to declare that we know things 'intuitively' is a weird departure, and, if true, would be a reason for abandoning scientific research forthwith and depending on intuition. Anyone with the remotest knowledge of the 'interlocking armamentaria of the humanities' will know that differences of opinion in that department proliferate like bacteria.

The idea that they confirm matching thoughts and emotions is absurd. As for 'detailed verbal descriptions of emotion', language cannot, as we have seen, even describe a face so that it can be recognized by someone else, so there is no reason to suppose that it could be more efficient when describing something as abstract and ephemeral as emotion.

Realizing, perhaps, that his excursion into the arts leaves something to be desired, Wilson changes tack and suggests a scientific solution. He asks us to imagine that in the future scientists will develop an 'iconic language' called 'mind-script' from 'the visual patterns of brain activity'. He asks us, too, to imagine an experiment designed to put one mind in direct contact with another, an experiment that will allow someone to feel another's feelings, think another's thoughts. In this experiment a volunteer, with his or her brain under observation, will recite a poem or read a novel or recall a piece of music. The watching scientist will read the mind-script unfolding, 'not as ink on paper but as electric patterns in live tissue'. The 'fiery play' of the volunteer's 'neuronal circuitry' will be made visible, so the scientific observer will be able to feel as the volunteer feels. He will laugh when the volunteer laughs, and weep when the volunteer weeps.

Is this believable? The watching scientist, Wilson makes it clear, will not hear the poem or the music that the volunteer recites or remembers 'in the silent recesses of the mind'. All the scientist will have access to is the mind-script. He will not know whether the volunteer is experiencing Mozart or Scott Joplin or Tennyson. Mind-script will allow him to bypass the actual poem or music and enter straight into the volunteer's subjective experience. Presumably if someone stuck a knife into the volunteer, the observer would scream.

What Wilson's ingenious experiment strives to describe is unmediated communication. But unmediated communication

is an illusion. For something to be communicated, it must travel from one person to another, and whatever it travels through is the medium. In Wilson's experiment mind-script is the medium. His assumption is that when the scientist reads the mind-script his experience will exactly match the volunteer's. But in fact he will read the mind-script with his own faculties, his own assumptions, his own culture, his own nervous system – in short, his own mind. Consequently he will not feel what the volunteer feels. There is no more guarantee that their experiences will match than if the scientist merely read a letter by the volunteer in ordinary script.

There is a further point which Wilson does not raise. Could the scientist judge the *value* of the volunteer's experience, even supposing he had access to it? We have seen that Zeki considers questions of value completely outside neurology's remit. The scientist in Wilson's experiment, when he discovered afterwards what piece of music or poetry the volunteer had been responding to, might feel deeply ashamed that he had laughed or wept. He might find that he had wept at something he considers sentimental trash or laughed at an obscenely racist joke. Why his tastes differ from those of the volunteer, and whether his tastes are superior, and in what respect such a claim could have any meaning, are questions untouched by Wilson's experiment and, it seems, will remain beyond science's scope even in the imaginable future. To that degree the answer to 'Can science help?' is no.

I hope this chapter will not appear, and it certainly is not meant to be, disparaging about science, particularly brain-science. Even a brief exposure to the complexities of that field of research makes the head swim. It is making rapid advances, and there seems little doubt that we shall one day be able to observe all the observable aspects of the reactions that take place in the brain of a particular person experiencing a particu-

lar artwork. Where science cannot go, I believe, is beyond that. I do not see how it could make sense to claim to *evaluate* the experience or the artwork scientifically, or to claim that the experience can be shown to be identical with the experience of some different person. Perhaps these doubts are misconceived. Time will tell.

# Do the arts make us better?

The belief that art can make people better goes back to classical times. Aristotle taught that music was character-forming and should be introduced into the education of the young. In listening to music, he maintained, 'our souls undergo a change'. It arouses 'moral qualities'. However, it must be the right sort of music. The wrong sort of music, particularly that of the flute, which Aristotle considered 'too exciting', appeals to 'mechanics, labourers, and the like', as well as to slaves and children, and its influence is 'vulgarizing'.

Plato, of course, thought that the arts make people worse. Unlike reason and science, they are 'far removed from truth' and have 'no true or healthy aim'. At best 'only a kind of sport or play', they incite 'lachrymose and fitful' behaviour in their adherents. Their encouragement of the passions works against 'the rational principle in the soul'. Arranging human souls into nine grades, according to merit, Plato puts philosophers top, tyrants bottom, and artists sixth, just above artisans and husbandmen. However, even Plato makes an exception for music, so long as it is 'virtuous' music that appeals to 'the best and the best educated', as opposed to 'vicious' music that appeals to the majority.

With the Enlightenment, and the invention of aesthetics in the 18th century, the idea that works of art improve their recipients morally, emotionally and spiritually became part of

Western intellectual orthodoxy. Hegel, typically, teaches that art can 'mitigate the savagery of mere desires', by 'fettering and instructing the impulses and passions'. Shelley's claim that poets are 'the founders of civil society', because they nurture the imagination, which is 'the great instrument of moral good', belongs to the same optimistic agenda. As Carol Duncan shows in her book *Civilizing Rituals*, this development coincided with a decline in religious belief among the educated. It represented a transference of spiritual values from the sacred sphere to the secular. Art galleries came to resemble temples, both in their architecture and in their visitors' reactions. Goethe, visiting the Dresden Gallery in 1768, received a solemn impression, akin to 'the emotion experienced upon entering a House of God', from the 'objects of adoration in that place consecrated to the holy ends of art'. William Hazlitt felt that an excursion to the National Gallery in Pall Mall was like going on a pilgrimage to the 'holy of holies'. The business of the world at large seemed 'a vanity and an impertinence', compared to this 'act of devotion performed at the shrine of art'.

In the 19th century it became a widespread cultural assumption that the mission of the arts was to improve people and that public access to art galleries would effect this. It was felt in particular that if the poor could be persuaded to take an interest in high art it would help them to transcend their material limitations, reconciling them to their lot, and rendering them less likely to covet or purloin or agitate for a share in the possessions of their superiors. Social tranquility would thus be ensured. Charles Kingsley, suggesting that the working classes should visit art galleries, spoke for a broad sector of educated opinion:

> Pictures raise blessed thoughts in me – why not in you, my brother? Believe it, toil-worn worker, in spite of thy foul alley, thy crowded lodging, thy ill-fed children, thy thin, pale wife, believe it, thou too,

and thine, will some day have *your* share of beauty. God made you love beautiful things only because He intends hereafter to give you His fill of them. That pictured face on the wall is lovely – but lovelier still may the wife of thy bosom be when she meets thee on the resurrection morn! Those baby cherubs in the old Italian painting – how gracefully they flutter and sport among the soft clouds, full of rich young life and baby joy! – Yes, beautiful indeed, but just such a one is that pining, deformed child of thine, over whose death-cradle thou wast weeping a month ago; now a child-angel, whom thou shalt meet again, never to part.

To the modern reader this is plainly sickening cant. Yet Kingsley did not mean to be hypocritical. His trust in art's uplifting effect was quite genuine – too genuine for him to realize that the worker addressed might justifiably reply: 'Why have you and your kind left me to struggle in poverty and dirt? Is that the morality your so-called art promotes? If so, I want none of it.'

In failing to anticipate this retort, Kingsley was not alone. His belief that looking at pictures would give the poor elevated sentiments, similar to his own, and so endorse their common humanity, was entirely in line with 19th-century philanthropic thought. Sir Robert Peel, speaking of the National Gallery in the 1830s, emphasized that the purpose of making pictures publicly available was a social one – 'to cement the bonds of union between the richer and poorer orders of the state'. In 1835 a select committee of the House of Commons examined the government's involvement in art education and the management of the public collections, and numerous expert witnesses testified that art could be depended on to improve the morals and deportment of the lower orders. Trafalgar Square was chosen as the new site of the National Gallery so that the poor could walk to it from the east and the rich drive to it from the west. By 1857 the effects of air pollution on the pictures was causing concern, and it was proposed to remove the collection

to the cleaner atmosphere of Kensington. But Lord Justice Coleridge, among others, opposed this, since it would make access for the poor more difficult. They needed art, he testified, 'to purify their tastes and wean them from polluting and debasing habits'.

How looking at pictures did actually affect the poor, and whether they thought it cemented their bonds with the rich, are, of course, difficult questions, and such evidence as there is can be variously interpreted. Lecturing in 2002, Neil MacGregor, the then Director of the National Gallery, quoted Peel's remark, and agreed with it. His own support for free admission to public collections was based, he said, on the belief that it fostered 'social cohesion', and he cited, by way of illustration, a letter written by Lord Napier in 1884. Napier was writing to Lord Savile who had recently presented Velasquez's *The Christian Soul Contemplating Christ after the Flagellation* to the National Gallery. Napier told Savile that he had taken his wife to see the picture, and Lady Napier had been 'completely penetrated' by it:

> When we went to the picture there was an old woman of the better lower class looking at it, who said to Lady Napier spontaneously and with a very moving expression, 'Look at his poor hands, that is his child.' She obviously did not understand that it was Jesus. She apparently thought it was some helpless innocent Martyr (or perhaps even a malefactor) and that his child was brought to take leave of him to soothe his sufferings. I observed that when we looked fixedly at the picture a number of the humble sort of people flocked to it and seemed to survey it with much interest.

MacGregor takes this as indicating that Velasquez's picture had indeed operated to 'cement the bonds of union' between rich and poor, since the old woman had been emboldened to address a lady of evidently superior social status. However, the cement does not seem to have adhered to Lord and Lady

Napier. The terms of the letter ('the better lower class', 'the humble sort of people') assert class gradations with undiminished confidence. Besides, since the old woman's mistake shows that she had little knowledge of art (or Christianity), her good heart cannot be attributed to art's influence. It seems, rather, that her knowledge of suffering had developed her sympathy for sufferers, and that her remark to Lady Napier was an attempt to bring that knowledge home to someone who, because of her evident class advantages, was less likely to be acquainted with it. Interpreted in this way, the old woman's words signal her acknowledgement of the gulf between the classes rather than the contrary. Be that as it may, Lord Napier, like MacGregor, evidently thinks the picture had an improving effect on the old woman and on the other humble people, and the improvement consisted in their displaying interests and emotions that would normally be the prerogative of their social superiors, such as himself.

In America, as Carol Duncan records, the civilizing function of art received particular emphasis since it held out the promise of instilling Anglo-Saxon moral and social virtues into polyglot immigrant hordes. New York's Metropolitan Museum of Art, Boston's Museum of Fine Arts and Chicago's Art Institute were all founded in the 1870s. To stock these and other museums, millionaire Americans embarked on extravagant shopping-sprees, shipping home enormous quantities of art from Europe. Art museums, they believed, could function as unifying, democratizing forces in society, allaying fears aroused by strikes and workers' riots, and transforming American cities by lifting the inhabitants above the material concerns of life. In fact, Duncan notes, their effect was to reinforce class boundaries. In New York, as in Chicago and Boston, the public art museums quickly established themselves as havens for the genteel and educated. But this did not shake the confidence of the

genteel and educated in their civilizing potential. Joseph Hodges Choate, the distinguished lawyer and a founder of the Metropolitan Museum of Art, was representative of his class in predicting that 'knowledge of art in its higher forms of beauty would tend directly to humanize, to educate and to refine a practical and laborious people'.

The assumption that exposure to high art is morally and spiritually beneficial is still powerful, as Neil MacGregor's testimony indicates. It underlies public subsidy of the arts, and constitutes the case for free admission to art galleries and museums. It seems, however, to be based on no evidence, and such attempts as have been made to provide factual support for it have proved fruitless. Summarizing the results of over a hundred years of experimental psychology in their book *Psychology of the Arts*, Hans and Shulamith Kreitler conclude that there is no reason to expect that works of art will produce behavioural changes in their recipients, since behaviour is a product of many and varied conditions which cannot be created or modified through art. Attempts to relate the general moral level of a culture to its artistic appreciation are also suspect, the Kreitlers warn. The widely shared belief that art can instruct the public, and help to attain a better state of affairs, lacks any factual backing.

A similarly disheartening conclusion is reached by those who work in arts education. The mid-20th-century confidence that an introduction to the arts at school would have a beneficial effect on the characters of pupils has now, it seems, evaporated. The American arts-education expert Elliot W. Eisner in his book *The Arts and the Creation of Mind* (2002) concludes that whether work in the arts affects other aspects of a student's contact with the world 'cannot now be determined with any degree of confidence'. All that can be determined is that 'work in the arts evokes, refines and develops thinking in the arts'.

Eisner still cautiously hopes that 'meaningful experience in the arts' might carry over into 'domains related to the sensory qualities in which the arts participate'. Students who have 'had their sensibilities refined' by arts education, should be able to see more, 'aesthetically speaking', than their peers. They will develop 'the ability, for example, to notice the patterns of sunlight on a wall, or the countenance of a homeless person pushing an overloaded shopping cart down the street'. As examples of the benefits to be acquired from study of the arts, these seem unfortunate. Seeing a homeless person merely as an aesthetic effect, comparable to sunlight on a wall, illustrates the desensitizing influence of aestheticism, in that it reduces a fellow human being, with needs comparable to one's own, to an object of artistic contemplation. If this is what arts education achieves, it seems a good argument for discontinuing it.

However, Eisner feels unable to promise anything more farreaching or beneficial. The aim of education, he acknowledges, is to help students to lead personally satisfying and socially constructive lives outside school. But setting up an experiment to find how far this is achieved by arts education would, he anticipates, be next-to impossible. You would have to have two groups of students, one following an arts curriculum, the other not, and you would have to decide what kind of moral character you would like them to have, what could count as evidence of their having it, and how the extent to which they had it could be measured and evaluated. Even the more limited claim that arts education improves academic performance in other spheres is, as Eisner sees it, questionable. He casts doubt on the so-called 'Mozart effect', according to which pre-school children's spatial ability is enhanced by exposing them to classical music several times a week. He also pours cold water on the claim that students who enrol in arts courses in American high schools get better Scholastic Achievement Test (SAT) scores

than those who do not. Taking more courses in any field, he points out, correlates with better SAT scores, and science and maths courses correlate more highly than arts courses. The entire issue of the *Journal of Aesthetic Education* for Fall–Winter 2000 was devoted to an analysis of studies that claim to have discovered the effects of art experiences on academic performance. This analysis is the most thorough to date, and, Eisner concludes, it 'leaves little doubt that most of the claims go far beyond any prudent appraisal of the evidence'.

The assumption that the arts make people better is seldom accompanied by any serious consideration of what better people might be like. But the issue is one that has long intrigued utopians and futurists. Margaret Atwood in her novel *Oryx and Crake* envisages a genetically engineered human race, developed to correct the shortcomings of the present model. Her new humans, like many inhabitants of utopias since the Garden of Eden, are naked vegetarians, but they also have more unusual attributes. Their minds do not register skin colour, so they are incapable of racial prejudice. They copulate only once every three years, which solves the birth-control problem, and they self-destruct at the age of thirty. No one has ever expected the arts to improve human beings on quite this scale, and even utopians generally settle for more modest advances. However, if a consensus about what human attributes are most desirable were to be sought in European and American utopian writing since the time of Plato, the answer would certainly be unselfishness, leading to some sort of egalitarian society. Communism is the rule in Sir Thomas More's austerely regimented 16th-century utopia, where all houses and cities are built to the same pattern, and everyone wears identical clothes and works the same hours. It is also the principle behind Charles Fourier's post-French-Revolution utopia of complete sensual freedom, where even the old and deformed are entitled to have their sexual

needs regularly satisfied by willing and obliging 'sexual athletes', male and female. Edward Bellamy's late 19th-century American utopia of industrial armies, where everyone carries a credit card entitling him or her to an exactly equal share of the gross national product, is another variation on the communist theme, and there are many more. Marx's recipe for social health – 'from each according to his ability, to each according to his need' – was the principle behind Western utopian writing long before Marx. So if the creators of utopias are trustworthy guides, the general consensus of humanity is that people would be better if they were less selfish, and content with an equal share of what the planet yields. Christianity, of course, teaches the same, since loving your neighbour as yourself entails ensuring that he is equally well cared for.

Comparatively few have argued that it is art's job to improve people along these lines, but one of them is Leo Tolstoy. In *What Is Art?* he is dismissive of all previous aesthetic theories. The 'so-called science of aesthetics', he observes, consists in first acknowledging a certain set of productions to be art, because they please us and the people we associate with, and then concocting a theory that accommodates productions of this kind. 'No matter what inanities appear in art, when once they find acceptance among the upper classes of our society, a theory is quickly invented to explain and sanction them.' His own belief is that art does not reside in picture galleries, concert halls and the like, but is much more widespread:

> All human life is filled with works of art of every kind, from cradle song, jest, mimicry, the ornamentation of houses, dresses and utensils, up to church services, buildings, monuments and triumphal processions.

Taste, Tolstoy recognizes, is infinitely variable. There can be 'no objective definition of beauty', and 'no explanation of why

one thing pleases one man and displeases another'. It follows that art cannot be defined with reference to the pleasure it gives. We must, rather, consider its moral effects, and the purpose it serves in the life of man. Once this adjustment is made, Tolstoy argues, we shall see that art should be a 'means of progress', a way of 'moving humanity forward towards perfection'. It will do this by contributing to the evolution of human feelings. 'Feelings less kind and less needful for the well-being of mankind' will be replaced by others 'kinder and more needful'. 'That is the purpose of art.'

Tolstoy's theory is emphatically Christian. He dismisses as 'astonishing' contemporary reverence for the art of ancient Greece:

> according to which it appears that the very best that can be done by the art of nations after 1900 years of Christian teaching is to choose as the ideal of their life the ideal that was held by a small, semi-savage, slave-owning people who lived 2000 years ago, imitated the nude human body extremely well, and erected buildings pleasant to look at.

Similarly absurd, Tolstoy insists, is the claim that Western art is 'real' and 'true' and the source of the 'highest spiritual enjoyment':

> Two thirds of the human race (all the people of Asia and Africa) live and die knowing nothing of this sole and supreme art. And even in our Christian society hardly one per cent of the people make use of this art.

He indicts 'pseudo-cultured' people who dismiss Christianity as superstition. 'All history shows that the progress of humanity is accomplished not otherwise but under the guidance of religion.' Christianity, he is aware, has been differently interpreted in different ages, but the 'religious perception' of his own time, he insists, points towards 'the growth of brother-

hood among men'. Art that flows from this should be encouraged. Art that runs counter to it should be condemned.

Tolstoy's magnanimity is not in doubt, and his theory is gratifying to utopians. However, whether art can actually influence feeling and behaviour in the way he hopes remains questionable. As we have seen, the Kreitlers, assembling the psychological evidence, conclude that it cannot. Further, Tolstoy evidently regards Christianity as the major force working towards the brotherhood of man, and that priority renders art superfluous or at best secondary. It is also the case that Tolstoy's criteria have seemed irrelevant, or worse, to many lovers of high art. For them, art's refinement and splendour represent the summit of civilization, whereas Tolstoy's contention that true art must be intelligible to an illiterate peasant represents a debasement. Kenneth Clark, who took *Civilization* as the title for his famous television series, made no secret of his belief that 'popular taste is bad taste, as any honest man with experience will agree'. For him art, like civilization, was generically connected with wealth and large country houses.

Of course, if civilization is equated with the possession of art, then it follows that possessing art makes one more civilized. However, this is not an argument but a tautology. In reality, what constitutes civilization is not a simple question. John Berger's book *Ways of Seeing* was, in effect, a retort to Clark, and far from regarding the history of Western art as a monument to civilization, Berger denounced it as a monument to privilege, inequality and social injustice. Further, since art in our culture is enveloped in an atmosphere of bogus religiosity, it is used, Berger pointed out, to give a spurious spiritual dimension to the structures of political power. The whole concept of the national cultural heritage, enshrined in national galleries, opera houses and so forth, exploits the authority of art to glorify the present social system and its priorities.

Put simply, the issue is do we regard civilization as a machine for producing painted canvas, symphony orchestras and ballet dancers, or do we expect it to ensure that the earth's resources are evenly distributed, and that people do not perish in ignorance and want? The current statistics are well known. Half the world, nearly 3 billion people, live on less than $2 a day, and more than a billion live in what the UN classifies as absolute poverty. 1.3 billion have no access to clean water; 2 billion no access to electricity; 3 billion no access to sanitation. Nearly a billion people entered the 21st century unable to read or write. Approximately 790 million people in the developing world are chronically undernourished, and each year more than the entire population of Sweden, between 13 and 18 million, mostly children, die of starvation or the side-effects of malnutrition. Meanwhile the Western nations live in unprecedented luxury. The richest 20 per cent of the population of the developed countries consumes 86 per cent of the world's goods. Shopping for inessentials on which to off-load surplus wealth is a major Western occupation, as are programmes for countering the effects of over-eating. Annual expenditure on alcoholic drinks in Europe is $105 billion, whereas global expenditure on providing basic health and nutrition for the world's poorest is $13 billion. An analysis of long-term trends shows that the distance between the richest and poorest countries was 3 to 1 in 1820, 35 to 1 in 1950, and 72 to 1 in 1992. Is a world that allows this to happen civilized, and is it correct to equate civilization, in the Kenneth Clark manner, with art production and art appreciation?

Eisner's claim, cited above, that art 'refines' its recipients' 'sensibilities' is central to many theories about art's improving effect. Some treat being 'refined' as an end in itself, but some maintain that when our sensibilities have been properly adjusted we shall gain an insight into how other people feel, and con-

sequently behave better towards them. The arts, as Eisner puts it, 'enable us to step into the shoes of others and to experience vicariously what we have not experienced directly'. This is a popular explanation of the moral effect of art and literature, and statements of it are often both confident and extreme. John Dewey, in *Art as Experience*, declares that art is 'a means of entering sympathetically into the deepest elements in the experience of remote and foreign civilizations', and that consequently it fosters global understanding. 'Barriers are dissolved, limiting prejudices melt away, when we enter into the spirit of Negro or Polynesian art.' Dewey does not explain how he knows when he has entered into the deepest elements of a Negro or Polynesian, and the most remarkable thing about his theory is that it could ever have been seriously entertained even for a moment. But it testifies to a deep wish among art-lovers to believe that art makes them better and more understanding of other people.

A fuller statement of the case is made by Frank Palmer in his book *Literature and Moral Understanding*. According to Palmer, an important function of literature is that it strengthens our moral imagination by teaching us what it would be like to be someone else. He selects Shakespeare's *Macbeth* as an example. When we read or watch the play, he claims, we 'get inside the mind' of Macbeth, and this teaches us 'what it is about murder that makes it so dreadfully appalling'. One obvious objection to this is that Macbeth is a fictional character. Unlike a real person, he does not have a 'mind' for us to 'get inside'. We have the illusion that he has, but illusions of this kind merely confuse fiction with reality, and lead us to believe that we have experiences that we have not. The result can be very far from educative. To believe that, from reading books, you know what it really feels like to starve, to be in continual pain, to watch your children die – in short, to subsist in the Third World – is not a

refinement of sensibility but a trivialization of others' sufferings. It is self-serving and crassly unimaginative to think that any amount of reading will allow you to share the feelings of people in such situations. As for Palmer's claim that you need to read *Macbeth* in order to understand that murder is 'dreadfully appalling', it is plainly preposterous. Genuine abhorrence of murder is not limited to readers of *Macbeth*, and for Palmer to suppose the contrary is far from supporting his theory that literature enhances understanding of other people.

Irrespective of these problems, knowledge of how those versed in the arts actually treat other people forces Palmer to an unwelcome conclusion. Poetry and music do, he insists, 'breathe spiritual dispositions into people'. But:

> There is of course no necessary connection between such rapture or exaltation and our subsequent conduct as moral beings. It is utterly baffling that a man of fine artistic sensibilities may, in other respects, remain a swine.

The specific swine he has in mind are Tolstoy and Delius. But very little knowledge of artists' and writers' biographies is needed to supplement the list, and Palmer is left with, at best, the claim that literature and the arts ought to make us better, but seem not to in practice.

One of the fullest and most thoughtful attempts to link the arts to desirable ways of behaving is made by the psychologist Howard Gardner in his wide-ranging study *The Arts and Human Development*. Gardner believes that Piaget and others have erred in positing as the ideal end-product of psychological development a scientist, or at any rate a logical, scientific-type thinker. His own view is that a better end-state for humanity to aim at would be someone able to appreciate the arts. He points out that in painting, literature and music a normal child of seven or eight is, in many respects, already able to appreciate

artistically as well as most adults. The average adult and the average ten-year-old perform about the same on aesthetic appreciation tests. But experiments on children in the six-to-fifteen range suggest that imaginativeness and sensitivity in the aesthetic realm start to wane at about the age of ten and decrease in adolescence. Many children come to the threshold of artistic flowering and then fall away. Around puberty there is a 'universal change' from natural participation in artistic behaviour to inhibition, abstract thought, and a failure of creative enjoyment.

These experimental findings prompt Gardner to ask how the young child comes to possess such artistic aptitude. His answer is couched in technical language relating to 'modes' and 'vectors'. But essentially it is that the child learns to perceive the world through its own body. In its early months its libidinal energies are based, progressively, on the mouth, the anal region and the genitals. Each of these has its own kind of physical apprehension. The mouth can be open or closed, empty or full, and so leads to notions of getting and taking in. The anal region relates to holding on and letting go, and the genitals to intrusion and inclusion. During the first year of life the child becomes increasingly able to transfer these feelings, and other feelings such as hollowness, roughness, smoothness, activity, depth, width and narrowness, which occur in relation to its own body, to its perception of the outside world. It reads the outside world as representing interior states. Gardner cites Piaget's observation that his nine-month-old daughter would watch him stick out his tongue and then raise her forefinger, showing that she had transferred the idea of protrusion from her body to something outside. Similarly she would open and close her hand after he had opened and closed his eyes.

Gardner's contention is that this is how artists perceive. The natural sense of oneness between the body and the outside

world is, as he puts it, 'another way of cutting up the universe', an alternative to the objective, scientific way, and it is the artist's way as well as the young child's. This explains why so many artists talk of their art as a regression to childhood. Moreover, the bodily tensions that the young child projects onto the outside world are, Gardner argues, not merely physical. Qualities like hollowness, balance, solidity, openness and closedness have, or develop, emotional and moral connotations. He regards emotions such as pride, jealousy and awe, and the qualities that pervade aesthetic discourse, such as balance, elegance and rhythm, as developments of the child's bodily apprehension of the world. So the child could be said to invent the moral universe as it reads the outside world through its body. Gardner adds, but does not elaborate on, the important claim that this kind of body-feeling is necessary not only for art but for the full experience of interpersonal relations.

The attractions of Gardner's theory are evident, especially to those who wish to find a scientific basis for the superiority of art. But it raises difficulties, as he is quick to admit. It is not clear that a scientifically-minded adult is inferior to a ten-year-old child, though Gardner seems to take this for granted, and the aim of art, according to his theory, is to convert one into the other. A world populated by children aged ten-and-under might, we can accept, be good at body-thinking, but deficient in rationality, justice and most other kinds of cerebration. Gardner stresses that his parallels between how artists and infants think are, in any case, tentative: 'unfortunately the experimental evidence on these questions is almost non-existent'. He is putting forward a 'hypothesis, and no more than that'. Though his theory assumes that all children develop through body-thinking, it is not the case that all children are artistically gifted. Some, Gardner acknowledges, display an almost complete lack of productive impulse and aesthetic

sense. This range of ability in children's early artwork has not been satisfactorily explained, but it suggests, he believes, a strong genetic basis for artistic talent, and this would weaken the argument for a connection between body-thinking and art.

If art fosters body-thinking, which is superior to cold, scientific brain-thinking, then it might seem likely that it would be effective as therapy in various psychological disorders. But Gardner is suspicious of such claims. The role played by the arts in the rehabilitation of children suffering from neurosis or psychosis is, he contends, open to dispute. A surprising number of studies in this area, he notes, use no control group, and there is no means of distinguishing whether artistic progress is a symptom or a cause of psychological improvement.

Art as psychological therapy seems doubtful, then, and art as an improver of personality and morals appears even less promising. Gardner's suggestion that artistic proficiency based on body-thinking engenders a capacity for interpersonal relations looks susceptible to objective testing. But where tests have been attempted they do not yield encouraging results. He cites a study, published in Genetic Psychology Monographs, which reports on a psychological assessment of actors and others working in the theatrical profession. It concludes that such people have difficulty establishing normal family ties, and undergo a higher-than-average proportion of divorces. Also, they tend to be insensitive to other people's feelings, treating them as objects to be amused, teased or manipulated.

Nevertheless Gardner's relation of art to body-thinking does find support in the way some poets, painters and musicians talk about their work. An outstanding case is Seamus Heaney, the Irish poet and winner of the Nobel Prize for Literature. When pondering the sources of his poetic faculty Heaney persistently traces it to his childish fascination with mud, moss, peat and suchlike damp softnesses:

To this day, green, wet corners, flooded wastes, soft rushy bottoms, any place with the invitation of watery ground and tundra vegetation, even glimpsed from a car or a train, possess an immediate and deeply peaceful attraction.

The poem 'Personal Helicon' presents the writing of poetry as an adult substitute for his childhood obsession with poking around in old wells and fingering slime. This seems to validate Gardner's body-thinking insight and, as Heaney develops the idea, earth and digging and art-as-a-return-to-childhood coalesce with an implicit claim that these things are fundamental and give poetry its value. Discussing the verb 'hoke' in his poem 'Terminus', Heaney writes:

When I hear somebody say 'hoke', I'm returned to the very first place in myself. It's not a standard English word, and it's not an Irish-language word either, but it's undislodgeably there, buried in the very foundations of my own speech. Under me like the floor of the house where I grew up. Something to write home about, as it were. The word means to root about and delve into and forage for and dig around, and that is precisely the kind of thing a poem does as well. A poem gets its nose to the ground and follows a trail and hokes its way by instinct towards the real centre of what concerns it.

As we have seen, Gardner believes that body-thinking is better than scientific thinking and produces better people. Heaney, too, has long been in search of ideas about how art might improve people. He began to write poetry during what he calls the 'terrible black hole' of Northern Ireland's sectarian conflict. As an Ulster Catholic he could not be neutral, and pressure was brought on him to support the cause. His refusal to write political poetry was courageous, but it looked evasive and made him feel guilty. This forced him to confront basic questions. What is the good of poetry? Can it contribute to society? Does it make people better? The answer he evolved differs from Gardner's body-thinking and Palmer's moral imagi-

nation, and it seems to have been suggested by his reading of T. S. Eliot. He found that, in the Second World War, Eliot too had begun to wonder whether 'fiddling with words and rhythms' could be justified during an armed struggle. To counter these doubts Eliot evolved his theory of the 'auditory imagination'. According to this, what the poet writes about does not really matter. Meaning is secondary. What matters are the sounds and rhythms. The noises poems make penetrate 'far below the conscious levels of thought and feeling, invigorating every word, sinking to the most primitive and forgotten, returning to the origin and bringing something back'.

Heaney finds this idea extremely attractive. It correlates with his sense that a word like 'hoke' is a tap-root plunging deep into the earth of his childhood, and it allows him to formulate a theory about how poetry improves people. Commenting on the acoustic qualities of a poem by Elizabeth Bishop, he remarks:

> The lines are inhabited by certain profoundly true tones, which as Robert Frost put it, 'were before words were, living in the cave of the mouth', and they do what poetry most essentially does: they for-tify our inclination to credit promptings of our intuitive being. They help us to say in the first recesses of ourselves, in the shyest, pre-social part of our nature, 'Yes, I know something like that too. Yes, that's right; thank you for putting words on it and making it more or less official.'

The details of this theory remain, admittedly, foggy, but the essentials are clear. Poetry works through making noises that stir deep unconscious memories, both racial memories of man's pre-verbal cave-dwelling past and memories of our very early childhood – possibly, as others have suggested, though Heaney does not, memories of the first semi-articulate converse between mother and child. The effect of these memories is to make us trust the 'promptings of our intuitive being' (as

opposed, presumably, to logic, reason and science) and Heaney considers this an improvement. In his Nobel Lecture, *Crediting Poetry*, he gives a slightly different but complementary version of the theory, relating it to his own continual effort, as a lyric poet, to make poems sound right ('straining towards a strain . . . a musically satisfying order of sounds'). When they do sound right, he claims, they 'touch the base of our sympathetic nature'. The right sounds, organized into poetic form, give poetry 'the power to persuade that vulnerable part of our consciousness of its rightness in spite of the evidence of wrongness all around it'.

In Heaney's theory, then, poetry improves people because by stirring deep acoustic memories it prevails on them to trust the intuitive, sympathetic and vulnerable parts of themselves, giving them an inner strength to withstand the 'wrongness all around'. The sincerity with which he expounds this credo is not to be doubted, but it clearly offers some obstacles to understanding. The resemblance between the sound of poetry and the noises made by cave men, infants, or whatever other preverbal creature is intended, is impossible to establish. It remains purely speculative and seems, on the face of it, hard to credit. Are all noises all poems make of this kind, or only some in some poems? Even if we grant that hearing a noise in a poem could stir a memory of some pre-verbal existence, it is not clear why the moral gain Heaney posits would accrue. A sophisticated modern poet withstanding 'the wrongness all around' does not sound like a cave man or infant, and only a very careful selection of the imagined properties of cave men or infants could produce the appealing effect Heaney desires. Then again, leaving aside the difficulties of the sonic rapport with the remote past that Heaney credits, and the impossibility of checking whether it actually happens, there is the question of who it happens to. Do all readers of poems receive these benefits or only some? As with many theories about the good feel-

ings induced by art, the suspicion lingers that the kind of people affected were quite likely to have the good feelings anyway. Most readers of poetry are educated, sensitive people of gentle disposition. However, it seems probable that this is due not to the improving power of poetry, but to the process of self-selection that makes educated, sensitive people of gentle disposition readers of poetry in the first place.

When Heaney was teaching English in the early 1960s at St Thomas's Secondary School in the Ballymurphy area of Belfast, his headmaster, a Mr McLaverty, had a strong belief in the improving power of poetry. He would bustle into Heaney's class and enquire whether he was doing any poetry with the boys and whether he was seeing any improvement in them as a result. Heaney would dutifully answer both questions in the affirmative. 'Mr Heaney', McLaverty would continue, 'when you look at the photograph of a rugby team in the newspaper, don't you always know immediately from the look of the players' faces which ones of them have studied poetry?' Unfailingly Heaney would reply that he did. The whole thing was, he recalls, a comic masquerade. Yet, as he acknowledges, McLaverty's trust in the humanizing power of art was not some personal idiocy but in line with two and a half millennia of Western aesthetic and educational theory. In believing that the study of poetry would lead Heaney's pupils to virtue he was simply repeating an orthodox cultural assumption – and one that Heaney's theory about poetry's auditory power does in fact endorse. In reality, Heaney tells us, many of the boys in his class ended up a decade later as active members of the Provisional IRA, so whatever effect poetry had on them it was not the one he hoped for.

Claims that the arts make people better or more civilized seem, then, problematic, and some thinkers have urged that art, far from encouraging fellow-feeling among people, is

essentially divisive. David Lewis-Williams's book *The Mind in the Cave* suggests that Western art was in its very origins a means of social distinction. Lewis-Williams's subject is the cave-paintings dating from the late Ice Age and discovered at Altamira, Lascaux and other sites. At the time these paintings were produced, about 40,000 years ago, two different kinds of humanoids were living side by side in Western Europe. There were the Neanderthals, beetle-browed primitives who had already been around for two millennia, and there were the new people, immigrants from the near east and ultimately from Africa, who belonged to our own species Homo Sapiens. A crucial difference between them, so Lewis-Williams and some other anthropologists believe, was that the Neanderthals, because of the neurological structure of their brains, could not form or remember mental images, whereas the new men could. This meant that the new men could think symbolically, so they could paint pictures and carve statuettes which, to Neanderthals, would be no more recognizable as pictures and statuettes than they would be to an animal. It is Lewis-Williams's theory that what spurred the new men to create cave art was to register their superiority to the Neanderthals. It was a proof of their entry to a world of image-making that Neanderthals were for ever debarred from. Having registered their superiority as a species, the new men could exterminate the Neanderthals with a clear conscience, as it seems probable they did.

True or not, Lewis-Williams's idea that Western art was originally and essentially a means of social distinction accords well with modern theories such as that set out in Pierre Bourdieu's classic work of sociology, *Distinction: A Social Critique of the Judgement of Taste*. This was based on the results of questionnaires collected from some 1200 French people of all classes in the 1960s. Bourdieu investigated their preferences not

only in art and music but also in other areas of lifestyle such as cooking, cosmetics, clothing, interior decoration, cars, newspapers and holiday resorts. His conclusion was that taste has nothing to do with intrinsic aesthetic values in the objects it chooses. It is a marker of class, reflecting educational level, social origin and economic power. 'Taste classifies, and it classifies its classifier.' Its purpose is to register one's distinction from those lower in the social order. For this reason, upper-class taste expresses its possessor's ability to transcend economic necessity and the practical urgencies of life which afflict those lower down the social scale. Making a meal, for example, becomes an affirmation of ethical tone and social refinement rather than simply a way of appeasing hunger. Bourdieu links this transcendence of 'vulgar' appetite and physical satisfaction, which is essentially an expression of economic power, to the emphasis in Kantian aesthetics on 'pure' contemplation from which all desire has been eliminated. He cites, as a particularly blatant instance of the process, Schopenhauer's condemnation of Dutch still-lives that portray food:

> Painted fruit is yet admissible, because we may regard it as the further development of the flower, and as a beautiful product of nature in form and colour, without being obliged to think of it as eatable; but unfortunately we often find, represented with deceptive naturalness, prepared and served dishes, oysters, herrings, crabs, bread and butter, wine and so forth, which is altogether to be condemned.

In this superior aesthetic, natural human desires are rejected as coarse, vulgar, venal or servile, because they relate to economic necessities that exponents of the aesthetic have surmounted. It affirms the superiority of those who can be satisfied with sublimated, refined pleasures. Similarly, common moral responses are suspended, because economic power frees its possessors from the need to take moral issues seriously, and because by adopting a sophisticated moral agnosticism they can express

their unusualness and their freedom from herd instincts. Bourdieu asked his respondents whether a series of objects would make beautiful photographs, and found that those at the higher end of the social scale rejected sunsets, landscapes and other objects of popular admiration in favour of subjects such as car crashes, cabbages and pregnant women, which those of lower class considered unaesthetic. The ultimate expression of economic power is, for Bourdieu, music which, having nothing to say, represents the most radical and absolute negation of the ordinary world's neediness and practicality, a negation that 'high' aesthetics demand of all forms of art.

Bourdieu's theories are not beyond criticism. His social divisions reflect the rather stuffy French class-structure of the early 1960s. American commentators, in particular, find them unrecognizable. Inspection of his statistical tables reveals considerable variation of taste within classes. There are members of the working class who put *The Well-Tempered Clavier*, normally an upper-class taste, among their preferences, and higher-education teachers who like *La Traviata*, usually a middle-class choice. Such variations disturb the authority of his class-based aesthetics. Also, his own prejudices slant his analysis. Though his theory demands that all artworks should be equally devoid of intrinsic aesthetic value, deriving their power solely from their operation as markers of social class, he seems not to believe that this is so in circumstances where he feels his own cultural distinction being trespassed on. He is contemptuous of 'middlebrow' culture, and those who cater for it. The producers of cultural programmes on TV and radio, and the commentators and critics in 'quality' newspapers and magazines, are engaged in the 'impossible' task, he contends, of divulging 'legitimate' culture to the uncultured. He scorns the 'petit-bourgeois' relation to culture and its capacity to make middlebrow whatever it touches. What prevents the petit-bourgeois

from being cultured 'is, quite simply, the fact that legitimate culture is not made for him (and is often made against him), so that he is not made for it, and it ceases to be what it is as soon as he appropriates it'.

Bourdieu seems here to have ceased to be an objective critic, surveying the cultural scene with scientific detachment, and to have become a rather sorry specimen of the kind of class-feeling he anatomizes. For if works of art are simply markers of social class there is clearly no reason why an upwardly mobile petit-bourgeois should not aspire to the 'legitimate' art of people like Bourdieu, just as he might buy a more expensive car. To insist that 'he is not made' for a car of this kind, or that an artwork 'ceases to be what it is' when he develops a liking for it, is to suppose that it 'is' something intrinsically, irrespective of how it is perceived or valued – and that is precisely what Bourdieu denies with respect to cars, artworks, cosmetics, holiday resorts and all other consumer desirables. However, Bourdieu's outburst against the insidious encroachments of the petit-bourgeois, and his fierce assertion of cultural apartheid, are no more than a practical demonstration, suitably raw and splenetic, of his theory's main point, namely, its emphasis on the divisive effects of taste, and its supreme importance in social, political and personal life. Far from being something incidental or superficial, taste is, he asserts, the basis of all that one has, both people and things, and of all that one is for others. Consequently intolerance in matters of taste is, he observes, inevitable and terribly violent. There is nothing that fortifies us in despising other people so thoroughly. Taste, defined as the propensity and capacity to appropriate a given class of classified and classifying objects or practices, is the generative formula of lifestyle, and aversion to different lifestyles is one of the strongest barriers between classes.

The strength of Bourdieu's demonstration of art's essentially

divisive nature lay in his preliminary opinion poll. It was this that elevated theory into sociological fact. A less extensive but similarly pioneering survey was carried out in England in the early 1960s by Marghanita Laski, and it addressed the question not only of whether the arts make us better, but also whether there is anything distinctive in the experience they give. The arts, it is often claimed, transport their adherents to a higher, spiritual realm, or awaken the soul, or allow glimpses of the divine, and these benefits, it is assumed, give the arts priority over lowlier amusements. It was this assumption that Laski decided to address, as well as the assumption that the arts improve us as people. Her experiment had two parts. One was to draw up a graduated table of the kinds of action she felt could be accepted as criteria of kindness and altruism, and as evidence, therefore, of goodness in the person performing them. Tending, for no reward, a sick, incontinent, mentally defective stranger comes top of her list. Tending a similarly afflicted close relative comes second, and the actions continue through decreasing levels of difficulty down to giving money to registered charities. The other part of the experiment was to send out a questionnaire. The first question Laski asked did not relate directly to the arts, because one of her aims was to find whether the spiritual effects attributed to the arts were also obtainable from other sources. The question she asked was whether her respondents had ever felt 'a sensation of transcendent ecstasy'. Supplementary questions asked about the duration and the frequency of the sensation and what had triggered it.

To exemplify the kind of claim for art that she was questioning Laski cited Bernard Berenson, who describes, in *Aesthetics and History*, how he had a mystical experience looking at some carved scrolls in Spoleto, and how this gave him faith in the ultimate rightness of his judgements about art. 'Only works of art', he declares, 'can be life-enhancing.' Natural objects,

whether animate or inanimate, cannot, 'because they stimulate activities that are greedy, predatory or coldly analytical'. Laski found that her respondents were far from agreeing with Berenson. Sixty of the sixty-three people she questioned said that they had known ecstasies, and the experiences that had triggered them often had nothing to do with art. Natural scenery was the most common. Sex was also popular – at some time or other it had made 43 per cent ecstatic. Other triggers included childbirth, solving mathematical problems, physical exercise (swimming, skiing), and (in one case) eating bread, butter and jam as a child ('I can recapture it in memory even now,' the respondent wrote). The arts did, nevertheless, come high on the list. Music, painting and literature together accumulated the second-largest number of votes, with music scoring higher than the other two, and Beethoven coming top among composers.

Having satisfied herself that other things besides art provided ecstatic experiences indistinguishable from those claimed for art, Laski then confronted the question of whether ecstasy makes people better. The ecstatic experiences her subjects described often included extravagant feelings of revelation and enlightenment, which Laski calls 'totality expressions'. During ecstasy, they claimed, they achieved 'identity with the universe' and knowledge of 'everything' – 'knowledge', as one of them put it, 'of the smallest bacteria in the field, how the blade of grass works, and the universe, in the same detail'. These claims resemble and perhaps echoed those made – quite seriously, and without the aid of ecstasy – by many leaders of abstract art in the 20th century, who maintain that art reveals ultimate spiritual truths, beyond the material world. Kandinsky in his *Reminiscences* (1913) attests:

> Not only the stars, woods, flowers of which the poets sing, but also a cigarette butt lying in the ash tray, a patient white trouser button

looking up from a puddle in the street, a submissive bit of bark that an ant drags through the high grass in its strong jaws to uncertain but important destinations, a page of the calendar which the conscious hand reaches to tear forcibly from the warm companionship of the remaining block of pages – everything shows me its face, its innermost being, its secret soul, which is more often silent than heard. Thus every still and moving point (= line) became equally alive and revealed its soul to me.

Laski does not quote this passage from Kandinsky, but she does note that the ecstatic sense her subjects report of 'being in touch with the Creator' or 'joined to God', or of having 'knowledge of the reality of things', or of feeling that 'the universe is a living presence', closely resemble the claims made, throughout the centuries, by religious mystics. She cites, for example, the German Jakob Boehme (1575–1624): 'I saw and knew the being of all things . . . I saw and knew the whole working essence . . . and likewise how the fruitful bearing womb of eternity brought forth.'

The point Laski wishes to make about these feelings is that they are delusions. It does not make sense – indeed, is not sane – to say that you have knowledge of everything, any more than it does to claim acquaintance with the soul of a trouser button. It would be mistaken, therefore, to regard such ecstatic revelations as a benefit bestowed by art, even if only artistic ecstasies gave rise to them. Far from being a benefit, experiences that reveal 'truths' contrary to reason are pathological. They can easily be induced by chemical interference with the brain. Laski cites several accounts of experiences under mescalin, including those reported by Aldous Huxley, which include 'totality expressions'. Patients undergoing anaesthetic are often similarly deluded. In a case reported in *The Lancet*, among Laski's examples, a woman patient tells of being 'filled with unspeakable joy' and having 'a complete revelation about the ultimate

truth of everything'. When she comes round from the anaesthetic she tells the doctor, who asks what the revealed truth was. 'I faltered out, "Well, it's a sort of green light."'

Ecstatic experiences are harmful, Laski argues, not only because they delude, but because they make the real world and its real evils irrelevant. Among the cases collected by William James in *Varieties of Religious Experience* is that of a subject who has a visionary experience on his way home in a cab: 'I saw that all men are immortal . . . all things work together for the good of each and all . . . and that the happiness of each and all is in the long run absolutely certain'. This optimism is characteristic of religious ecstasy. Mystics like Hugh of St Victor talk of plunging into an ineffable peace where all wretchedness and pain are forgotten. But how desirable is it, demands Laski, to forget wretchedness and pain? Is it not this same detachment that allows delight in the arts to co-exist with starvation in Africa? If this is what the arts provide, are they any better than hallucinogenic drugs? Huxley, describing his experience of mescalin, said that he broke through to a luminous world, identical, he thought, to that of the religious mystics, where the revelation was vouchsafed to him that the universe was ultimately 'all right'. Obviously, if that is so, there is no point in trying to amend it. Religious ascetics who withdraw from life and seek the divine are, for Laski, monsters of selfishness, and people who seek the ecstasy of art and ignore the wants of their fellow mortals are, she believes, directly comparable.

A flaw in her research programme is that she apparently never made any attempt to find out how her sixty ecstatics scored in terms of charitableness and altruism. Having worked out her graduated table of selflessness with such care, she should surely have questioned them to find how they rated on it, and whether their rating improved after ecstasy. Whether the artistic ones were more or less altruistic than those who

124

attained ecstasy during sport or sex would also have been a relevant enquiry. Perhaps Laski did embark on this, but was too embarrassed to publish the results. She clearly suspects that artistic ecstasy tends to make people more selfish rather than less. How many of those who have achieved ecstatic experiences through art, or anything else, she demands, have undertaken kinds of charity work that involve personal contact with people who are physically disgusting? How many have refrained out of kindness from breaking off an unwanted marriage? Not many, is her implied response – and she alludes darkly to women friends who have been shattered by disappearing husbands. But she admits she does not know the answers to these questions, and she adds, rightly, that no systematic attempt has ever been made to find out the answers, though they are crucial to any claim that the arts make people better.

Another defective aspect of her research relates to social class. Her sixty subjects were, she says, almost all middle class, and most had tertiary education. In an appendix she relates how she attempted to atone for this bias. She prepared another questionnaire, in which the first question was 'Have you ever known a feeling of unearthly ecstasy?', and put a hundred copies of it through letter-boxes in a working-class district of London, together with stamped-addressed envelopes. Only eleven replies were returned, ten of them negative. This leads Laski to speculate that only the educated have ecstatic experiences, not 'the unlettered, the prosaic, the solid masses'. A Victorian medical authority she has read reports that nitrous oxide gives 'ordinary people' merely a sense of well-being, whereas 'persons of superior mental power' report apocalyptic, secrets-of-the-universe revelations, and this reinforces her belief that ecstasy is linked to social class. A more likely explanation seems to be that the degree of self-importance implicit

in the claim that one's experiences merit description as 'unearthly ecstasy' is class-linked. Many of the recipients of Laski's comminication must have regarded her language alone as automatically excluding them. Claims to transcendence and universal knowledge are evidently a way of conferring significance on oneself and one's experiences, and are likelier to occur to those already in possession of social confidence and economic power. Seen in this way, parading one's ecstatic feelings about art would be a reinforcement of art's divisive effect, as analysed by Bourdieu. It seems to occur to Laski that a better way of testing her hypothesis might be to question nurses, social workers, elementary school teachers and other professions widely valued for their unselfish conduct, so as to discover their artistic tastes and their experiences, if any, of ecstasy. Unfortunately, however, she does not do this.

A curious footnote to her research, strongly endorsing her doubts about ecstasy and its effects, is supplied by Bill Buford's book *Among the Thugs*. Laski is under the impression that ecstasy is a solitary experience, and that being part of a crowd would be anti-ecstatic. She would like, she says, to ask football hooligans if they had ever known transcendent ecstasy, and would expect negative answers. Buford could have put her right. In his book he describes travelling to away matches with a hard core of Manchester United supporters, and taking part in crowd violence. When abroad, the supporters behave with loutish arrogance, urinating over women at restaurant tables, looting, clearing shops of goods, emptying cash registers. Buford finds the violence 'transcendent', and compares it to 'religious ecstasy'. 'I know no excitement greater,' he attests. It gives 'an experience of absolute completeness'. In Turin his group of supporters kick and beat a young Italian boy. There is a long description of the boy writhing and the 'soft, yielding sound' of the blows.

Everyone around him was excited. It was an excitement that verged on being something greater, an emotion more transcendent – joy at the very least, but more like ecstasy. There was an intense energy about it. It was impossible not to feel some sort of thrill. Somebody near me said he was happy. He said that he was very, very happy, that he could not remember ever being so happy.

The question of whether the experience of ecstasy affects subsequent behaviour seems, in Buford's case, to be answerable in the affirmative. Back from Turin, he arrives at Marble Arch and takes the escalator to the underground station. An elderly couple, both with walking sticks, are helping each other down. 'I shoved them forcibly aside, pushing them sideways with the flat part of my hand. I shot past them and looked back up at them. "Fuck off,", I said. "Fuck off, you old cunts."' Buford is a literary and artistic person, and by writing about crowd violence he aestheticizes it, absorbing it into a literary and artistic experience. The interest of his book, from the viewpoint of Laski's thesis, is that it bears out – more sinisterly than she could have hoped – her association of ecstasy with self-gratification and contempt for others.

Though generally anti-ecstasy, she does allow that one kind of ecstatic experience may, in evolutionary terms, have had a beneficial effect. Descriptions of ecstasies by those who have undergone them include a category that she labels 'Adamic', in which feelings of kindness and love to others predominate. Memory of such ecstasies may, she thinks, account for the idea that equality between people is right. Nothing observable in the animal world or in the conduct of human societies could have given rise to such an idea, she points out, and it is difficult to see where else it could have originated. Yet it is widespread in human thought, and integral not only to many utopias but to major religions such as Christianity.

Laski's suggestion may be correct. But an alternative expla-

nation for a residual belief in equality, accepted by some anthropologists, is simply that humankind has lived for most of its history in hunter-gatherer societies, and developed habits of thought appropriate to such a condition. Hunter-gatherer societies depend on communal effort and survive by communal distribution, and they cannot accommodate individualistic divergence. Belief in equality is necessary for sustaining these arrangements. Laski's explanation seems less likely, in that it traces belief in equality to visionary ecstasies, which, presumably, only a minority would have experienced, and which the majority would have had no pressing need to credit, whereas the anthropological explanation traces it to practices that were adopted by whole communities and vital for survival. But whatever the rights and wrongs of this particular debate, the power, range and originality of Laski's thinking, and her fearless questioning of fundamental issues, are beyond doubt. All accounts of artistic experience as 'spiritual' and 'ecstatic' are affected by her argument. By seeing such accounts as harmful, delusive and self-serving she disposes of what has traditionally been revered as art's highest splendour.

Essentially her analysis depends on a distinction between those who care about art and those who care about people. On her reading, art is good if it promotes concern for people, bad if it does not. As we have seen, arguments for public funding of the arts tend to assume that people will benefit, and this seems to carry with it the assumption that in the end people matter, rather than the arts themselves. However, the spiritual aura that surrounds artworks operates against this assumption. Its tendency is to bestow on artworks a divine status, as if they were portable deities, and to make people, by comparison, dispensable. This becomes evident at times of crisis. During the Second World War, for example, elaborate precautions were taken to protect the national art collections from enemy bomb-

ing. In 1939, when it was certain that war was imminent, the Trustees of the National Gallery, headed by Kenneth Clark, decided that the whole collection should be sent to Canada. On Churchill's intervention the plan was modified and the pictures were moved to slate mines in Wales. Civilian populations could not, of course, be provided with comparable protection and were killed in large numbers.

Art-lovers would presumably defend this procedure on the grounds that people are replaceable whereas artworks are not. However, that is not true. People are not replaceable. They are individuals, as unique as artworks. Further, people can create artworks, though artworks cannot create people. An alternative view of how threatened artworks should be treated was supplied during the 1857 debate, referred to at the start of this chapter, about whether the national collection should be moved to Kensington from Trafalgar Square to avoid the damage the pictures were sustaining from air pollution. As Neil MacGregor records, Mr Justice Coleridge spoke against the move, on the grounds that it would make the pictures less accessible:

> After all, if it were demonstrable that the pictures in their present position must absolutely perish sooner than at Kensington, I conceive that this would conclude nothing. The existence of the pictures is not the end of the collection but a means to give the people an ennobling enjoyment . . . If while so employed a great picture perished in the using, it could not be said that the picture had not fulfilled the best purpose of its purchase or that it had been lost in its results to the nation.

The 1939 Trustees took a different view. For them the artworks were not expendable, nor merely a means to an end. They were precious and sacred, and more worth preserving, when it came to the crunch, than human life, and this exemplifies the relative disregard for the human inherent in art-worship that Laski exposes. Of course, preserving artworks for posterity can be

made to appear simply prudent and responsible. But the prioritizing of art over people that it implies is identical with, though less obviously horrifying than, the example of concentration camp commandants who enjoyed string quartets played by Jewish prisoners before executing them.

Laski's simple distinction, taken together with Mr Justice Coleridge's intervention, gives us a way of distinguishing between art-lovers. The question we need to keep in mind is, how does this person's love of art affect his, or her, attitude to human beings? An instructive example is John Paul Getty. By any standards Getty must qualify as one of the most lavish art-lovers of all time, and one of the greatest benefactors of the arts. 'The beauty one can find in art', he said, 'is one of the pitifully few real and lasting products of human endeavour.' He had catholic tastes, collecting ancient Greek and Roman marbles, bronzes and mosaics, Renaissance paintings, 16th-century Persian carpets, and 18th-century French furniture and tapestries. He acquired three of the Elgin marbles, including a celebrated 4th-century BC stele of a young girl. In 1938 he bought Rembrandt's portrait of Marten Looten, and in 1962 he paid half a million dollars for Rembrandt's *Saint Bartholomew*. The previous year he had bought Rubens's *Diana and her Nymphs Departing for the Hunt*. He eventually donated the whole collection, valued at the time at $200 million, to the John Paul Getty Museum in California, which cost $17 million to build.

Getty left ample records, in his autobiography and elsewhere, of his views about the relative merits of art and people. His belief was that only a love of art could qualify you as a complete human being. 'The difference between being a barbarian and a fully fledged member of a cultivated society', he explained, 'is in the individual's attitude towards fine art. If he or she has a love of art, then he or she is not a barbarian.' In his

estimate half the human race, as currently constituted, failed his test. 'Tragically, fifty per cent of the people walking down any street can be classed as barbarians according to this criterion . . . Twentieth-century barbarians cannot be transformed into cultured, civilized human beings until they acquire an appreciation and love for art.'

The barbarians, in Getty's imagination, were not merely uncultivated but often shamefully dependent on welfare handouts. Grumbles about the taxes he had to pay, and the money the government squandered on 'failures and freeloaders', were among his favourite themes. He was not himself by any means a self-made man, having had the good fortune to inherit his father's oil business. However, this did not diminish his conviction that people in general should be made to fend for themselves. Welfare only made them dependent, and robbed them of initiative and self-respect. A better scheme than state charity for dealing with the non-productive urban mass, he suggested, would be to transport them to remote rural areas. 'They will be provided with shelter, a plot of ground, basic tools, seeds and fertilizers. From then on, each able-bodied individual will be on his or her own.' At the same time, stringent legislation should be put in hand to prevent the masses from irresponsible breeding and ensure, if possible, zero population growth. People will be required to obtain a government licence before they have children, and this will be issued only if they meet certain criteria, including a satisfactory track-record of productive work on the part of both parents. Anyone likely to become a welfare client will be refused the right to parenthood. There will be mandatory abortion for women who become pregnant without an official licence. Stricter measures would also be introduced to combat crime and violence. Getty ridiculed enlightened, liberal views about rehabilitation, and recommended harsher penalties, including capital punishment.

'This', he advised,' is the only kind of language some people understand.'

The Getty plan for human improvement was not, he claimed, without government support. 'Considerable research' had been done at 'official levels', drawing up contingency plans along the lines he favoured. The subsistence agriculture to which he intended to consign the needy contrasted markedly with his own lifestyle. In 1959 he bought Sutton Place in Surrey, a 72-room Tudor manor house with 750 acres, previously owned by the Duke and Duchess of Sutherland. At the opening party 2,500 people dined on caviar, lobster, strawberries and champagne, and danced to the music of three orchestras.

True, Getty is an extreme case, but he usefully illustrates Laski's distinction between those who care about art and those who care about people. In his world-view, artworks are clearly superior. Indeed, people only qualify as fully human if they appreciate artworks. He would certainly have endorsed a policy that exposed human populations to aerial bombardment from which artworks were protected. His art collection might be viewed as his external or surrogate soul, enshrining his spiritual essence as the soul has traditionally been supposed to do, but not actually encased in his body. It was a locus of spiritual values, inherent in the artworks, but attributable to him since he owned them. As such, it was a triumphant response to those who might see him as a mere cut-throat businessman. It proved that he possessed spirituality, and in very expensive quantities.

Viewed as a humanizing influence, the Getty art collection was admittedly a failure insofar as it affected its owner. Its contribution to our debate about whether the arts improve people must be a negative. There is little point in acquiring two Rembrandts and a Rubens if your social views remain indistinguishable from those of any saloon-bar fascist. However, Getty's purchase of a surrogate soul, consisting of works of art,

was not some singular deviation but a common practice. Artworks are regarded as repositories of spiritual power, and the power is presumed to transfer to the nations or individuals that possess them. The English Royal Collection, for example, comprises 7,000 oil paintings and more than 500,000 prints and drawings. It is not to be supposed that these are for the personal delectation of the monarch. Their function is totemic. They are like bullion locked in a vault, underwriting the spiritual authority of their possessor. If art were truly believed to improve people the obvious step would be to distribute these treasures in local art galleries throughout the land. But that would be unthinkable. It would seem, to traditionalists, like dismantling the nation's soul, much as if the National Gallery's holdings were broken up and distributed through the regions, where people could more easily see them. The function of art as a surrogate soul has become so generally accepted that, as Carol Duncan points out, Third World monarchs and military despots in the 20th century created Western-style art-museums to demonstrate their respect for Western values and worthiness as recipients of Western military and economic aid. In 1975, Imelda Marcos, wife of the Philippine dictator, put together a museum of modern art in a matter of weeks, ready for the meeting in Manila of the International Monetary Fund.

This chapter has examined various theories about how the arts might improve people, and various notions about what a satisfactorily improved person might be like. It has considered the use of the arts as a means of raising the thoughts and improving the behaviour of the poor, and so making them feel less antagonistic towards the rich. It has gathered evidence from psychologists and art-educationalists who dispute received beliefs about the benefits the arts bestow. It has placed the Tolstoyan faith in the arts as promoting Christian brotherhood against anthropological and sociological definitions of

the arts as essentially divisive. It has questioned the equation of art with civilization, and the concept of civilization that such an equation endorses. It has pointed out objections to the belief that literature allows you to know how other people feel. It has examined proposed connections between early child development, art, and alternatives to scientific thinking, and has raised doubts in relation to these. It has noted obstacles to believing that the sounds made by poetry arouse pre-conscious memories in a morally improving manner. It has contested the common assumption that the ecstatic or transcendent experiences associated with the arts are beneficial.

The claims and theories debated in this chapter amount, I think, to a fair and comprehensive summary of the various lines of thought pursued by those who contend that the arts make people better. As readers will gather, none of them seems to me to bear scrutiny. How experience in the arts affects behaviour, whether it increases or decreases altruism and practical benevolence, or does not affect them at all, whether there is any correlation between artistic deprivation and anti-social conduct, what artistic experience workers in the most self-sacrificing jobs and callings have – these and related questions are obviously vital to our understanding of what art is and does and how it operates in a culture, and in place of answers what we have currently are lax and baseless assumptions and pious hopes. Admittedly systematic research in this area is difficult, but it is not impossible. Where it has been attempted – as in the work of Bourdieu and Laski – the results do not support the conventional belief that exposure to the arts makes people better.

# Can art be a religion?

The appropriation of artworks as surrogate souls, which advertise the spirituality of the individuals or institutions that own them, raises the question of art's relationship to religion. The association goes back a long way. The connection of prehistoric art with shamanism is a commonplace of anthropology. Drama, music, sculpture and poetry have been incorporated into religious rituals worldwide from the earliest recorded times. Even Plato, while banning poets from his Republic, thought that they were divinely inspired.

However, the elevation of art into a religion or substitute religion is a much more recent development, traceable, as I suggested in the first chapter, no earlier than the mid-18th century. Until then art was, at best, religion's handmaid. The change of attitude can be neatly illustrated by the fortunes of Leonardo's *Last Supper* in the refectory of the Dominican monastery of Santa Maria Delle Grazie in Milan. This is now one of Western art's most sacred relics. A pilgrimage site for global tourism, it is venerated as a cultural treasure quite irrespective of its religious significance. Yet as recently as the mid-17th century the monastic authorities had a hole knocked through it, taking away part of the tablecloth and Christ's feet, in order to make a new doorway into the refectory. Clearly this made sense at the time, since the life of the monks, and their worship of the Almighty, were infinitely more important than a mere painted

wall, which could if necessary be demolished altogether without diminishing one iota of God's glory, and which, insofar as it attracted admiration, instead of arousing religious devotion, would rightly be condemned by the church as idolatrous. Today, however, any such architectural modification of Leonardo's fresco would be decried as a monstrous sacrilege – an offence not against the Christian God, who has little or no significance for many of the artwork's devotees, but against the religion of art.

Since its inauguration in the Enlightenment, this modern belief-system has licensed innumerable statements about the religious status of art and artists. William Blake in *Laocoön* (1820) is uncompromising:

> A Poet a Painter a Musician an Architect: the Man or Woman who is not one of these is not a Christian . . .
> You must leave Father & Mother & Houses & Lands if they stand in the way of Art.
> Prayer is the study of Art
> Praise is the Practice of Art . . .
> Jesus & his Apostles & Disciples were all Artists . . .
> Art is the Tree of Life.
> Science is the Tree of Death.

Turning art into religion often carries with it the assumption that there is a higher morality of art, distinct from conventional morality. 'Taste', declared John Ruskin, 'is not only a part and an index of morality: – it is the ONLY morality.' This seems objectionable on several counts. It would surely be inadequate to classify murder and rape, say, as lapses of taste, yet if taste were the only morality there could be no other way of classifying them. Secondly, surely people who live blameless and unselfish lives might be accounted moral, even if their taste is, by Ruskin's personal aesthetic standards, inferior. But Ruskin does not regard his aesthetic standards as merely personal.

They have the authority of religious truths, as he goes on to explain:

> But you may answer or think, 'Is the liking for outside ornaments, for pictures, or statues, or furniture, or architecture, a moral quality?' Yes, most surely, if a rightly set liking. Taste for *any* pictures or statues is not a moral quality, but tastes for good ones is. Only here again we have to define the word 'good'. I don't mean by 'good', clever – or learned – or difficult in the doing. Take a picture by Teniers, of sots quarrelling over their dice; it is an entirely clever picture, so clever that nothing in its kind has ever been done equal to it; but it is also an entirely base and evil picture. It is an expression of delight in the prolonged contemplation of a vile thing, and delight in that is an 'unmannered' or 'immoral' quality. It is 'bad taste' in the profoundest sense – it is the taste of the devils. On the other hand, a picture of Titian's, or a Greek statue, or a Greek coin, or a Turner landscape, expresses delight in the perpetual contemplation of a good and perfect thing. That is an entirely moral quality – it is the taste of the angels . . . What we *like* determines what we *are*; and to teach taste is inevitably to form character.

Ruskin's belief that the specimens of European art he happens to like are what the angels like too seems nowadays merely quaint. But the religious status of art is still a powerful element in contemporary thought. Artists, as Jacques Barzun has observed, are popularly credited with the divine powers formerly attributed to religious figures. They are expected to be 'demanding' and obscure, like ancient oracles. They are always 'ahead of their time' like biblical prophets.

The development of abstract painting in the early 20th century was a religious as well as an aesthetic movement. It was seen by many as a decisive step in art's assumption of the mystery and authority of religion. By transcending the material world, it was claimed, art entered a spiritual realm of pure idea. Kandinsky, the pioneer of abstraction, wrote his treatise *Concerning the Spiritual in Art* in 1910 – the year in which he also

painted his first abstract composition. In it he argues that abstract art will allow mankind to escape from 'the nightmare of materialism'. He was under the impression that the discovery of electrons had proved that the material world did not exist, and that consequently science was 'tottering'. Abstract art would take its place. Each shape and colour in abstract art had 'its particular spiritual perfume', and operated by causing 'spiritual vibrations' which could give 'observers capable of feeling them emotions subtle beyond words'. These would have an improving effect on conduct. 'Suicide, murder, violence, low and unworthy thoughts, hate, hostility, egotism, envy, narrow patriotism', and other evils, would disappear before the refining power of abstract art, and be replaced by 'lofty thoughts, love, unselfishness' and 'joy in the success of others'. Like his fellow-painter Piet Mondrian, the sculptor Constantin Brancusi and the poet W. B. Yeats, Kandinsky was a convert to Theosophy, a ragbag of arcane superstitions deriving partly from India, which he considered 'synonymous with eternal truth'. He was also an admirer of its most fervent proselytizer Madame Blavatsky. His belief that abstract art was a religious force that would change the world was perfectly genuine. He rejoiced in the thought that mankind was on the threshold of 'an epoch of great spirituality'. Given that the First World War was only four years away, however, his prophetic powers seem to have been no more dependable than those of Madame Blavatsky herself, who foretold that 'the earth will be heaven in the 21st century'.

Kandinsky's magic mantle descended, as Robert Hughes traces, upon the Abstract Expressionists. Jackson Pollock possessed a copy of *Concerning the Spiritual in Art*, and the more pretentious Abstract Expressionists spoke, like Kandinsky, as if they were founders of world religions. 'I had made it clear', claimed Clyfford Still (1904–80), 'that a single stroke of paint, backed by work and a mind that understood its potency, and

implications, could restore to man the freedom lost in twenty centuries of apology and devices for subjugation.'

Feminist critics such as Carol Duncan and Linda Nochlin have, understandably, taken a different view of modern art's struggle against matter. They see its trajectory of heroic advance into the abstract world, and its assumption of priest-like authority, as peculiarly male phenomena. The modern art museum is, for Duncan, 'a ritual of male transcendence'. She interprets two key modern works, Picasso's *Les Demoiselles d'Avignon* and Willem de Kooning's *Woman I*, with their grotesquely deformed female figures, as calculated assertions of masculine ownership of high culture. Given that the church's male priesthood has for centuries asserted masculine owner-ship of God, this seems an entirely expectable direction for the religion of art to take.

Like the older religions that it has replaced, the religion of art claims supremacy. It sees itself as the true and unique reposito-ry of spirituality, and it devalues, by comparison with itself, ordinary life and ordinary people. Art, affirms the Bloomsbury aesthete Clive Bell, 'is a religion', and it is towards art that 'the modern mind' turns 'for an inspiration by which to live'. It dif-fers from other religions, however, in several respects. Unlike Christianity, it is not egalitarian: 'All artists are aristocrats', according to Bell, 'since no artist believes honestly in human equality.' It is also amoral, releasing its initiates from the cus-tomary rules of social conduct: 'All art is anarchical, to take it seriously is to be unable to take seriously the conventions and principles by which societies exist.' These aspects reinforce, for Bell, art's transcendental drive:

> Why should artists bother about the fate of humanity? If art does not justify itself, aesthetic rapture does. Whether that rapture is to be felt by future generations of virtuous and contented artisans is a matter of purely speculative interest. Rapture suffices.

The most prominent instance of art-worship co-existing with disregard for the fate of humanity is, of course, Adolf Hitler. Art-lovers used to dismiss him as a mere dauber with kitsch tastes, but Frederic Spotts's book *Hitler and the Power of Aesthetics* has made that gambit unplayable. Spotts shows beyond doubt that Hitler had a deep and serious interest in music, painting, sculpture and architecture. An heir of the Romantic tradition that regarded art-worship as man's highest aspiration, he left home in 1907 to become an artist, and was shocked when the Vienna Academy of Fine Arts turned him down. With selfless dedication he eked out a livelihood painting and selling scenes of Vienna, which he would turn out at the rate of five or six a week, sometimes bartering a picture for a meal, and sleeping in cafés, cheap lodging houses and shelters for the homeless. Though entirely self-taught, he became a competent watercolourist, earning a modest income and receiving occasional commissions.

But it was as a patron of the arts that he excelled. He was convinced that the ultimate aim of political effort should be artistic achievement, and he dreamed of creating the greatest culture state since ancient times. 'I became a politician against my will,' he would say. By choice he would have been 'an artist or philosopher'. His passionate concern for cultural matters, and relative lack of interest in warfare, was the despair of his generals. When Goebbels visited him at his military headquarters at Rastenberg in East Prussia, at the height of the Stalingrad campaign, Hitler began by talking of his pleasure in Bruckner's symphonies, and concluded by comparing the philosophies of Kant, Schopenhauer and Nietzsche. A feeling for the arts was crucial to earning his respect. Goebbels had written plays and a novel; Alfred Rosenberg had studied architecture; Goering was an art collector.

An intense admirer of Greek classical art, Hitler held views

close to those of J. J. Winckelmann, the 18th-century art historian and founder of neo-classicism, The Greeks, he declared, had linked 'physical beauty' with 'noblest soul'. His prize possession was the best surviving copy of Myron's *Discobolus* – a 2nd-century Roman marble replica of a Greek bronze. His well-known dislike of modernist art was, Spotts points out, in line with most critics at the time and with the overwhelming weight of public opinion. Modernist art had engendered hatred everywhere, from London and New York to St Petersburg and Budapest. Hitler denounced it because he believed, correctly, that it was elitist, and had no meaning for the great mass of the public. His Degenerate Art exhibition in Munich in 1937 was visited by derisive crowds who treated the modern artworks on display as a freak show. One aim of his Strength through Joy organization was to bring culture to the masses. Music festivals, travelling art exhibitions and free concerts were part of his civilizing mission. His enormous generosity funded commissions, grants, awards, scholarships and tax abatements for artists, as well as studios and houses. 'My artists should live like princes', he declared, 'and not have to inhabit attic rooms.' The millions of marks needed for these endowments came partly from the royalties earned by his autobiography *Mein Kampf*, and partly from a special tax levied on every postage stamp that had Hitler's picture on it.

During the war he insisted that Germany's theatres, museums and other cultural venues should be open as usual. The major orchestras and opera companies continued to give outstanding performances right to the end. Art helped, it seems, to surmount fear of death, and that may be what Hitler intended. 'Art', he said, 'is the great mainstay of the people, because it raises them above the petty cares of the moment and shows them that, after all, their individual woes are not of such great importance.' His insight appears to be confirmed by a

grotesque episode, which Spotts relates, at a concert given by the Berlin Philharmonic in the closing days of the war. There was, apparently, an understanding that when the programme included Bruckner's Fourth Symphony, the final phase of the Third Reich would have come. The concert of 13 April included it, and as the audience left after the performance uniformed members of Hitler Youth at the exits handed out free cyanide capsules.

His total commitment to artistic values was apparent, Spotts observes, from the start of his political career. After becoming Chancellor in 1933, the first building he erected was a massive art gallery. He insisted that it was right to spend huge sums of public money on culture, even when Germany was struggling to recover from a catastrophic war and inflation. He planned new opera houses, theatres and libraries all over Germany. Linz, his birthplace, was to have the greatest art collection in the world. As his armies overran Europe in 1940 Hitler looted the national collections of the defeated, and confiscated artworks from Jewish collectors, notably the Rothschilds, as well as from the national collections of Poland, Czechoslovakia and France. His haul makes the Getty collection look like a bargain basement. It included fifteen Rembrandts, twenty-three Breughels, two Vermeers, fifteen Canalettos, fifteen Tintorettos, eight Tiepolos, four Titians and a Leonardo – the *Lady with an Ermine* from Cracow. All this was destined for the Linz gallery. It was, as Spotts remarks, the greatest feat of art collection in history.

His passion for music was similarly intense. His love-affair with Wagnerian opera began at the age of twelve when he attended his first opera, *Lohengrin*. His childhood friend Kubizek recalls how Wagner's music would send Hitler into a trance, an 'escape into a mystical dream world'. His devotion was explicitly religious. Wagner's operas were 'holy', he said, lifting one up into 'the purer air'. He had a detailed knowledge

of Wagner's scores, and Spotts estimates that he heard *Tristan und Isolde* and *Die Meistersinger* a hundred times in the course of his life. He developed a close relationship with Winifred Wagner and her children, and his annual pilgrimage to the Bayreuth Festival was one of the great festivals of Nazi culture, for which the town was swathed in swastikas. He also admired Puccini and Verdi, and believed that it was a duty of the modern state to make opera available to everyone, whatever their income. 'Doing away with the aristocratic and bourgeois character of opera' was one of his cultural goals. Though he preferred opera to symphony he developed an enthusiasm for Bruckner, whom he placed on a level with Beethoven.

In architecture he favoured the neo-classical style. Its simplicity, power and austerity, he said, represented the keynotes of his ideology. He was fond of talking of the 'eternal value' and 'timeless significance' of his planned buildings. Speer, his architect, envisaged buildings that would last a thousand years, and resemble, in their final stage, classical ruins. The range and precision of Hitler's architectural knowledge was, Spotts shows, phenomenal. Close acquaintances claimed that he knew by heart the size and ground plan of every significant building in the world. With Speer, he replanned all the major German cities, drawing up grandiose new layouts and having models constructed, which he never tired of poring over and adjusting. Linz was to be a city of European culture. Its architectural model was transferred to his bunker, and he spent hours gazing at it while the Third Reich crumbled.

Worship of art made human beings expendable. Hitler welcomed the allied bombing raids on German cities because they cleared the way for his designs. After the massive raid on Cologne in August 1942, Goebbels found him studying a map of the city, and he confided that the demolished streets would have had to be razed anyway. In 1943, following the heavy raids

on the Ruhr which severely damaged Düsseldorf, Dortmund and Wuppertal, and virtually destroyed the town of Barmen, he remarked that these conurbations were 'not attractive aesthetically' and had needed reconstruction. Beauty mattered more than people. In November 1943 he altered the German strategic plan, giving orders that Florence should not be defended. 'Florence is too beautiful a city to destroy,' he insisted. By contrast 'I do not feel a thing about levelling Kiev, Moscow and Petersburg to the ground . . . In comparison with Russia even Poland is a cultured country.' The same aesthetic standards governed his estimate of individuals. Art and those who produced it were the supreme consideration. 'Really outstanding geniuses', he explained, 'permit themselves no concern for normal human beings.' Their higher mission justified any cruelty. Compared to them, ordinary people were mere 'planetary bacilli'.

The contempt for people embedded in Hitler's art-worship makes it perhaps marginally easier to understand how the ultimate inhumanity of the Holocaust could have been engendered in a nation as rich in culture as 20th-century Germany. The classic study of that development is George Steiner's *In Bluebeard's Castle*. It is a book written in a quandary, and it embraces, as a result, profound contradictions. For Steiner wishes passionately to celebrate the 'incomparable human creativity' of Western art. Yet he is forced to acknowledge that, when tested, it proved useless, or worse. After the Holocaust we can no longer take it as axiomatic that 'the humanities humanize'. Aesthetic sensitivity, we now know, can co-exist with systematic demonic cruelty:

> A fair proportion of the intelligentsia and of the institutions of European civilization – letters, the academy, the performing arts – met inhumanity with varying degrees of welcome. Nothing in the next-door world of Dachau impinged on the great winter cycle of

Beethoven chamber music played in Munich. No canvases came off the museum walls as the butchers strolled reverently past, guide-book in hand . . . We now know . . . that obvious qualities of literate response, of aesthetic feeling, can co-exist with barbaric, politically sadistic behaviour in the same individual. Men such as Hans Frank who administered the 'final solution' in Eastern Europe were avid connoisseurs and, in some instances, performers of Bach and Mozart. We know of personnel in the bureaucracy of the torturers and of the ovens who cultivated a knowledge of Goethe, a love of Rilke.

Why, demands Steiner, should we labour to elaborate and transmit culture if it did so little to stem the inhuman? Great art and music have flourished under totalitarian regimes, and this suggests that culture has always been 'tautological with elitism'. Are not the elevation and transcendence that culture induces essentially irresponsible? Those for whom art is a supreme value are in collusion, in effect, with the 'throwers of napalm', because they look away, and cultivate in themselves a stance of objective sadness or historical relativism. Besides, the assumption that Western culture represents the best that has been said and thought implicitly devalues other cultures. In our post-imperial world it is no more than a 'racially tinged absurdity'.

Having put the case against Western culture with such assurance, however, Steiner starts to retract. With whatever 'penitential hysteria' we blame Western culture for the Holocaust, he insists, it remains true that Western culture is best. 'The manifest centres of philosophic, scientific, poetic force have been situated within the Mediterranean, north European, Anglo-Saxon racial and geographic matrix.' This may, he speculates, be due to climate and nutrition, with higher protein levels producing better brains. Whatever the cause:

> it remains a platitude – or ought to – that for us the world of Plato is not that of the shamans, that Galilean and Newtonian physics

have made a major portion of human reality articulate to the mind, that the inventions of Mozart reach beyond drum-taps and Javanese bells – moving, heavy with the remembrance of other dreams as these are.

The rhetorical sleight of hand that dismisses all non-Western music as 'drum-taps and Javanese bells' scarcely accords with the view that devaluation of non-Western cultures is a racially-tinged absurdity. Pursuing his reoccupation of lost ground, Steiner proceeds to argue that the remorse the West feels about the atrocities it has committed is itself a proof of our racial and cultural superiority. 'What other races have turned in penitence to those whom they once enslaved, what other civilizations have morally indicted the brilliance of their own past?' These rhetorical questions clearly imply that we are outstandingly good at feeling sorry, just as we are outstandingly good at culture. But the questions are hard to answer, partly because the West has so successfully driven other cultures to near extinction (the North and South American Indians, the Australian Aborigines), or to actual extinction (the native Tasmanians, the Cape Hottentots), that we cannot now tell whether they would have been as good at feeling sorry as we are. In any case the argument that, though we may commit atrocities, we repent afterwards, seems weak as a foundation for assertions of cultural supremacy. Nor does it seem clear that even those most steeped in the treasures of Western culture are necessarily as smitten by post-Holocaust remorse as Steiner imagines. John Drummond in his memoir *Tainted by Experience: A Life in the Arts*, recounts how, in 1963, he was making a BBC documentary about Georg Solti's Decca recording of Wagner's *Götterdämmerung* in Vienna, a commission which brought him into close contact with members of the Vienna Philharmonic Orchestra.

> The orchestra was riddled with anti-Semitism . . . When he [Solti] later received the Gold Medal of the Gesellschaft der Musikfreunde for the *Ring* and other opera recordings, practically no one from the professors of the orchestra committee turned up. They all had their excuses – teaching, travel, or prior engagements. On the morning of the presentation day, Solti was telephoned in his room at the Imperial Hotel and a woman's voice said, 'They are not coming because you are a dirty Hungarian Jew.' After receiving the award, as Solti walked along the corridor, the door of the office of Ernst Vobisch, the orchestra's chairman, was open, and all the missing committee members were sitting there having coffee. Vienna doesn't change.

If Western culture truly had the effect Steiner claims, then here at its very heart, among gifted practitioners who are devoted to its daily perfection, in the very country where the Holocaust was engendered, and within two decades of its horrors becoming common knowledge, we should surely find, if anywhere, some evidence of remorse. Drummond's story, on the contrary, shows hatred festering on, unrepented, unassuaged.

In the end, though, Steiner does not stake his claim for culture either on its alleged humanizing influence or on its remorseful promptings. A defence of culture 'made on a purely secular basis' – that is, a defence that had regard to culture's effects in our world – would, he believes, 'have a void at its centre'. The core of a theory of culture must, in his view, be 'religious'. By that he does not mean that culture need have anything to do with belief in a God. Culture is religious, he explains, because the artist or writer aims at immortality. His ambition is to outlast 'the banal democracy of death'. Without this urge for immortality in the artist, and without a corresponding sense in us that artworks partake of immortality, there can be no 'true culture'. The 'divinity' in the artist's mind, as Pindar writes in his *Third Pythian Ode*, which Steiner quotes, 'hungers for a glory that will rise higher hereafter'. Modern ten-

dencies towards the ephemeral – the ideology of the 'happening' (Steiner was writing in 1971), the cult of auto-destructive artifacts – are to be deplored, he warns. If this kind of thing gets a hold 'the core of the very concept of culture will have been broken'. True art must be religious, and what makes it religious is belief in immortality through artistic creation. So Steiner believes.

These arguments seem unsatisfactory. No art is immortal, and no sensible person could believe it was. Neither the human race, nor the planet we inhabit, nor the solar system to which it belongs, will last for ever. From the viewpoint of geological time, the afterlife of any artwork is an eyeblink. This is hardly new knowledge. The Victorians were perfectly accustomed to it. Geology revolutionized thought and feeling in the early 19th century. Its effects spread far beyond the scientific community, destroying established truths, and forcing ordinary men and women to realize that they, and everything they thought of as time and history, were a mere blip in the unimaginable millions of years of the earth's existence. The manifesto of the new science was Charles Lyell's *Principles of Geology* (1830–3) in which Lyell anticipates a time when the present mountain ranges, continents and seas will have disappeared and every single trace of mankind's existence will have been obliterated. These new facts rapidly infiltrated literature. From Tennyson's *In Memoriam* to H. G. Wells's *The Time Machine*, writers persistently reminded the Victorian public of the eventual annihilation of all living species, including the human. In the mid-19th century there was a further scientific advance. The theory of entropy and the eventual heat death of the universe were propounded by German physicist Rudolf Clausius, who had formulated the second law of thermodynamics in 1850.

How can Steiner have overlooked these developments? His talk of 'immortality' suggests that almost two centuries of

Western thought have passed him by. Not that he is alone in his extravagant rhetoric, of course. The trope of immortality is regularly bandied about by admirers of art and other pastimes. As I write, the radio is announcing that the Arsenal football team have 'joined the immortals' by remaining undefeated in the 2003–4 season. It might be pleaded, in Steiner's defence, that his claim that true art is 'immortal' uses the word merely in this banal and vulgar way, and is not seriously intended. But that is clearly not so. His argument that its 'immortality' makes true art religious prevents any such let-out. Once the idea of religion is introduced, it brings with it a meaning of 'immortality' that is not trivial or metaphorical but literal and absolute. In religion, to be immortal means to live eternally with God, even after the world, and the universe, have been destroyed. Whatever we think of such a belief, it is clear that, by comparison, talk of the immortality of art, in the absence of a belief in God, is childish and self-deceiving.

More importantly for our discussion, Steiner's salutation of art's immortality and divinity seems perilously close to the beliefs underlying Hitler's art-worship. That is not to claim, of course, that Steiner is remotely like Hitler. Such a suggestion would be ridiculous. The similarity of their testimonies in this one respect testifies to a widespread Western belief in endurance as a necessary component of art's value. Nevertheless, the similarity is marked. Hitler would have eagerly endorsed the proposition that works of art are immortal, and his classification of normal people as 'planetary bacilli', insignificant by comparison with artistic geniuses, is thoroughly compatible with the reverence for the artist's 'glory', transcending death's 'banal democracy'. Both attitudes devalue ordinary people, particularly inartistic people, or those with 'lower' tastes than oneself. Steiner doubts whether high art can ever be made widely accessible: 'dumped on the mass market,

the products of classic literacy will be thinned and adulterated'. The kind of art the masses can appreciate only serves, he suspects, to make them worse. Their 'tissues of sensibility' are 'numbed or exacerbated' by the throb of popular music, 'pop, folk, or rock', in which they immerse themselves.

As we saw with Clive Bell and Paul Getty, the religion of art regularly engenders these disparaging estimates of other people, and this is one thing that distinguishes it from Christianity, the religion with which Western art has usually twinned itself. Even allowing for Christianity's inbuilt disregard for the damned, pagans and other non-persons, it remains a religion for the uncultured, the unpretentious and the low. All are equal before God's judgement seat. The poor and simple are as likely to receive grace as the mighty who, the *Magnificat* reminds us, will be dethroned, while the humble and meek are exalted.

Given that the poor and simple are always more numerous than the mighty, these considerations inevitably give real religion a wide appeal, and there are other factors that strengthen its hold on the human mind. The evolutionary psychologist Robin Dunbar has recently listed these in his book *The Human Story*. Religion gives its followers a sense of coherence by providing a metaphysical scheme that explains why the world is as it is. Religion allows its followers to feel they have a greater control over the vagaries of life, through prayer and other rituals, than they would otherwise do. Religion provides rules – ethics, moral codes – about how we should behave in society, and has supernatural threats and promises at its disposal to enforce them. The pseudo-religion of art can do none of this.

Religion's strengths account for its virtual ubiquity. All known human societies have embraced it in some form. Its benefits may be physical as well as mental. According to Dunbar, there is evidence that people who belong to an organized religious group can resist disease and cope with life's

traumas better than those with no such communal support. He thinks that various religious practices, such as fasting or communal hymn-singing, stimulate the production of endorphins, the brain's painkillers, and that this in turn stimulates the immune system into greater activity, thus indirectly protecting the body against disease and injury. Admittedly, other activities, unrelated to religion – laughter, for example, and jogging – also stimulate endorphin-production, and the 'uplifting' effect of music may be traceable to the same source. Dunbar describes an experiment in which subjects listened to tapes of music, and indicated when they felt a thrill of excitement at a particular passage. The pattern of thrills varied with each listener but was quite consistent, from one day to the next, for each particular subject. However, when they were given an injection of naloxone, which blocks endorphin production, they failed to experience any thrills the next time the tape was played. This strongly suggests that endorphins are involved in music's 'uplifting' power. The audience queuing for their cyanide capsules after Bruckner's Fourth Symphony were presumably high on endorphins.

However, even if it is found, as may be the case, that other arts too – dance, say, or the rhythms of poetry – stimulate endorphin-production, as religion does, it would still leave art ill-equipped as a substitute religion. It cannot conquer death or offer eternal life. It cannot explain the universe. It cannot enforce a moral code. Consequently it has always been relatively impotent, for good or ill. No one dies or kills for it. It does not inspire suicide bombers. Nor, unlike religion, can it lay claim to a centuries-old global tradition of charity, good works and self-sacrifice. As a religion, in fact, art is simply an idolatrous fake. Perhaps I should add that these remarks are made by someone without religious faith, and are merely an attempt to see the situation impartially.

Art-worship, we have noted, is transcendent. It encourages contempt for the merely human. If that is a false direction for art to take, it might prompt us to ask whether there is an alternative direction – one that avoids art-worship's fallacies. A fruitful approach might be to reverse art-worship's priorities. Art-worship is essentially consumerist. It situates art in picture galleries, concert halls or theatres, where an audience attends passively to receive it. Also, it is inextricably linked to the idea of excellence. It sees art as a triumphal display of iconic masterworks, fashioned by geniuses. If we reverse these two positions we arrive at an idea of art as something done, not consumed, and done by ordinary people, not master-spirits. Among those who have furthered this approach is Ellen Dissanayake, whom we have already met with in Chapter 2, where she was proposing that the concept of art should be widened to take in 'low' activities like home decoration.

Dissanayake is an American, and she is worried about the state of America's young. It seems to her that modern culture has failed them. Suicide is the third highest cause of death among American teenagers, and the teen suicide rate rose 95 per cent between 1970 and 2000. Dissanayake looks for the roots of modern malaise in our evolutionary past. Human needs and expectations evolved over millennia, she observes, in hunter-gatherer societies. That is where most of human history has been spent, and in these societies making things by hand was necessary. This is why manual contact with the natural world is satisfying to us. Pleasure in handling is hard-wired into our brains because our history predisposes us to be tool users and makers. But, Dissanayake regrets, 'our marvellous, long-evolved, specialized hands, which can weave baskets, fashion arrows, or mould vessels, are now chiefly used for pressing buttons on appliances and computer keyboards'. This means that we lose the sense of competence for life that making and handling things gives. She

cites Neil Postman's book *Technopoly: The Surrender of Culture to Technology*, which estimates that between the age of three and eighteen the average young American watches half a million TV commercials. Like all commercials in a capitalist society, these are designed to give watchers a sense not of their competence for life, but of their inadequacy. With great persuasive skill and psychological adroitness, they aim to convince their victims, hour by hour and day by day, of what they lack and must acquire if they are to become enviable and glamorous like the people in the commercials.

Dissanayake's answer to the sense of inferiority and inadequacy this induces is art, but art as doing not watching. She attaches special importance to group arts – song, dance, mime, drama. These are all transient, and signal a different understanding of art's function from the art-worshippers' quest for 'immortality', which she regards as narrowly male and Western. In early societies, and surviving tribal societies, she points out, art's value has no necessary connection with its power to endure. The Owerri, for example, a southern Ibo group in Nigeria, have a practice called *mbari* which involves the construction of a two-storey building full of painted figures. It takes years to make, but is then allowed to crumble away or melt in the rain. Richard L. Anderson has found, similarly, that the Inuits of the North American Arctic, a surviving Stone Age society, make ephemeral artworks of snow and ice, as well as carving figures in ivory and bone. Dissanayake's emphasis on art as a communal activity derives from her theory of art's origins. She believes that it grew from the sounds, play, facial expressions and rhythmic movements of mother-and-baby interaction. This also, as she sees it, builds the adult's ability to feel and express love, which is why adult lovers use baby-language – and not only human adults. Adult hamsters utter contact calls like those of baby hamsters.

Few will question Dissanayake's belief in the importance of mother-infant mutuality, or doubt her claim that it influences the child's and later the adult's capacities for love, for belonging to a social group, for finding and making meaning, and for acquiring a sense of competence through handling and elaborating. True, its connection with art is hard to test. It would be interesting to know whether individuals who were deprived, in babyhood, of the mothering attentions she specifies turn out to be artistically incompetent as well as limited in other ways. But her recommendation of art-as-doing is not dependent on the correctness or otherwise of her theory. Art, she argues, should be for everybody, in schools and communities. The opportunity to participate in art from one's earliest years should be a human birthright.

Other modern thinkers share some of Dissanayake's perceptions. The psychotherapist Rollo May argues in his book *Power and Innocence* that a number of factors in modern life generate feelings of powerlessness, so that people resort to violence as a way of asserting their significance. Acts of violence are performed largely, he notes, by those who are trying to assert or protect their self-esteem, and are oppressed by their own inconsequentiality. This is a common characteristic of all mental patients. Drug addiction is also often an effect of powerlessness, and suicide, as an affirmation of one's right to control one's fate, may be traceable to the same cause. 'No human being', May points out, 'can exist for long without some sense of his own significance.' If this cannot be derived from social status or fulfilling work, then it may be got by shooting a haphazard victim in a street.

It could be argued that violence, expressing feelings of powerlessness, may also account for the disintegration of language in contemporary society. Obscenity is a form of psychic violence, and whereas its use was, until only a few decades back,

restricted to lower-income groups, whose powerlessness was apparent, it has now spread up the social scale as more people have come to feel pressured and driven by the modern world. The remedy for violence, May suggests, is to defeat impotence – to find a way of making every person feel that he counts, and is not 'cast on the dunghill of indifference as a non-person'. Clearly this is problematic. To persuade the poor and starving that they count calls for ingenuity, since they plainly do not, at any rate to those in power. Historically, religion has been the best solution, with its promise that the poor and starving count to God, and that their wrongs will be righted. Art, even as Dissanayake envisages it, cannot compete with this. But if it engages the mind and hands and is not just passive connoisseurship, it can, May believes, go some way towards providing an alternative to violence. The hunger for significance that fuels violence can be deflected into an urge to create.

Richard Sennett in his book *Respect* also regards low self-esteem as a basic cause of modern violence and criminality, as May does, and, like Dissanayake, he favours participation in arts and crafts as a counter-measure. Sennett is no ivory-tower idealist. He grew up on a Chicago welfare housing project terrorized by rival gangs of black and white children, and he trained as a cellist to find his way to something better. Learning an art or craft gives you self-respect, he argues, because ratings and testings are deflected from other people into yourself. You set your own critical standard internally. Dissanayake would agree. She sees art-making as instilling qualities of character such as self-discipline, patience, and delay of immediate gratification.

In England, however, public policy has not favoured the view that the making of art should be spread through the community. When the Council for the Encouragement of Music and the Arts, which later became the Arts Council, was set up in 1940, it

had to choose between promoting art by the people or art for the people. Should central government funding of the arts encourage us in using our 'marvellous, long-evolved, specialized hands', or should it turn us into passive art-worshippers? The Council chose the latter course. The mandarin aesthetes among its members, headed by Kenneth Clark, who saw the arts as essentially a professional activity, prevailed. W. E. Williams, the Secretary General of the Arts Council, in his 1956 Report, made it quite clear that the Council envisaged art as enshrined in showpieces of national pride, precisely of the kind Hitler had planned to build. 'The Arts Council believes, then, that the first claim upon its attention and assistance is that of maintaining in London and the larger cities effective power-houses of opera, music and drama; for unless these quality institutions can be maintained, the arts are bound to decline into mediocrity.' The image of 'power-houses' is revealing. Art is to be beamed out to consumers like electricity. All they have to do is switch it on. It is not something that arises from them and from the cultivation of their abilities.

Robert Hewison relates this sorry history in his powerfully antagonistic book *Culture and Consensus: England, Art and Politics since 1940*. He sees the Arts Council as, from its inception, elitist both in its make-up and in its policies. The American sociologist John Harris pointed out in 1970 that there were few differences in the social background of the Labour and Conservative appointees to the Arts Council, except that Labour appointed more from the top twenty public schools. Almost none were of working-class origin. The millionaire Peter Palumbo attracted public attention when, as head of the Council, he spent £100,000 of his own money decorating his offices. He was succeeded by Lord Gowrie, who had resigned as Minister for the Arts, saying he could not live on his salary of £33,000. The image of the arts as the preserve of the wealthy was

intensified, Hewison points out, by the colossal allocations of public funds to the Royal Opera House, and by showpiece events such as opera at Glyndebourne and Shakespeare at the Barbican, which became celebrations of the professional art establishment's ownership of cultural activity. At the start of the 1980s the Arts Council solved the problem of amateur-versus-professional by announcing that, because resources were so stretched, in future only professionals would receive Arts Council funding. Between 1989 and 1994, following the recommendations of the Wilding Report, all but 125 of the Arts Council's clients were devolved to the new Regional Arts Boards, leaving the Arts Council responsible only for 'national' companies.

Hewison's remarkable book is deficient in only one respect. It assumes that the arts have a moral and educative effect, but brings forward no evidence to support the assumption, or to explain what the effect might be. In the Thatcher years, he complains, it became official policy to regard the arts as part of the 'culture industry', to be justified, if at all, on economic grounds. Arguments for support based on their 'educational value and intrinsic worth' lost their force. He persistently regrets the disappearance of such justifications, and emphasizes the need for them. 'What is needed is plainly a new argument for the arts.' 'We need to develop a value system which not only asserts, but guarantees, the existence of a common interest in the health of the arts.' But it is one thing to declare a need, and quite another to satisfy it. Hewison's book contains no new argument for the arts, only broad and unsubstantiated claims. 'Culture', he declares, 'of which the work of artists is the most easily identifiable manifestation, is the shaping moral medium for all society's activities, including the economic.' But he does not make even the most tentative gesture towards showing how culture – pictures, literature, music –

does in fact shape what people do and how they behave. He does not so much as consider the question of how a dynamic interest in 'the health of the arts' in Hitler's Germany became the 'shaping moral medium' for the Holocaust. Nor does he examine how the 'shaping moral medium' of the arts affects their practitioners, such as the members of the Vienna Philharmonic Orchestra in Drummond's anecdote.

Hewison is hardly to blame. The art-world has paid almost no attention to how active participation in art alters people. An exception is the small, specialized section of the art-world who take art into prisons. In effect, their activities submit the theories of Dissanayake, May and Sennett to experimental testing, and in the least auspicious conditions. Two-thirds of the prisoners in British prisons are illiterate or innumerate, or both, to a degree that makes them virtually unemployable in the outside world. Excluded, on release, from jobs, incomes and possessions, they have no alternative but to re-offend. Crime offers instant access to rewards, or to the means – drugs, alcohol – of escaping the reality of social exclusion. It follows that those who take art into prisons are confronted with an unpromising clientele. They also face opposition from prison officers and others who insist, understandably, that acquiring literacy and numeracy is far more important to prisoners than developing an interest in art. All this makes the success they have met with the more remarkable. A number of them have written of their experiences in *Including the Arts: The Route to Basic and Key Skills in Prisons*, published in 2001, and now out of print, though fortunately available on the Internet.

The book's central statement is made by Professor Robert Graef, a criminologist. Like Rollo May, he argues that violence is a form of expression – an outlet for pent-up anger and frustration, and the visible form of 'an intense longing to make an impact, a need to be noticed'. Like May, too, he believes that

art, as well as crime, is an expression of violence. Being full of violence, prisons are, to this degree, ideal arenas for art, and Graef has found, working with prisoners, that art can accommodate their violent feelings in a way that does not harm other people, and enhances their lives instead of damaging them. Art 'can break the cycle of violence and fear'. Taking part in the making of art 'dramatically improves inmates' attitudes and behaviour both in the short and long term'. Performance in operas, musicals and dramas 'gives voice to anguish, pain and confusion that each inmate felt was only their private hell'. Graef tells the story of a lifer – a former carpenter who had become a serial killer, and who had not spoken for fourteen years. Somehow he got caught up in an art class and discovered he could draw. He began to do likenesses of fellow-prisoners, which were sent home to wives and partners. Soon he was taking commissions for portraits. He started to speak, and to take a constructive part in prison activities. It is essential, Graef concludes, if people are to live peacefully in the world, that they renounce violence and learn to express themselves without it. Art is 'the single most powerful tool' for effecting this change.

Pauline Gladstone and Angus McLewin, in their chapter on drama-based arts in prison, endorse this claim. A wide range of drama companies currently work in prisons – Clean Break Theatre Company (in women's prisons), The Comedy School, the London Shakespeare Workout and others. Geese Theatre runs a five-day course of plays and workshops with violent offenders, which allows them to act out violence and examine the cognitive processes behind it. Post-course evaluations have shown a 20 per cent reduction in the propensity to violent or hostile feelings and expressions. In 1999, prisoners at HMP Bullingdon, with help from the Irene Taylor Trust, put on a musical version of *Julius Caesar*. The Prison Adjudication Sheets of those who took part showed a 58 per cent reduction in

offending behaviour from six months before to six months following the project.

Spectators at prison drama productions are left in no doubt that ideas about art as a lightning conductor for violence have real substance. Libby Purves, attending an adapted *Macbeth* put on in Pentonville by London Shakespeare Workout, writes:

> It made your hair stand on end from the first moment when a dozen men flung themselves on the floor and crawled hissing like Gollum around our feet . . . This circle of men play the emotion of the piece: they are the witches and the clowns but also the temptations, the spirits of cruelty conjured by Lady Macbeth, the physical symbols of compulsion, remorse and the mocking, snarling violence in the human heart which – as any prisoner knows – can turn either outwards or inwards.

Talking to the actors afterwards, Purves finds that they are alive to the power of whatever it is that has taken them over – 'It's very intense, very. It carries you' – and want to do something like it themselves: 'I'm going to try and write something. It's opened up my head.' Lives are changed. LSW keeps in touch with prisoners after their release. Ex-offenders come back and take part in productions, including the one Purves watched.

Besides providing a means of mastering violence, the arts in prison build self-confidence and self-esteem. All the contributors to *Including the Arts* stress this. Routine prison education-classes often do the opposite, confronting prisoners with their inabilities. But the arts are different. As Gladstone and McLewin put it, they 'start from where people are'. They are accessible to almost everyone. They give many offenders their first experience of a positive and absorbing activity and, through contact with an arts educator, their first link with someone who is interested in what they can do rather than what they cannot. The confidence gained can, in turn, improve performance in numeracy and literacy classes. The same point

is made by Dorothy Salmon, writing for the Koestler Trust. Founded by Arthur Koestler with the help of Home Secretary R. A. Butler, the Trust runs an extensive range of activities in Britain's prisons, special hospitals and young offenders' institutions. It now embraces fifty-eight categories of arts and crafts, ranging from musical composition, poetry and playwriting to computer skills and construction industry training. A Koestler Awards Scheme for the arts was introduced into prisons in 1961, and the winning entries are shown at an annual exhibition of paintings, drawings, prints, embroidery and other craftwork in London. Judgements of quality are subjective, of course, but as someone who has visited and bought artwork at one of these exhibitions, I should say that it would be impossible, walking round, to know that you were not at the annual show of some rather high-grade local art society in a prosperous commuter suburb. But in any case 'quality' is not the point. Secretary General of the Arts Council W. E. Williams's fear that art will 'decline into mediocrity' if the 'quality institutions' are not maintained envisages art as some kind of competitive sport, requiring regular injections of public money to keep standards up. Art is what matters to the Arts Council, Williams makes clear, not people. Prison-art's priorities are the opposite. It is not what you paint on a piece of canvas that counts, but what painting a piece of canvas can do to you.

The success of art in prison may not, it is true, be solely attributable to art. Simply to be treated as a human being, and to co-operate on friendly terms with cultured, educated people, could be a transforming experience for prisoners if they were being taught first aid or fly-fishing rather than art. Clive Hopwood, in his chapter on the Writers in Residence in Prisons scheme, recognizes that getting the undivided attention of a real live professional writer for a thirty-minute session is itself a boost to the self-valuation of someone who has been

told all his life that he is a failure and has let his loved ones down. Nor is the friendliness prisoners respond to fake. 'We outsiders felt it was important to actually make friends with the people with whom we were working,' writes Jason Shenai, who ran a photography course in HMP Wandsworth in the 1990s. 'Some of the prisoners have remained friends now that they have been released.' However, though being treated as a human being can undoubtedly be a transforming experience, art seems to give prisoners something else as well. Graef's point about art as the expression of violence points to a psychological gain that goes beyond social acceptance.

Another possible objection to the claims of the art-in-prison lobby is that what prisoners respond to is not art but its social cachet. They recognize that people with culture are respected, and since they want respect they adopt culture as a means to it. That may be true. But the motives behind culture-acquisition are, for anyone, intricately obscure. The South African novelist J. M. Coetzee, Professor of Literature at the University of Cape Town, recounts how one summer afternoon in 1955, when he was fifteen, he was mooning around in his family's back garden in the suburbs of Cape Town when he heard music from the house next door. It was, though he did not know it at the time, a recording of Bach's *Well-Tempered Clavier*, played on the harpsichord. 'As long as the music lasted, I was frozen. I dared not breathe. I was being spoken to by the music, as music had never spoken to me before.' He did not come from a musical family, and musical instruction was not offered at school. Nor would he have taken it if it had been offered, as classical music, in his social orbit, was regarded as sissy. Then came the moment in the garden, and his life changed. But what, in fact, was he responding to?

The question I put to myself, somewhat crudely, is this: is there some non-vacuous sense in which I can say that the spirit of Bach

was speaking to me across the ages, across the seas, putting before me certain ideals; or was what was really going on at that moment that I was symbolically electing high European culture, and command of the codes of that culture, as a route that would take me out of my class position in white South African society?

One would be deluded, says Coetzee, to imagine one could answer that question about oneself, and we should be equally deluded to imagine we can answer it about prisoners on art-schemes. Nor does it matter. If art is valuable in prisons because it gives self-respect, there seems no point in agonizing over exactly how the self-respect filters through the maze of social and cultural self-positionings embedded in everyone's mind. Self-respect is self-respect, whether it comes from enjoying classical music and painting, or from realizing that enjoying them puts you on a level with people you have previously felt inferior to.

The same question is raised by the case-studies in Jonathan Rose's fascinating and original book *The Intellectual Life of the British Working Classes*. To gather materials for this study Rose read hundreds of working-class autobiographies from the late 19th and early 20th centuries, mostly unpublished, and explored oral-history archives, social surveys and library records. The people he investigated – housemaids, weavers, cotton-mill workers, shoemakers, miners, fishermen – had been largely excluded from formal education, except of the most elementary kind, but had managed, by tenacity and individual initiative, to break through to the world of literature and art. They often rapturously recall the life-changing moment, similar to Coetzee's, when they first picked up a book and embarked on their odysseys of self-education. 'It was like coming up from the bottom of the ocean and seeing the universe for the first time,' exults a cowman's son. A charwoman, who never had time to read until her last illness, devours the complete

works of Shakespeare, and asks that the corneas of her eyes should be used to enable someone else to read. Rose's subjects often testify that it was only through reading that they came to think of themselves as individuals. For a Birmingham factory hand, Everyman's Library's cheap classics brought 'self-realization'. Reading *Tess of the d'Urbervilles*, with its working-class heroine, gave a downtrodden housemaid the sense that she was a 'person in her own right', even when her employers treated her as if she did not exist: 'This book made me feel human.' The housemaid's gain in self-respect, like the gain in self-respect of prisoners on art-schemes, fuses social, cultural and aesthetic elements, and trying to separate them out would be futile.

Of course, there is no guarantee that art education will transform a violent criminal into a peace-loving citizen. Sceptics point to celebrated cases where the treatment has failed to work. In 1978 Norman Mailer began a correspondence with a convicted killer, Jack Henry Abbott, who was imprisoned in Utah. Abbott had been a criminal since childhood, and had spent most of his life behind bars. Mailer came to admire him both as a writer and as 'a potential leader, a man obsessed with a vision of more elevated human relations'. His prison letters to Mailer were published as the best-selling *In the Belly of the Beast* (1981), and when he came up for parole Mailer wrote to the Utah authorities on his behalf. Transferred to a New York halfway-house, Abbott became the darling of Manhattan literary society, the guest of honour at celebratory dinners, and the subject of stories in *People* magazine and *Good Morning America*. But six weeks after his transfer to New York, despite his vision of more elevated human relations, he stabbed to death a twenty-two-year-old actor and writer Richard Adan. The newly-married manager of his father-in-law's Greenwich Village restaurant, Adan had made the mistake of telling Abbott that the washroom was for the use of staff not customers. Abbott received a fifteen-

year sentence and wrote a second book, *My Return* (1987), in prison, where he depicted himself as a victim of the judicial system, and complained that he 'would just like an apology of some sort'. When he applied for parole in 2001, he expressed no remorse for Adan's death. Parole was refused, and he hanged himself in prison in February 2002.

A more recent case in Sweden in 1999 involved Lans Noren, the country's most famous playwright. When three prisoners wrote asking him to help them choose a play for the dramatic studio they had in prison, he went to see them, listened to their stories, and wrote a play for them to act in which allowed them to give vent to their extreme neo-Nazi views. They were granted leave to go on tour with Noren's play, as this was regarded as a chance to rehabilitate them. After what turned out to be the play's final performance, however, one of the prisoners absconded, met up with two other neo-Nazis, and murdered two policemen.

These cases are shocking. But they are also unusual, and could diminish the case for art education in prisons only in the mind of someone already determined to rubbish it. What is more worrying is the difficulty prisoners have in keeping their interest in art alive after release. The Arts Council's historic fear that art would decline into mediocrity if it was disseminated among ordinary people continues to be reflected in the contrast between the opportunities offered for art in prison and the lack of them outside. Peter Cameron, an ex-offender who took a Koestler Trust course in prison, and is now a professional artist, testifies to this in his contribution to *Including the Arts*:

> It is important to grasp the fact that it is easier to take up arts activities inside than it is outside. Art is something that would bypass most people in their normal lives. I have spoken to many inmates and former inmates who have said exactly this – they never knew they liked or valued art – it had never been on the menu.

It is not only the difficulty of getting hold of materials that turns people off art after leaving prison. The arts feel accessible in prison because of personal contact with writers and artists. But on release ex-offenders find the art-world 'elitist', and its 'posh buildings' intimidating. The result is predictable. Research shows that while prisoners engage actively in the arts on the inside, this is rarely continued beyond prison.

Another group of people who suffer from low self-esteem, and may be helped by art, are depressives. Depression is thought to affect one in five people in Britain at some stage in their lives, and antidepressant drugs like Prozac and Seroxat are notoriously over-prescribed. Some 72 per cent of GPs said that they prescribed more antidepressants in 2004 than they did five years before, and the long-term side-effects are causing concern. A project in the Kirklees and Calderdale areas of West Yorkshire promotes reading as an alternative to drugs. It employs seven bibliotherapists, who aim to boost self-esteem through one-to-one book-advice surgeries, conversations about books, and group readings. Patients are referred to them by community psychiatric nurses, health visitors, social workers and GPs. As with art-in-prison projects, those who benefit have a sense of self-discovery. 'It brought something out in me that I didn't know I had,' said one middle-aged man, who had never been 'much of a reader' before, and had suffered from severe paranoia and depression for many years. Compared to the painting and craftwork encouraged by art-in-prison, reading might seem passive. But in reality it is creative, as bibiotherapist John Duffy explains: 'The written word lets you create pictures in your own head. Any one book offers people many different things.' I shall return to this point in Chapter 7.

In the first chapter I argued that to find out what a work of art is we no longer go to connoisseurs or pundits or the 'art-world'. We decide ourselves. The concept of art has extended

beyond anyone's control or permission. Anything can be art, if we think it is. In this chapter I have been suggesting that the practice of art and the funding of it should extend too. It should not be kept in 'power-houses' in big cities but spread through the community. Every child in every school should have a chance to paint and model and sculpt and sing and dance and act and play every instrument in the orchestra, to see if that is where he or she will find joy and fulfilment and self-respect as many others have found it. Of course it will be expensive – very, very expensive. But then, so are prisons. Perhaps if more money had been spent on, more imagination and effort devoted to, more government initiative directed towards art in schools and art in the community, Britain's prisons would not now be so overcrowded. Perhaps if the fledgling Arts Council had decided, at that crucial, never-to-come-again moment at the end of the Second World War, that community art was its remit, not showpiece art, the whole history of post-war Britain, and all our preconceptions about what art is, would have been different. The religion of art makes people worse, because it encourages contempt for those considered inartistic. We now know that it can foster hideous and earth-shattering evil. It is time we gave active art a chance to make us better.

Another thing we should do, I would suggest, is to switch the aim of research in the arts to finding out not what critics think about this or that artwork – which is necessarily only of limited and personal interest – but how art has affected and changed other people's lives. Ever since Aristotle, critics have spun their theories, but they have very seldom recorded how people feel about art, what they like, whether it has altered the way they think and behave. The history of audiences and readerships is largely a blank. Arts research needs to change direction, to look outwards, and – following the example of Laski and Bourdieu – investigate the audience not the texts. It needs to link up with

sociology and psychology and public health, and create a body of knowledge about what the arts actually do to people. Until that happens, we cannot even pretend that we are taking the arts seriously.

# The Case for Literature

# Literature and critical intelligence

So far this book has questioned the existence of absolute values. It has argued that to call something a work of art is to express a personal opinion. There is no transcendental category, occupied by 'true' works of art. Consequently, debates about whether this or that object belongs to such a category are meaningless. It has argued, too, that since other people's states of mind are inaccessible to us, we have no means of evaluating them. It is self-deception to imagine that our feelings, when we are in contact with what we consider 'true' art, are more valuable than the feelings others derive from 'low' or 'false' art, or from pursuits we should not consider art at all. Indeed, to claim that our feelings are, in an absolute sense, more valuable than someone else's (as opposed to simply more valuable to us) does not make sense, and would not do so even supposing we could have complete knowledge of another person's consciousness. It might, in theory, be possible to demonstrate that exposure to certain kinds of art makes people better – or worse. However, evidence for this, though earnestly sought, has to date proved elusive. Quite apart from the problem of agreeing on meanings for 'better' and 'worse' in this context, psychologists and educationalists find no reliable connections at all between artistic appreciation and behaviour.

If the situation in aesthetics is as I have outlined it, it does not differ very greatly from our current situation in ethics. Of

course, as I said at the start of this book, aesthetic questions can rapidly be settled (at least, to our personal satisfaction) if we believe in a God or gods with aesthetic interests. Similarly, belief in a God who sanctions a particular moral code will settle moral questions – at any rate in the opinion of the believer. However, this book's remit is secular, not religious, and once belief in a God is removed, moral questions, like aesthetic questions, become endlessly disputable. Indeed, moral questions could be defined as questions to which no answers are available. Consequently, agreement about them is not to be expected. In this they differ from scientific or mathematical questions. Disagreement is, in other words, a necessary condition for the existence of ethics as an area of discourse. We have only to consider perennial moral polarizers like abortion or capital punishment or human cloning to realize that hopes of a 'consensus' on such issues are illusory, and that there is no 'middle way' – a foetus is either aborted or not, a condemned criminal either alive or dead. The existence of different religions, with different moral codes, serves to intensify disagreement over a whole range of ethical questions, as the events of 11 September 2001 and their global repercussions have reminded us.

However, though ethical questions are by their nature insoluble, we cannot avoid making decisions about them. Treatment of other people in our everyday lives necessitates constant moral decisions, though, because they issue from our cultural indoctrination and upbringing, they may seem natural and involuntary. We are unlikely, too, to remain neutral on ethical issues more remote from our daily life – whether, for example, slavery or child prostitution are desirable social arrangements, or whether democracy or dictatorship are preferable political systems, or whether women should be allowed to drive cars or wear Western clothes. There is no global agreement on these issues, and no reason for supposing there

ever will be, but we must decide where we stand. In aesthetics, likewise, though there are no absolutes, we have to choose. Even choosing to have no interest in art at all is a choice. But though preferences between arts, and decisions about what a work of art is, are personal choices, that does not mean that they are unimportant. On the contrary, like ethical choices, they shape our lives. Nor does it mean that they are unalterable. Just as we can be argued out of or into moral convictions (as, for example, in cases of religious conversion), so our aesthetic preferences may change. This may be sudden and drastic, like J. M.Coetzee's life-altering exposure to Bach. Or it may be the result of gradual discovery and persuasion – a process we generally call education.

To parents, or anyone the young look to for direction, this is a vital consideration. If we believe our lives have been enriched by any activity, artistic or otherwise, we will naturally want to ensure that our children share it. Communicating our enthusiasm will help, of course. But interrogating ourselves, to discover what we value and, if possible, why, will also be advisable, if only to forestall the interrogations of the sceptical young. In the rest of this book I intend to make out the case for valuing literature, taking examples for the most part, but not exclusively, from English literature – a branch of knowledge which, in recent years, has been progressively devalued in schools and universities, and regarded as rather shamefully parochial and old-world compared to, say, media studies or cultural history. In opposition to this, I shall also try to show why literature is superior to the other arts, and can do things they cannot do. Just in case anyone should seize on these aims as inconsistent with the relativist cast of the first part of my book, let me emphasize that all the judgements made in this part, including the judgement of what 'literature' is, are inevitably subjective. My definition of literature is writing that

I want to remember – not for its content alone, as one might want to remember a computer manual, but for itself: those particular words in that particular order. Like all criticism of art or literature my judgements are camouflaged autobiography, arising from a lifetime's encounters with words and people that are mostly far too complicated for me to unravel. They may, of course, persuade some or all of my readers, and I hope they do. But this will not show that they are true, only that they are persuasive. We cannot talk of truth and falsehood except where proof is available, and where proof is available persuasion is not needed.

The first claim I would make for literature is that, unlike the other arts, it can criticize itself. Pieces of music can parody other pieces, and paintings can caricature paintings. But this does not amount to a total rejection of music or painting. Literature, however, can totally reject literature, and in this it shows itself more powerful and self-aware than any other art. An example might be taken from Jean-Paul Sartre's *What Is Literature?*

> It must be borne in mind that most critics are men who have not had much luck and who, just about the time they were growing desperate, found a quiet little job as cemetery watchmen. God knows whether cemeteries are peaceful; none of them are more cheerful than a library. The dead are there; the only thing they have done is write. They have long since been washed clean of the sin of living, and besides, their lives are known only through other books which other dead men have written about them . . . The trouble-makers have disappeared; all that remains are the little coffins that are stacked on shelves along the walls like urns in a columbarium. The critic lives badly; his wife does not appreciate him as she ought to; his children are ungrateful; the first of the month is hard on him. But it is always possible for him to enter his library, take down a book from the shelf, and open it. It gives off a slight odour of the cellar, and a strange operation begins which he has decided to call

reading ... Written by a dead man about dead things, the book no longer has any place on this earth; it speaks of nothing which interests us directly. Left to itself, it falls back and collapses; there remain only ink spots on musty paper. And when the critic reanimates these spots, when he makes letters and words of them, they speak to him of passions which he does not feel, of bursts of anger without objects, of dead fears and hopes.

You may protest, rightly, that Sartre is not being fair. His 'critic' is a satirical construct, and his nagging wife and unlovely children (one of them, it transpires, as Sartre elaborates his fiction, is a hunchback) are extraneous to the issue he is supposed to be addressing. But fairness is not the point. Sartre is using all the arts of literature to reject literature. He puts the case that the literature of the past is irrelevant, dead, and only for losers, and he does so as confidently as any sozzled clubber or idealistic modern schoolteacher – though with more wit and intelligence.

Sartre is not alone. Writers reject writing and reading in many different ways and for all sorts of reasons. John Milton, in *Paradise Regained*, puts his rejection of books into the mouth of the Son of God – an authority hard to contradict. The scene is the wilderness, where Satan is tempting Jesus with various offers – among them, knowledge of all that the ancient philosophers have written. Jesus, an unknown boy from Bethlehem, will become, at one stroke of the Satanic wand, a walking library. But, being Jesus, he calmly rejects Satan's proposal.

> ... many books
> Wise men have said are wearisome; who reads
> Incessantly, and to his reading brings not
> A spirit or judgement equal or superior,
> (And what he brings, what needs he elsewhere seek)
> Uncertain and unsettled still remains,
> Deep-versed in books and shallow in himself.
>
> [IV, 321–7]

So . . . reading will do you no good unless you have a spirit and judgement equal or superior to the books you read. And if you have that already, you do not need to read books. Conclusion: reading is either harmful or unnecessary. Milton, of course, read voraciously till he went blind, and Sartre was equally addicted. Their inconsistency or self-contradiction is not a flaw for us to 'deconstruct' and crow over, but a condition of the ruthless power of the art they practise – literature – which operates not just to delight like painting or music or dancing, but to question everything including itself. A third example – there are many – might come from Wordsworth:

> Books! 'tis a dull and endless strife:
> Come, hear the woodland linnet,
> How sweet his music! On my life,
> There's more of wisdom in it.
>
> And hark! How blithe the throstle sings!
> He, too, is no mean preacher:
> Come forth into the light of things,
> Let Nature be your teacher.
>
> She has a world of ready wealth,
> Our minds and hearts to bless –
> Spontaneous wisdom breathed by health,
> Truth breathed by cheerfulness.
>
> One impulse from a vernal wood
> May teach you more of man,
> Of moral evil and of good,
> Than all the sages can.
>
> Sweet is the lore which Nature brings;
> Our meddling intellect
> Mis-shapes the beauteous forms of things:–
> We murder to dissect.
>
> Enough of Science and of Art;
> Close up those barren leaves;

> Come forth, and bring with you a heart
> That watches and receives.

This poem against books was, contrarily, published in a book. But that means only that Wordsworth was not locked in a consistent world-view. The poem is about getting out. Its cheerful, holiday rhythms can conceal, if we read carelessly, the astonishing educational claim it makes, which is that just being in a wood in springtime, and hearing birdsong, can teach you about – not ornithology or botany – but morals. It can teach you more about good and evil than has ever been written about them. Wordsworth meant it seriously, just as he believed seriously that 'every flower/ Enjoys the air it breathes'. Being at one with nature, among the unbarren leaves, was for him like prayer, and like prayer did not need books, or even words, to do its transforming work.

Literature is not just the only art that can criticize itself, it is the only art, I would argue, that can criticize anything, because it is the only art capable of reasoning. Of course, paintings can convey implicit criticism – Hogarth's *The Gate of Calais*, say, or Ford Madox Brown's *Work*. But they cannot make out a coherent critical case. They are locked in inarticulacy. Operas and films can criticize, but only because they steal words from literature, which allow them to enter the rational world. When literature criticizes other arts its target is often their irrationality. Tolstoy's dead-pan description of an opera in *War and Peace* is a classic example:

> Smooth boards formed the centre of the stage, at the sides stood painted canvas representing trees, and in the background was a cloth stretched over boards. In the middle of the stage sat some girls in red bodices and white petticoats. One extremely fat girl in a white silk dress was sitting apart on a low bench, to the back of which a piece of green cardboard was glued. They were all singing something. When they had finished their chorus a girl in white advanced

towards the prompter's box, and a man with stout legs encased in silk tights, a plume in his cap and a dagger at his waist, went up to her and began to sing and wave his arms about.

And so on. Music is the art that has most consistently seemed irrational to poets and writers. We now know, as writers of the past did not, that language and music activate different hemispheres of the brain – music, the right hemisphere; language, the left. But even in the absence of this knowledge, the antipathy between the two activities has been felt. Milton, in a Latin poem addressed to his father, who was a musician, complains that, unless it is used as an accompaniment to words, music is as meaningless as birdsong. By itself it is inane and senseless ('*inane . . . sensusque vacans*'). It does not engage the reason, and reason, for Milton, links man with God. (Milton was, incidentally, a keen instrumentalist, but literature's self-critical faculty applies here too.) Settembrini, the philosopher in Thomas Mann's *The Magic Mountain*, disparages music on similar grounds. It is 'irresponsible' and 'inexpressive'. Words are 'the gleaming ploughshare of progress'. They can bring about political change. But music cannot. 'Let music play her loftiest role, she will thereby but kindle the emotions, whereas what concerns us is to awaken the reason.' Mann was profoundly interested in music. But that does not make Settembrini just a joke. He puts an alternative view, continuing the ceaseless reappraisal of opinions that literature consists of.

There is plenty of literature in praise of music too, of course, as E. M. Forster's Bloomsburyish raptures in *Howards End* remind us ('It will be generally admitted that Beethoven's Fifth Symphony is the most sublime noise that has ever penetrated into the ear of man'). Indeed, for some writers it is precisely being empty of meaning that makes music good. Meaning limits. To mean one thing is to exclude everything else. But music leaves listeners free to make up their own meanings as they go

along. As we saw in Chapter 3, surveys reveal that the same piece of music stimulates all sorts of different trains of thought in its audience. Forster, for example, thinks Beethoven's Fifth is about goblins, as *Howards End* reveals. Because it can accommodate their own thoughts, listeners can feel that music is also expressing their own emotions. The novelist DBC Pierre recounts how this off-the-peg adaptability, peculiar to music, once saved his life. Broke, dodging bailiffs and battling depression, he was on the edge of suicide when he heard a symphony on his radio one night. He thinks it was Howard Hanson's Symphony Number 2, 'The Romantic':

> I realized my feelings were being set to music. I froze, and heard every detail of my turmoil being painted in the symphony. The music acknowledged tumult, contradiction, confusion, fear and the ultimate conquest of the dark plains of psyche and soul. It announced that misery was life's default, and beckoned me to stay close to it, proposing conflict to be a sweet and human thing, a many-textured set of riddles that needed recourse to nothing but a working nervous system.

So he did not kill himself.

English literature does not go in much for art-worship of the mystical, Hitlerish kind. True, Walter Pater's famous vapourings about the *Mona Lisa* testify to an outbreak of it in the later 19th century. But Dickens's Mrs Wititterly in *Nicholas Nickleby* represents literature's more usual scepticism about such flights. Prostrate on her sofa, Mrs Wititterly is a martyr to sensibility. She is so excited, her husband explains, by the opera, the drama and the fine arts that it takes the strength from her legs. The doctors diagnose her complaint as too much soul. Essentially the same suspicion of art, and its inflating effect on the ego, drives Browning's anti-art poems. He knew more about art than almost any other 19th-century writer, but he nearly always associates it with anxiety and crime. His Italian grandees ooze malig-

nancy like brake-fluid, yet their munificence funds the master-works of the high Renaissance. The Duke in 'My Last Duchess' shows off his late wife's portrait to a visitor and reveals in passing – secure in the aristocratic grandeur that protects him from retribution – that he had her murdered. It was not for any misdeed, exactly, but because she was 'too soon made glad'. She would smile and be courteous to social inferiors:

> as if she ranked
> My gift of a nine-hundred-years-old name
> With anybody's gift . . .
> Oh sir, she smiled, no doubt,
> Whene'er I passed her; but who passed without
> Much the same smile? This grew; I gave commands;
> Then all smiles stopped together. There she stands
> As if alive.

Browning means us to see the irony of 'As if alive' – an irony that cuts at those who prefer the deadness of art to life. As they leave the apartment, the Duke indicates another piece of treasured deadness:

> Notice Neptune, though,
> Taming a sea-horse, thought a rarity,
> Which Claus of Innsbruck cast in bronze for me.

A super-being subduing nature, the bronze suitably bespeaks the Duke's preferences. Browning would not have been surprised by Hitler. He shows repeatedly how art destroys its worshipper's human core, and leaves a monster. His bishop, planning the decorations for his tomb in St Praxed's church, combines art-worship and cruelty, holiness and racism, Christianity and paganism, impotence and lust, in a single poisonous amalgam:

> Some lump, ah God, of *lapis lazuli*,
> Big as a Jew's head cut off at the nape,

Blue as a vein o'er the Madonna's breast . . .
Saint Praxed in a glory, and one Pan
Ready to twitch the nymph's last garment off,
And Moses with the tables . . .

The bishop subscribes wholeheartedly to the Steineresque ideal of immortality – art's power to outlive life – and it makes the flesh creep.

Only literature can criticize, then. Further, only literature can moralize. Nowadays this is frowned on. Literature, we are advised, should show not tell. It should work obliquely, through narrative. This is rather like saying that Christ would have done better to stick to parables – the Good Samaritan, the Prodigal Son – instead of announcing, with tactless directness, that it is easier for a camel to go through the eye of a needle than for a rich man to enter the kingdom of heaven. However, Christ used both modes, and so does literature. Our hunger for narratives is understandable. They allow us to escape, for a while, from the narrative of our own lives that we are condemned to. But narrative, unlike moralizing, is not unique to literature. Dance can enact a narrative, though it cannot comment on it, as literature can – and it is when it starts commenting that literature moralizes.

In the rest of this chapter I shall look at how literature moralizes, and how its moralizing is diverse and contradictory. To illustrate the diversity I shall take pairs of writers from different historical periods, starting with the 17th century. You could easily start earlier. There are tempting instances in the Middle Ages. In Chaucer's Pardoner's Tale, for example, three young drunks swear, when they hear that one of their friends has died, that they will seek out Death and kill him. Of course, they all end up dead. In its ridicule of simple, violent solutions, this could be read as a satire on George Bush's America and the 'War on Terror', penned a century before America was discov-

ered. But generally moralizing was so entangled with Christianity in the Middle Ages that it scarcely existed as a separate form. It was the revival of classical scepticism and the new interest in scientific observation that, at the end of the 16th century, made moralizing new and challenging. Scepticism tells us that we cannot know anything, because we are caught in our own subjectivity. John Donne, writing to a friend, puzzles over this, when discussing the difference between diseases of the body and diseases of the mind. Bodily diseases, he reasons, can be at least partly understood. Physicians can observe and diagnose. They know what a healthy body is like, and can recognize when it is malfunctioning.

> But of the diseases of the mind there is no criterion, no canon, no rule, for our own taste and apprehension and interpretation should be the judge, and that is the disease itself.

To take a proper, diagnostic look at your own mind, Donne reasons, you would need to get outside your own mind – and that cannot be done. The instrument you must use to probe your mind is already bent, for it is your mind.

This is a salutary reminder to critics of literature and the other arts that their preferences are unrelated to any objective 'truth', and by the same token the pieces of moralizing I am going to select in this section (and, for that matter, all the literary examples I cite in this half of the book) are ones that happen to appeal to me. Not surprisingly, they also concur, as the Donne quotation does, with some of the positions taken up in this book's first part. The inaccessibility of other people's minds, for example, is spelt out early in the 17th century by Sir Thomas Browne in *Religio Medici*, together with a recognition that objective truth is unavailable:

> No man can justly censure or condemn another, because indeed no man truly knows another. This I perceive in myself, for I am in the

dark to all the world, and my nearest friends behold me but in a cloud . . . Further, no man can judge another, because no man knows himself; for we censure others but as they disagree from that humour which we fancy laudable in ourselves, and commend others but for that wherein they seem to quadrate and consent with us. So that in conclusion, all is but that we all condemn, self-love.

Browne feels he has a centre of self, hidden even from friends, so he credits others with the same. He was an obscure physician, living in Norwich, and his thoughtfulness derived partly from Bacon, who, like Montaigne in France, and at about the same time, took moralizing in new, tolerant directions, and initiated a new phase in human thought. Here is Bacon, in his essay 'Of Revenge', discrediting revenge:

There is no man doth a wrong for the wrong's sake; but thereby to purchase himself profit, or pleasure, or honour, or the like. Therefore why should I be angry with a man for loving himself better than me? And if any man should do wrong merely out of ill-nature, why, yet it is but like the thorn or briar, which prick and scratch, because they can do no other.

This is not Christian (though Bacon, of course, was). In Christianity, people should not love themselves better than others, and they have freedom of choice, whether to do wrong or not. They are not like thorns or briars. Bacon's sideways glance at botanical specimens is a scientist's reflex, and anticipates genetic determinism. Though he reaches the same conclusions about revenge as Christianity (i.e. he condemns it), it is by an entirely different route. Here are no entreaties to turn the other cheek and love one another. It is a philosopher's calm, disillusioned scrutiny of the human animals that surround him.

Browne never quite achieves Bacon's calm, for he is torn between contraries – science and religion, reason and transcendence. 'I love to lose myself in a mystery', he admitted, 'to pur-

sue my reason to an *Oh altitudo.*' But his contradictions contribute to the persistent reappraisal that is literature's process. He is very human, congratulating himself on his lack of pride, and adopting a grandiose style to give his sayings more weight. But in an era of religious persecution his tolerance was truly admirable. He does not, for example, share the contempt for papist idolatry exhibited by his fellow Protestants:

> I should violate my own arm rather than a church window, nor willingly deface the memory of saint or martyr . . . I cannot laugh at but rather pity the fruitless journeys of pilgrims . . . At a solemn procession I have wept abundantly, while my consorts, blind with opposition and prejudice, have fallen into an access of scorn and laughter.

Respect for other people's sensibilities, and something more – a response to the spiritual, however it manifests itself – is at work here. That is one source of his tolerance. The other is science, which, he believes, elevates him above common likes and dislikes – as, for instance, in matters of diet:

> I wonder not at the French for their dishes of frogs, snails and toadstools, nor at the Jews for locusts and grasshoppers, but, being amongst them, make them my common viands; and I find they agree with my stomach as well as theirs. I could digest a salad gathered in a churchyard as well as in a garden. I cannot start at the presence of a serpent, scorpion, lizard or salamander. At the sight of a toad or viper, I find in me no desire to take up a stone to destroy them.

This is a scientist's rationality. By our standards, it is true, Browne did not know much about science. Most of his ideas were wrong, even in embryology, which was his specialism. However, it is not being right or wrong that makes a scientist. It is respect for proof and freedom from prejudice. Browne had these to a degree unusual in his day, and they taught him the wisdom of doubt:

> I could never divide myself from any man upon the difference of an opinion, or be angry with his judgement for not agreeing with me in that, from which perhaps within a few days I should dissent myself.

This sounds more like Montaigne than Bacon (though Browne said he did not read Montaigne's *Essays* until he had written the *Religio*). However, it bears comparison with Bacon's thought in 'Of Revenge' because it moralizes against moralizing. It favours uncertainty in place of moralizing's usual self-assured convictions.

With the 18th century, the scientific revolution that Bacon had begun gathered momentum, and the new idea of human progress took hold. The century's two foremost literary moralizers, Swift and Johnson, were, however, entirely unimpressed by these developments. Johnson's *Rasselas*, written in a week to pay for the cost of his mother's funeral, is, like Voltaire's *Candide*, which was published in the same year, a warning against optimism. It is addressed to 'Ye who listen with credulity to the whispers of fancy, and pursue with eagerness the phantoms of hope'. The hero of this fable, Rasselas, is a prince of Abyssinia who, like other princes of Abyssinia from time immemorial, is obliged to dwell, during his father's lifetime, in a 'happy valley', cut off from the outside world. He contrives, however, to escape, along with his sister Nekayah, her waiting-maid Pekuah, and an old philosopher, Imlac. They travel the world searching for someone who is truly happy, so that they may learn to be happy themselves. A series of disappointments follows. They come upon shepherds, living in pastoral simplicity, and, imagining they must be happy, engage them in conversation. But they find that they are 'cankered with discontent', and consumed with 'stupid malevolence' towards the rich, for whose luxury they labour. They visit a celebrated philosopher, who advises them that the way to happiness is

through truth and reason, which are eternal, and can elevate the mind above passions and accidents. Much impressed, they call on him a second time, but find him plunged in grief, and learn that his only daughter has just died. Rasselas counsels him to summon truth and reason to his aid, but the suggestion is not well received. 'What comfort', said the mourner, 'can truth and reason afford me? Of what effect are they now, but to tell me that my daughter will not be restored?' They mingle with high society, frequenting splendid balls and assemblies, and for a time Rasselas feels that the world is overflowing with pleasure and benevolence. Wherever he goes he meets with gaiety and kindness, 'the song of joy or the laugh of carelessness'. Yet he still feels secretly restless and unsatisfied, and confides his disquiet to the sagacious Imlac, who tells him he is not alone.

> 'Every man', said Imlac, 'may, by examining his own mind, guess what passes in the mind of others. When you feel that your own gaiety is counterfeit, it may justly lead you to suspect that of your companions not to be sincere. Envy is commonly reciprocal. We are long before we are convinced that happiness is never to be found, and each believes it possessed by others, to keep alive the hope of obtaining it for himself.

We notice that Imlac says 'guess' and 'suspect', not 'know', which reminds us of Sir Thomas Browne's warning that we cannot know other people's minds. All the same, the travellers feel they know enough to give up their quest, and they return, wiser, to the happy valley.

Johnson teaches resignation. 'Human life is everywhere a state in which much is to be endured, and little to be enjoyed.' He destroys the illusion that if only we are lucky enough, or work hard enough, or have a high enough credit limit, or acquire a new car, or a second home, we will find happiness. That is not, he advises, how life works. One kind of good displaces another. 'Nature sets her gifts on the right hand and on

the left,' Princess Nekayah eventually comes to realize, 'as we approach one, we recede from another'. It is a lesson that, because of our power and affluence, we tend to forget, though its applications to our own times are obvious. You cannot, for example, leave your partner for another woman and expect your children not to feel insecure and unloved. You cannot be an earth-mother surrounded by a happy brood and have a high-powered career. You cannot educate pupils of lower-than-average intelligence alongside the highly gifted without their feeling humiliated and being disruptive. You cannot build houses over the countryside and still have countryside. You cannot overthrow another nation's regime and not incur the undying hatred of the defeated. Though it deals directly with none of these dilemmas, *Rasselas* operates to clarify them. It is one of the wisest books ever written, and can be read in an afternoon.

Literary moralizing does not just moralize, however. It disagrees and argues. The contrast between Johnson and Swift illustrates this. Swift is angrier, and his mind seethes with images that Johnson would have thought disgusting. The faculty of reason is important to them both. But they mean different things by it. As we have seen, Johnson's bereaved philosopher teaches us that reason cannot protect us from suffering. In life, much is to be endured. Reason cannot alter that. It is impotent when confronted with disaster. Not so with Swift. In the fourth book of *Gulliver's Travels* Gulliver voyages to the land of the Houyhnhnms, who are talking horses. They are perfectly rational, possessing reason to such a high degree that it protects them against all life's calamities. They feel neither grief not anger, and they do not fear death. However, they cannot feel love either, or not as we understand it. Their language does not even have a word for 'love'. They choose partners on purely rational grounds, so as to prevent the race from degenerating.

They have no affection for their colts and foals, unless they are virtuous enough to deserve affection. When they have produced one offspring of each sex, they no longer cohabit. If they have offspring of the same sex, they exchange with another couple who have offspring of the opposite sex, so as to end up with a balanced family. Swift shows, then, not the impotence of reason, like Johnson's bereaved philosopher, but its incompatability with things we deeply value, like conjugal and parental love. Whether he thought his Houyhnhnms represented the ideal of how to live is impossible to say, and futile to argue about. Perhaps he sometimes did, and sometimes not. What matters is his attempt to configure perfect rationality. No other art but literature could do this.

Reason means something different to Johnson and Swift because they see the alternatives to reason differently. For Johnson, the alternative to reason is imagination, which we now think of as admirable, but which he associates with madness. The travellers in *Rasselas* come across an astronomer who seems a normal, happy man. But they find on further acquaintance he is actually mad. He believes he is responsible for controlling the weather – that is, he has what psychologists call a saviour complex, a way the mad use to cope with feelings of inadequacy. Imlac sees him as an example of a general danger:

> Of the uncertainties of our present state, the most dreadful and alarming is the uncertain continuance of reason . . . There is no man whose imagination does not sometimes predominate over his reason . . . and force him to hope or fear beyond the limits of sober probability. All power of fancy over reason is a degree of insanity.

For Swift, though, the alternative to reason is not insanity but lust, bestiality, passion and the other human traits that the Houyhnhnms shun. The Yahoos, whom the Houyhnhnms use as draft animals, and who are really just ugly, depraved human beings with no clothes on, embody these traits. Quarrelsome,

ape-like creatures, they live in herds, each under a ruling Yahoo, and Swift's account of their behaviour is modelled on his observation of human society. The ruling Yahoo, he reports, appoints a favourite, whose duty is 'to lick his master's feet and posteriors, and drive the female Yahoos to his kennel'. When the favourite is eventually disgraced or dismissed, his successor, with all the other Yahoos of the district, 'come in a body and discharge their excrements upon him from head to foot'. It is easier for us than it was for Swift to explain the similarities between these Yahoo habits and the behaviour of humans, because we live in a post-Darwinian age. We know that we are not a divinely favoured species, but simply a branch of the ape family sharing 98.5 per cent of our DNA with chimpanzees. Swift knew none of this. He just saw that we act like apes.

His rationality also allowed him to see through human cultural developments and identify them as absurd. A simple switch of dimension was enough. In Lilliput human beings are only a few inches high, so their politics, intrigues, ceremonies and warfare all seem ludicrous to Gulliver – the pretensions of a race of midgets. In Brobdingnag, where the inhabitants are giants, Gulliver is Lilliput-size, and his earnest eulogies of European culture are received by the King of Brobdingnag with incredulity and derision. What a contemptible thing is human grandeur, he observes, when it can be mimicked by such 'diminutive insects', and taking Gulliver on the palm of his hand he asks, roaring with laughter, whether he is a Whig or a Tory. Gulliver's enthusiastic description of the effects of gunpowder, and his offer to instruct the King in the manufacture of cannon, elicit horror and disgust. 'He was amazed how so impotent and grovelling a creature as I (these were his expressions) could entertain such inhuman ideas.' The King's verdict on Western civilization is not at all what Gulliver had

expected: 'I cannot but conclude the bulk of your natives to be the most pernicious race of little odious vermin that nature ever suffered to crawl upon the surface of the earth.' Bacon had said that men without goodness were 'vermin'. But no one before Swift had helped the human race so forcibly along the path to self-knowledge, and no art but literature could have achieved it.

Reading Swift beside Johnson carries forward the moral debate that literature conducts. So, in the Romantic period, does reading Wordsworth beside Jane Austen. The figures at the centre of Wordsworth's moral universe, such as the old Cumberland beggar, or Margaret in 'The Ruined Cottage', or Betty and her idiot son, could never gain admittance to an Austen novel. People of their class are excluded from her knowledge and interest, and the human qualities Wordsworth treasures most are ones she distrusts. In his poem 'Michael' he tells of a Grasmere shepherd whose son, Luke, goes to the city to seek his fortune, falls into dissolute ways and, overcome with ignominy and shame, seeks 'a hiding place beyond the seas'. Michael is grief-stricken. He still goes from time to time to work at an unfinished sheepfold which Luke and he began to build before the boy left. People see him sitting there, lost in thought, with his old dog at his feet:

> . . . and 'tis believed by all
> That many and many a day he thither went
> And never lifted up a single stone.

But Wordsworth's point is that Michael is not destroyed by the disaster that has befallen him. He continues to ply his shepherd's trade, and can do so because he is sustained by love:

> There is a comfort in the strength of love;
> 'Twill make a thing endurable, which else
> Would overset the brain, or break the heart.

Compare this with the episode in Jane Austen's *Persuasion* where the Musgroves are grieving for their son Richard who joined the navy and died at sea. In its cause, and its long duration, their grief is similar to Michael's, but Austen's asperity is markedly un-Wordsworthian:

> The real circumstances of this pathetic piece of family history were, that the Musgroves had had the ill-fortune of a very troublesome, hopeless son, and the good fortune to lose him before he reached his twentieth year; that he had been sent to sea because he had been stupid and unmanageable on shore; that he had been very little cared for at any time by his family, though quite as much as he deserved; seldom heard of, and scarcely at all regretted.

The Musgroves' mourning is unsightly as well as unreasonable. Mrs Musgove is overweight, and her 'large fat sighings' over her son's death attract Austen's ridicule. Anticipating that this might shock her more tender-hearted readers, she defends her laughter. There is, she admits, no reason why fat people should not grieve. But she insists that for them to do so is 'unbecoming'. The conjunction of obesity and mourning is one 'which reason will patronize in vain – which taste cannot tolerate – which ridicule will seize'. So it is all right to laugh at a mother weeping for her son, so long as she is fat.

In these contrasting episodes Wordsworth and Austen represent respectively heart and head. Austen reacts like a Houyhnhnm (though a Houyhnhnm would not have laughed). Her callousness may disconcert us, but she has reason on her side. Poor dead Dick Musgrove was a no-good. However, Wordsworth's knowledge that 'There is a comfort in the strength of love' is far beyond her orbit. And perhaps it is beyond ours. For it is not clear what Wordsworth means. You might expect that the strength of Michael's love would make Luke's loss *less* endurable, more achingly unforgettable. Yet Wordsworth says the opposite. It is one of the great Words-

worthian moments, and it tells us that love is a strength in its own right, irrespective of whether it is justified or requited, and that it can sustain the heart and mind when reason cannot. But for Austen, love and reason should go together – and reason in her novels is seldom unconnected with money. In *Sense and Sensibility*, for example, Elinor and Edward 'were neither of them quite enough in love to think that three hundred and fifty pounds a year would supply them with the comforts of life'. Very wise and respectable of them too, we gather.

This comparison with Wordsworth is not meant to disparage Austen. She can teach us to think because she does not plunge into Wordsworth's gulfs of feeling. No other writer identifies vulgarity so unerringly. She saw that it extended right up through the social scale, just as it does today. Lady Catherine de Bourgh is as vulgar as Mrs Elton with her 'barouche landau' or Miss Steele and her 'smart beaux'. To be vulgar requires ignorance, self-esteem and stupidity, and Lady Catherine has all of these. Austen brings home, too, how little the young have changed. John Thorpe in *Northanger Abbey*, boasting about his alcohol consumption, and believing it a matter of real interest to other people, could be a contemporary teenager. So could his sister with her standardized teen-talk ('amazing'). Nor is Austen just a critic of manners. The scene at the start of *Sense and Sensibility* where the Dashwoods gradually persuade each other to reduce the allowance they will make to their poor relatives is as brutal as Goneril and Regan's systematic erosion of Lear's retinue of knights, on which it is presumably based. The difference between Austen and Wordsworth as moralists does not come down to social comedy versus elemental passions, for she is quite at home with the elemental passions. It is a question, rather, of whether certain people are beyond the pale or not. Wordsworth wants to embrace everything ('All thinking things, all objects of all thought'). For Austen, that would be

mindless and indiscriminate. The distinction comes out in their attitudes to contempt, which Wordsworth rejects:

> Know . . . that he who feels contempt
> For any living thing, hath faculties
> Which he has never used; that thought with him
> Is in its infancy.

Blake would have agreed ('As the air to a bird or the sea to a fish, so is contempt to the contemptible'). But in Austen's world some people (Mrs Norris, for example, or Maria Bertram, or Wickham, or Mr Collins) truly are contemptible, and it is right to contemn them. It is not a small matter. Whether other human beings are of equal worth with yourself, or whether they are inferior, and might therefore, by extension, be suppressed or destroyed, could be seen as the most important moral question of all, and the one on which the future of our world may hang. Confronting it, each of us must be either a Wordsworth or a Jane Austen – or perhaps a Jane Austen trying to be a Wordsworth. Their opposition clarifies our predicament.

This seems a good point to introduce George Eliot. No account of literary moralizers could leave her out, and the question at issue between Wordsworth and Austen – the limits of sympathy – ceaselessly engages her. For that matter, all the moral dilemmas we have been collecting recur in her work. Donne's perception that we are marooned in our own selfhood is recast in her image (in Chapter 27 of *Middlemarch*) of a mirror or piece of polished steel, covered in tiny scratches. The scratches point in all directions indiscriminately, but if you take a candle, and put it against the polished surface, they will 'seem to arrange themselves in a fine series of concentric circles around that little sun'. This, she says, is a 'parable'. The scratches are the various events of the world, and the candle is our egoism, which makes us think we are the centre of them. Again, Sir

Thomas Browne's realization that we cannot gain access to the consciousness of another creature is reworked by Eliot in Chapter 20 of the same novel:

> If we had a keen vision and feeling of all ordinary human life, it would be like hearing the grass grow and the squirrel's heart beat, and we should die of that roar which lies on the other side of silence. As it is, the quickest of us walk about well wadded with stupidity.

That final sarcasm is finely poised. For it is not stupid to be wadded against a roar that would kill us. The paltry limits of our senses rescue us, even if they make us paltry. Tragedy happens all around us, but we remain sheltered, which, Eliot acknowledges, is just as well, for 'our frames could hardly bear much of it'. This passage was surely in the mind of another Eliot when he wrote, in *Burnt Norton*, 'Human kind/ Cannot bear very much reality', and the echo illustrates the developing debate with itself that literature conducts.

Part of that debate, the opposition between Wordsworth and Austen over whether it can be right to feel contempt for another human being, is worked out by George Eliot through her characterization of Casaubon, the withered scholar whom young Dorothea unwisely worships and weds. Casaubon, engaged in his mythological research, and carrying his 'small taper of learned theory' among the 'tombs of the past', anticipates Sartre's satirical jibes about the typical critic in his cemetery of books. And in this respect Casaubon's depiction adds to the tally of literature's criticism of the literary. But Eliot, unlike Sartre, is not writing polemic, and repellent as Casaubon is – narrow, rigid, obstinate, jealous, tyrannical – he is also entirely human. When asked whom he was modelled on, Eliot pointed to herself. In creating him she leans towards Wordsworth rather than Austen. For he is in the end pitiable, not contemptible. No one who has ever written a book – or tried to –

can help but share Casaubon's terror and indignation when Dorothea, so brisk and well-intentioned, urges him to get on with it. It is because he is real, like us, that Eliot can use him for serious human purposes. Swift's Yahoos are not real. They belong in a zoo. But Casaubon could have just walked in from the next room. This gives an uncomfortable power to the scene where Dorothea tries to take his arm, and Casaubon, perturbed and angry with her, keeps it rigid:

> There was something horrible to Dorothea in the sensation which this unresponsive hardness inflicted on her. This is a strong word, but not too strong: it is in these acts called trivialities that the seeds of joy are forever wasted until men and women look round with haggard faces at the devastation their own waste has made and say the earth bears no harvest of sweetness – calling their denial knowledge.

Casaubon's fault is just a momentary, obstinate refusal to forgive – something we have all been guilty of. But Eliot's vision of the haggard faces, the devastation, the wasted seeds of joy, turns that small lapse into something universal, like the primal sin that blighted Eden. From her partner G. H. Lewes she had learnt how marriages are wrecked, and perhaps that helped to make her such a trenchant moralist for our age of wrecked marriages.

Pairing moralists as we have been doing is an arbitrary business – just a try-out. Other pairings would have done as well. That is the point. They are meant to illustrate that literature is a field of comparisons and contrasts, spreading infinitely outwards, so that whatever we read constantly modifies, adapts, questions or abrogates whatever we have read before. All we can be sure of – and this is what makes it different from all the other arts – is that moral questions will never be far away. From this viewpoint, any of the Victorian novelists might be used to complete our pair with George Eliot, but a less obvious com-

parison is with Joseph Conrad. Both were atheists, unlike the other writers we have looked at. Both were engaged with world events – Conrad with colonialism and terrorism, Eliot with the Jewish Diaspora. Both wrote parables. When the outcast weaver Silas Marner thinks that he sees his stolen gold and, reaching eagerly towards it, finds his hands touching a child's soft hair, the parable-effect is unmistakeable. Eppie, the lost child who has wandered into his hut, redeems his life as no gold could.

The same contrast is plotted in Conrad's *Nostromo*. When Charles Gould's silver-mine in the South American state of Costaguana first comes into production, his childless wife stays up late, watching the fires under the retorts. Then, at last, she 'laid her unmercenary hands, with an eagerness that made them tremble, upon the first silver ingot turned out still warm from the mould'. The warmth of the ingot is deceptive. It makes it seem alive, as Mrs Gould's hands and Eppie's hair are. But it is dead, and 'unmercenary' Mrs Gould values it only for what it means to her husband. The aliveness of her love and her trembling hands contrast with Charles Gould's dull money-worship – 'I pin my faith to material interests'. Conrad's novels are all parables – *Heart of Darkness* a parable about greed, *Lord Jim* a parable about cowardice, *Under Western Eyes* and *The Secret Agent* parables about betrayal. In parables it is clear who is right and who is wrong, and so it is in Conrad, though he concedes that there may be mitigating circumstances, particularly the mitigating circumstance of the Tsarist secret police, which makes it unwise for us to judge too harshly those, like Razumov and Verloc, who are caught in its meshes.

Like Eliot, Conrad sees how we cut ourselves off from the lives around us. But where Eliot feels for the palpitations of the squirrel's heart, Conrad resorts to disdainful irony, as when he skewers Charles Gould's equanimity about his father's ruined

life: 'It is difficult to resent with proper and durable indignation the physical or mental anguish of another organism, even if that organism is one's own father.' Eliot's Casaubon might, it is true, seem a character beyond Conrad's powers, despite the irony at his command. But if we look for a character who is a partial self-portrait, and a critique of the literary life, then Casaubon finds a parallel in *Nostromo*'s Martin Decoud. A journalist who has studied in Paris, and has aspirations to become a poet, Decoud is, like Conrad, a sceptic. He believes in nothing at all. Like Conrad, too, he uses irony to register the distance between him and the common run of mortals. Despite, or because of, these similarities, Conrad's treatment of him is merciless. Decoud represents 'mere barren indifferentism posing as intellectual superiority'. When, towards the novel's end, he is marooned amid the vast, silent spaces of the Golfo Placido, he comes to doubt his own reality, weights his pockets with silver ingots, and, leaning over the gunwale of his boat, shoots himself. All that is left is an empty boat and a small bloodstain. Conrad's post mortem is relentlessly ironic. The 'brilliant Costaguanero of the boulevards' has been eliminated, destroyed by 'solitude and want of faith in himself and others'; the 'brilliant Don Martin Decoud' has been 'swallowed up in the immense indifference of things'. It is as if Conrad's own brilliance, solitude, and distrust of himself and others, were being angrily erased.

The anger results, I think, from Conrad's realization that he is caught in an impossible dilemma. Decoud's 'indifferentism' makes him hollow. But what is the alternative? If the universe is, as Conrad believed, an 'immense indifference', utterly unconcerned about human life, then believing in justice and caring about injustice (as the Conrad who wrote *Heart of Darkness* of course did) is ridiculous. It is to put yourself on a level with the half-witted Stevie in *The Secret Agent*, who is so

upset when he sees a cabman whipping his horse, and so upset too by the hard-luck story the cabman spins him when he remonstrates, that he ends up wanting to take both horse and cabman home to bed with him. Poor Stevie wants to make the horse happy and the cabman happy, and, perceiving they are not, he thinks someone ought to be punished for it. This is the way all philanthropists' brains work, or so Conrad suggests. Philanthropists believe in setting things to rights, and so does Stevie. 'Being no sceptic, but a moral creature, he was in a manner at the mercy of his righteous passions'. So if you are a sceptic, like Decoud, it makes you a hollow man, and if you are not it makes you a half-wit, like Stevie. Hence Conrad's anger.

Where Eliot and Conrad might seem even more at odds is in their treatment of women. Yet they turn out to be closer than expected. For Eliot, women are the world's redeemers:

> Could there be a slenderer, more insignificant thread in human history than this consciousness of a girl, busy with her small inferences of the way in which she could make her life pleasant? – in a time, too, when ideas were with fresh vigour making armies of themselves ... What in the midst of that mighty drama are girls and their blind visions? They are the Yea or Nay of that good for which men are enduring and fighting. In these delicate vessels is borne onward through the ages the treasure of human affections.

A feminist might find the emphasis on delicacy and the passive role assigned to 'girls' objectionable, and insofar as the 'vessels' are the ovaries, a male might plead that the same could be claimed for the scrotum. But the passage's strength easily shakes off such carping, and Eliot translates her belief into the action and incidents of the novels. The quotation above is from *Daniel Deronda*, but a moment in *Middlemarch* acts like a gloss on it. When Celia, Dorothea's sister, hears the dreadful news of the engagement to Casaubon, she is busy cutting out a paper man:

Perhaps Celia had never turned so pale before. The paper man she was making would have had his leg injured but for her habitual care of whatever she held in her hands. She laid the fragile figure down at once and sat perfectly still for a few moments. When she spoke there was a tear gathering.

'Oh, Dodo, I hope you will be happy.'

Laying the paper man down carefully, and not cutting his leg, seem like nursing diligence. Lint and bandages and casualty clearing stations come, for a moment, into view. Celia, making a man, anticipates, also, maternity, and the thought that her sister's decision effectively relinquishes motherhood drives the blood from her face.

All this might seem extremely unlike Conrad. Yet women repeatedly play the redemptive role in his novels, and are the vessels of human affections. When affection is denied, or insulted, it may, as in Eliot, drive them to murder – as it drives Conrad's Winnie Verloc in The *Secret Agent* and Eliot's Gwendolen Harleth in *Daniel Deronda*. Both these women enter loveless marriages for financial reasons, but in the case of Winnie Verloc the reasons are nurturing and protective – to keep her mother out of the almshouse and put a roof over the head of her idiot brother Stevie. Verloc sacrifices Stevie, and Winnie, slaying him, is more like a mother avenging her child than a wife freeing herself from a hated husband. In *Lord Jim*, Jim's native wife, Jewel, is ruthlessly on the side of the human affections, while his mind is fixed on masculine heroism and self-sacrifice. Through his fault, her brother has been killed, and she knows her father, the tribal chief, will kill Jim in revenge. She urges him to fight – not to give himself up, but to make his way to safety over the bodies of her kinsfolk. Marlow, the narrator, learns how desperately she argued with him 'for the possession of her happiness', and when he calmly walked out of the hut to his death, a victim of 'superb egotism', she staggered out behind

him, 'with streaming hair, wild of face, breathless', like some ele-
mental female life-force, defeated and outraged by the male
death-wish. Again, in *Under Western Eyes* it is the lowly Tekla,
whose lover was destroyed by Tsarist torturers, who takes in and
cares for the disgraced and broken Razumov in his last days.

Of these seemingly inconsequential Conradian women who
are prepared, in a crisis, to fight tigerishly for life and love, the
most resplendent is Lena in *Victory*. A member of a bedraggled
female concert-party that tours the trading outposts of the
Malay archipelago, and also, it is suggested, an ex-prostitute,
Lena is rescued from her degraded existence by a chivalrous
Swede, Axel Heyst, who takes her to live on his lonely island.
Like Martin Decoud, Heyst is in some respects a self-portrait.
The falsity of people has left him disillusioned with life, and he
has no faith in anything beyond. Conrad ironically presents
him as someone who thinks too much: 'The habit of profound
reflection, I am bound to say, is the most pernicious of all the
habits formed by civilized man.' Thought about what humani-
ty is really like has deprived Heyst of every kind of idealism, and
even of resentment. 'I have refined everything away', he
explains, 'anger, indignation, scorn itself. Nothing is left but
disgust.' At the climax of the novel three armed desperadoes
arrive on the island, and Lena devotes all her energies to saving
Heyst's life. She succeeds, but is shot by one of the criminals.
Heyst had suspected that she was in league with them, and this
prevents him, at first, from taking her in his arms.

> Heyst bent low over her, cursing his fastidious soul, which even at
> that moment kept the true cry of love from his lips in its infernal
> mistrust of all life. He dared not touch her, and she had no longer
> the strength to throw her arms about his neck.
>
> 'Who else could have done this for you?' she whispered gloriously.
>
> 'No one in the world,' he answered her in a murmur of uncon-
> cealed despair.

She tried to raise herself, but all she could do was to lift her head a little from the pillow. With a terrified and gentle movement, Heyst hastened to slip his arm under her neck. She felt relieved at once of an intolerable weight, and was content to surrender to him the infinite weariness of her tremendous achievement. Exulting, she saw herself extended on the bed, in a black dress, and profoundly at peace; while, stooping over her with a kindly playful smile, he was ready to lift her up in his firm arms and take her into the sanctuary of his innermost heart – for ever! The flush of rapture flooding her whole being broke out in a smile of innocent, girlish happiness; and with that divine radiance on her lips she breathed her last, triumphant, seeking for his glance in the shades of death.

Conrad has not relinquished irony even here. Lena's romantic vision of herself and her glamorous lover (with his 'kindly playful smile', so unlike poor shattered Heyst) is ironically presented. But the irony does not condemn. To a sophisticate like Decoud, Lena's vision might seem the stuff of cheap romance. But it belongs, Conrad shows, with true and noble qualities far beyond the reach of Decoud's 'barren indifferentism'. By implication Lena's vision strikes a blow for 'low' popular art, and for the masses who have no knowledge of great literature, and it shows they are capable of supreme courage and pure, selfless love. Heyst's last words are reported by Captain Davidson who arrives on the island, shortly after Lena's death, on a routine trading trip: 'Ah, Davidson, woe to the man whose heart has not learned while young to hope, to love – and to put his trust in life.' So Lena's self-sacrifice does manage to cure him of his nihilism, though too late. When Davidson leaves, Heyst sets fire to the bungalow, reducing Lena and himself to ashes.

The eight writers I have instanced are, as I have said, arbitrarily chosen. Others could have as easily been found and could have as conclusively illustrated literature's persistent engagement with moral issues – and its refusal to agree about them. Diversity is its essence. Unlike science, it is not a field of

discovery in which the right answer will eventually displace and supersede the wrong ones. It is a field of accumulation, made up of an incalculable number of divergent trajectories, as diverse as humanity. That is why science cannot be a substitute for it (nor, of course, it for science). An alternative approach to this chapter would have been through topics not authors. Take any topic, from the whole gamut of human thought, and you will find in literature an endless diversity of opinion about. Since we are still (I hope) misty-eyed from reading Conrad's magnificent operatic *Liebestod* from the end of *Victory*, we might select, to test out this claim, the topics of death and love, and to make it more testing we will limit ourselves to the eight writers I have paired.

Death prompts one of the most terse and resonant moments in Bacon's *Essays*: 'Men fear death, as children fear to go in the dark.' The Bacon who wrote that had clearly been reading Seneca's letters. Like the passage quoted earlier from the essay 'Of Revenge', it is not a Christian sentiment, for Christians are supposed to know what lies beyond death, and it is not the dark. Though the essay 'Of Death' rapidly backtracks, introducing more pious viewpoints, it exits on a gentle pagan note, implicitly matching the oblivion that precedes life with an oblivion that succeeds it: 'It is as natural to die as to be born; and to a little infant, perhaps, the one is as painful as the other.' Sir Thomas Browne, as a doctor in an effectively pre-medical age, knew a lot about death, and perhaps for that reason his thoughts about it are more God-centred than Bacon's: 'I that have examined the parts of man, and know upon what tender filaments that fabric hangs . . . and considering the thousand doors that lead to death, do thank my God that we can die but once.' His thought about his own death is singular, and could have occurred only to someone who had seen, and shrunk from, many human carcases: 'I am not so much afraid of death,

as ashamed thereof; 'tis the very disgrace and ignominy of our natures, that in a moment can so disfigure us that our nearest friends, wife and children stand afraid and start at us.' Rather winningly, he goes on to assure his readers that his body is not misshapen in any way, nor marked by any 'shameful disease'. Not wanting to be looked at when dead is just the way he feels. From choice, he would like to be drowned in a shipwreck, and sink beneath the waters 'unseen, unpitied'.

Death comes into Johnson's *Rasselas* with the loss of the royal waiting-maid, Pekuah, and Imlac counsels the distraught Nekayah against excessive mourning: 'Do not suffer life to stagnate; it will grow muddy for want of motion. Commit yourself again to the current of the world. Pekuah will vanish by degrees.' We recall that Johnson was writing this to pay for his mother's funeral, so how to face bereavement was currently in his thoughts. The Wordsworth who wrote 'Michael' would have found Imlac's advice heartless, but Jane Austen would have agreed with Johnson, who was her moral mentor. In *Gulliver's Travels*, on his visit to Luggnagg, Gulliver learns of a race called the Struldbrugs, who are spared the terrors of death, because, through some biological quirk, they are born immortal. He is eager to visit such lucky beings, imagining the treasury of wisdom they must have accumulated through their centuries of life. He finds, however, that they are a bunch of decrepit, disease-wracked, mindless geriatrics. 'Envy and impotent desire are their prevailing passions . . . Those objects against which their envy seems principally directed are the vices of the younger sort and the deaths of the old.'

This sane 18th-century sermon about the wholesomeness of death comes up sharply, though, against the moment in *Middlemarch* when Casaubon learns from his doctor that he has heart disease and may die at any moment. 'Here', comments Eliot, 'was a man who now for the first time found him-

self looking into the eyes of death . . . When the commonplace "We must all die" transmutes itself suddenly into the acute consciousness "I must die – and soon", then death grapples us, and his fingers are cruel.' Literature's self-critical power, its admission that it is a shadowy replica of life, is what Eliot communicates here. For however sagely we may nod our heads over what she has written, what she is actually telling us is that, unless, like Casaubon, we have just learnt that we are mortally ill, we cannot know what he feels.

As with death, so with love, our eight writers all point in different directions. Bacon and Browne are negative. 'The stage', grumbles Bacon, 'is more beholding to love than the life of man.' He means it is harmless in comedies and tragedies, but extremely disruptive in reality – so what seemed belittlement turns out to be a tribute to love's power. Browne acknowledges its power, but resents it:

> I could be content that we might procreate like trees, without conjunction, or that there were any way to perpetuate the world without this trivial and vulgar act of coition. It is the foolishest act a wise man commits in all his life, nor is there anything that will more deject his cooled imagination, when he shall consider what an odd and unworthy piece of folly he hath committed.

In our present culture, partly because of the anxieties of an ageing population, sex is considered the highest good, and 'sexy' an unquestionably approving adjective (Jeanette Winterson, for example, recommends literature as 'sexy'). So Browne's alternative view is especially worth having.

Jane Austen, though, would have thought it culpably eccentric. She presents nascent love smilingly in *Northanger Abbey*. Catherine Morland is at Bath in the care of Mr and Mrs Allen, when she gets into conversation with a witty young student Henry Tilney. While they are talking Mrs Allen interrupts to ask Catherine to take a pin out of her sleeve.

'I am afraid it has torn a hole already: I shall be quite sorry if it has, for this is a favourite gown though it cost but nine shillings a yard.'

'That is exactly what I should have guessed it, madam,' said Mr Tilney, looking at the muslin.

'Do you understand muslin, sir?'

'Particularly well: I always buy my own cravats, and am allowed to be an excellent judge; and my sister has often trusted me in the choice of a gown. I bought one for her the other day, and it was pronounced to be a prodigious bargain by every lady who saw it. I gave but five shillings a yard for it, and a true Indian muslin.'

Mrs Allen was quite struck by his genius.

The conversation ends with Mrs Allen asking Tilney's opinion of Catherine's gown:

'It is very pretty madam', said he, gravely examining it; 'but I do not think it will wash well: I am afraid it will fray.'

'How can you', said Catherine, laughing, 'be so – ?' she had almost said, strange.

Something important is happening here. It is (I think) the first instance of teasing in the English novel. If, as is usually supposed, *Northanger Abbey* is Austen's first completed book, it precedes Elizabeth's teasing of Darcy in *Pride and Prejudice*. It may even be the first real teasing in English literature, not just the novel. True, Beatrice and Benedick tease each other, and Petruchio teases Kate, but it is cruder and stagier than this. Tilney's teasing is an exhibition of power, as male teasing always is. His solemn foolery tells Catherine that he is intelligent enough to outwit people of Mrs Allen's sort, and he flatters her by crediting her with the intelligence to see what he is about. Because it makes her an accomplice the teasing is a kind of wooing. What we have is unmistakeably masculine foreplay, as Catherine's flustered response acknowledges, though the trivial and vulgar act of coition is still some way in the future.

I have been emphasizing the divergence and diversity of

opinion that you find in English literature, wherever you choose to dip into it. This prompts the question whether there are any topics on which divergence and diversity are not apparent. Is there anything about which English literature could be said to express a consensus? Not everyone will agree, but it seems to me that antagonism to pride, grandeur, self-esteem and celebrity is a consistent literary animus. Shelley's 'Ozymandias' is a keynote. A traveller reports that he has found, in the desert, two vast stone legs, with a shattered stone head half-buried in the sand nearby:

> And on the pedestal these words appear:
> 'My name is Ozymandias, king of kings:
> Look on my works, ye Mighty, and despair.'
> Nothing beside remains. Round the decay
> Of that colossal wreck, boundless and bare
> The lone and level sands stretch far away.

It would be hard, I think, to find a work of English literature that took Ozymandias's side. The fall of princes is already a genre in medieval writing. The theme runs through Shakespeare's histories and tragedies, and on into the moral certainties of 17th-century poetry:

> The glories of our blood and state
>    Are shadows, not substantial things.
> There is no armour against fate,
>    Death lays his icy hand on kings,
>      Sceptre and crown
>      Must tumble down,
> And in the dust be equal made,
>    With the poor crooked scythe and spade.

Shortly before James Shirley wrote that, death had laid its icy hand on Charles I on a scaffold in Whitehall.

Ridicule of self-importance is endemic in the 19th-century novel, perhaps because as a middle-class form it is inherently

anti-aristocratic. It values unpretentious people, strangers to wealth or fame. The final sentence of *Middlemarch* reminds us how much the good of the world depends on those 'who lived faithfully a hidden life and rest in unvisited tombs'. At the close of Dickens's *Little Dorrit* Arthur and Amy are destined for 'a modest life of usefulness and happiness'. After their wedding they go down the church steps 'into the roaring streets, inseparable and blessed; and as they passed along in sunshine and shade, the noisy and the eager and the arrogant and the forward and the vain, fretted and chafed and made their usual uproar.' This disdain for ostentation had received a boost with the Romantic revolution, which was a political as well as a poetic revolution, dethroning grandeur and magnificence. Wordsworth identified the 'best portions of a good man's life' as 'His little, nameless, unremembered acts/ Of kindness and of love', and that vote for obscurity, together with hostility to flamboyance and luxury, reverberate through the literature of the next two centuries. They can still be identified in, for example, A. E. Housman's tight-lipped tribute to the 1914 British Expeditionary Force, 'Epitaph on an Army of Mercenaries':

> These, in the day when heaven was falling,
>   The hour when earth's foundations fled,
> Followed their mercenary calling,
>   And took their wages, and are dead.
>
> Their shoulders held the sky suspended,
>   They stood, and earth's foundations stay,
> What God abandoned, they defended,
>   And saved the sum of things for pay.

Behind the Wordsworthian tradition stands Milton, whom Wordsworth venerates, and in his national epic *Paradise Lost* Milton selects pride as the ultimate sin. It is through pride that Satan falls from heaven to hell, where he builds a palace of

hellish magnificence. His fall does not lessen his self-esteem. Caught trespassing in Eden by two young angels, and asked to identify himself, he is outraged by their ignorance: 'Not to know me argues yourselves unknown' (If you don't know who I am, you must be nobodies). Present-day celebrities who demand 'Do you know who I am?' of innocent cabin-staff are faithfully following the Satanic tradition. From this angle literature's contribution could be seen as a counterweight to the mass media's focus on celebrities, which helps to glue society together by giving it common interests, but is empty by comparison with literature. However, the small measure of literary consensus I am suggesting may be illusory. Some of Salman Rushdie's later work, such as *The Ground Beneath Her Feet*, seems quite naively excited by the subject of celebrity, and perhaps there are other examples unknown to me. If so, it only reinforces my main point about literature's essential diversity.

Let us be clear what I am claiming. I am not suggesting that reading literature makes you more moral. It may do, but such evidence as I have come across suggests that it would be unwise to depend on this. Envy and ill-will are, I should say, at least as common in the literature departments of universities as outside. Faculty members seem especially prone to a 'sense of injured merit', which is another characteristic of Milton's Satan. The texts I have been drawing on in this chapter are not obscure, and would certainly be familiar to someone of Bill Buford's education, yet as we have seen they did not prevent him assaulting and abusing two elderly people on the underground. My claim is different. It is that literature gives you ideas to think with. It stocks your mind. It does not indoctrinate, because diversity, counter-argument, reappraisal and qualification are its essence. But it supplies the materials for thought. Also, because it is the only art capable of criticism, it encourages questioning, and self-questioning.

Its function as a mind-developing agency gives it especial relevance in our present culture. A feature of our culture is that many people, particularly young people, feel driven to get out of their own minds. Drugs, drink and antidepressants are the usual routes. Clearly these people find their own minds too painful or too boring to stay inside. Boredom is a frequent complaint of the young. An article in *The Times* in May 2004 investigated under-age drinkers in a Gloucestershire village. A fifteen-year-old schoolgirl, Sam, drinking her fifth Bacardi Breezer, comments 'It is a no-brainer why young people here drink in such a big way – there is nothing else to do. The nearest cinema is ten miles away and the last bus from there leaves at 6.15 p.m.' Another fifteen-year-old schoolgirl observes that the heaviest drinkers are in the 13–18 age-group, and it is not unusual for two of them to get through a bottle of vodka in a day. 'What do you expect us to do? The only event of any excitement advertised on the village board is a meeting of the Mothers' Union.' Publicans and the police sympathise, we are told, and turn a blind eye. A barmaid commiserates: 'People should be sorry for them, not angry. They have nothing to do and nowhere to go.'

There is nothing singular in this report, of course – readers will have encountered many of the same kind. The girl's presentation of herself as intelligent (not a 'no-brainer') and her simultaneous assumption that it is someone else's job to occupy her mind for her, are also perfectly standard. No doubt the causes of this malaise are various, but the decline of reading is indisputably one of them, and it has taken place within a single lifetime. Statistics collected in Jonathan Rose's *The Intellectual Life of the British Working Classes* show that in 1940 boys were reading about six books a month, girls just over seven. A 1944 survey indicates that almost half of all unskilled workers grew up in houses with 'substantial libraries'. Today these figures

seem utopian. It occurs to no one in the Gloucestershire village to suggest that the bored young people might read a book. Plainly such an idea would be derided as utterly unreal and unmodern. It is not clear why. Enormous sums of public money are spent on making young people, as far as possible, literate, so to connive in their rejection of literature seems irrational. The argument that there are now more disincentives to reading than there were in the 1940s is questionable. There have always been disincentives, among them longer working hours and less money. Equally suspect is the argument that there is an essential mismatch between reading and current youth-culture. Literature has fed the minds of generations of young people. It is implausible that we should have suddenly produced a generation biologically immune to it.

Like drugs, drink and antidepressants, literature is a mind-changer and an escape, but unlike them it develops and enlarges the mind as well as changing it. A more hopeful note to end this chapter on than the young soaks of Gloucestershire is provided by another *Times* article, of 17 December 2003, by Carol Midgley. This was a report on a project at Deerholt young offenders' institution in Durham, where nine young men were chosen to study William Golding's *Lord of the Flies*, a novel about a group of choirboys marooned on a desert island. The auguries were not good. Literacy levels among young offenders are low. Maria Waddington, head of Deerholt's basic skills department, says that when some young men arrive they cannot tell the time, let alone read or write. One of her charges whose upbringing had been particularly neglected could not count up to ten. A member of the study group, Leonard Elmore, now seventeen and serving a two-and-a-half year sentence for arson, missed out on most of his education because his mother left home when he was nine and he had to care for his asthmatic, alcoholic father. There were no books in the

house. Even among the more literate, there was resistance to reading. Philip Haigh, nineteen, from Yorkshire, serving a sentence for aggravated burglary, objected when selected for the study group, 'I've never read a book. I've never got excitement from a book. It doesn't do nowt for me. It is not, like, a man's thing.'

Yet within three weeks many of the boys were analysing the novel with intelligence and insight. Leonard, who finished it in two days, had been bullied at school and he identified with Piggy, the fat, bespectacled boy who is victimized and eventually killed. At one point the boys in the study group painted their faces like the boys in the story, and Leonard saw this as a comment on life as he had experienced it: 'Most of us wear a mask in life. You hide your emotions. We can pretend that we're happy, but we aren't inside. But we don't want anyone to know.' This is close to Imlac's observation in Johnson's *Rasselas*, quoted above, though Leonard works it out from another literary text. Waddington chose Golding's novel because its themes of bullying, and being suddenly cut off from one's family, related to prison life, as did its exploration of man's natural tendency to barbarism. Her students, though some of them had never read a book before, were quick to grasp this. Chris Gibbons, nineteen, jailed for robbing a taxi driver, said that the book had made him think about civilization, and how it would collapse into chaos without law, and had even made it easier for him to accept being sent to prison for what he did. 'I still think the law is a bit sticky in places, but I know that we need it. We've all got a primitive streak in us; it doesn't matter how snobby or posh you are, it will come out if you let it.' Swift's Yahoos make the same point.

Reading Golding's novel has whetted the group's appetite for literature. Leonard is now reading Stephen King's *The Green Mile*. Others are working on Philip Pullman's *His Dark Materials*

trilogy. Philip Haigh, for whom reading was 'not a man's thing', has joined the prison's drama group and plans to go to college when he is released. Finding that they can manage and respond to literature has helped to repair their crushingly low self-esteem, derived from their often traumatic upbringings and their consequent failure to cope at school. 'It has made me realize that I'm smart. I'm not just a criminal and a thug,' says Chris Gibbons. 'My brain just seems to absorb books. I love to discuss what they are about, what they mean . . . I've got a massive imagination, I can picture every detail when I'm reading.' In the novel the boys on the island go in fear of an imaginary beast, and their terror kindles a lust to kill. Leonard quickly fathomed the psychology of this and applied it to his own case. 'The beast is my anger really. There was one point in time when I was really angry and bottling everything up. I would start hitting the wall and shouting at people. Now I've learnt to calm down and to try to explain it to people. A lot of the time we are hurting emotionally inside.'

I am not disputing the educational potential of other arts, but I do not believe that any other art than literature could have produced these results.

CHAPTER SEVEN

# Creative reading:
# Literature and indistinctness

The last chapter concentrated on literature's thought-content. It argued that literature was an idea-bank, and that no other art could compete with it in that respect. This chapter will move on to another aspect of literature's superiority, and consider how it appeals to the imagination. The young man from the *Lord of the Flies* study group who discovered, with delight, that he had a 'massive imagination' and could 'picture every detail' might have been speaking for all readers. Admittedly, it seems absurd to claim, when you have read a piece of imaginative literature, that you have done the imagining ('*I* have a massive imagination'). But that is what readers feel, and rightly. They know that imagining has happened inside their heads, and that it is special to them. Watching the grotesque liberties that a film or a TV version takes with something you have read confirms that this view of the situation is correct. How can they have got this or that character so wrong? How can they have missed out this or that vital bit? Of course, these grotesque liberties merely reflect someone else's equally special and authentic reading of the text. Literature's power to strengthen one's sense of selfhood and individuality, some instances of which we have noted, depends, to a large extent, on this capacity to cultivate and enfranchise the readers's private, individual imagining. The reader creates, and feels a creator's possessiveness.

But how can a text, which comes fully formed to the reader's

eye, leave space for the reader to create? I want to argue in this chapter that a vital element in all literature is indistinctness, and this empowers the reader. The reader, that is, not only can but must come to some kind of accommodation with the indistinctness in order to take meaning from the text. For that, the imagination must operate. I shall try to distinguish different kinds and levels of indistinctness, and see how they function in different writers. But first I must stress that, as in the last chapter, everything in this one is subjective. I have chosen bits of literature to analyse that I happen to like, and how I read them – where I find indistinctness, how I fill it in – reflects my personal bias. Readers will almost certainly disagree with me much of the time – indeed, my thesis requires that they should. For my thesis is that literary indistinctness generates multiple individual readings, which is why we can all feel we have produced our own.

Most of my examples will be from poetry, especially Shakespeare. But it seems appropriate to start with one from *Lord of the Flies*. In Chapter 9 a tragedy occurs. The good, brave Simon is beaten to death by his terror-maddened schoolmates. His body lies on the beach all night. Then, towards dawn, the tide rises:

> Along the shoreward edge of the shallows the advancing clearness was full of strange, moonbeam-bodied creatures with fiery eyes. Here and there a larger pebble clung to its own air and was covered with a coat of pearls. The tide swelled in over the rain-pitted sand and smoothed everything with a layer of silver. Now it touched the first of the stains that seeped from the broken body, and the creatures made a moving patch of light as they gathered at the edge. The water rose further and dressed Simon's coarse hair with brightness. The line of his cheek silvered and the turn of his shoulder became sculptured marble. The strange attendant creatures, with their fiery eyes and trailing vapours, busied themselves round his head. The body lifted a fraction of an inch from the sand and a bubble of air

escaped from the mouth with a wet plop. Then it turned gently in the water.

Somewhere over the darkened curve of the world the sun and moon were pulling: and the film of water on the earth planet was held, bulging slightly on one side while the solid core turned. The great wave of the tide moved further along the island and the water lifted. Softly, surrounded by a fringe of inquisitive bright creatures, itself a silver shape beneath the steadfast constellations, Simon's dead body moved out towards the open sea.

This wonderful silent requiem turns Simon's body into its own monument of sculptured marble. But it also shows it being eaten. For me it is the 'creatures' that provide the indistinctness. We are given one or two details – fiery eyes, phosphorescence. But we have to invent the rest. What about their teeth, as they bite or tear in their terrible brightness? Or perhaps you choose to think they are not eating him, just nuzzling him inquisitively and pushing him out to sea. It is, after all, not spelled out either way. The creatures are obviously important – the only living actors in the scene. They are nature's ministers, receiving Simon back into the non-human universe. But how you imagine them is up to you. You may, of course, decide to leave them indistinct, or think that is what you are doing. But however indistinct you think you are leaving them, some images will impinge – the fiery eyes, the trailing vapours – and how you interpret those words will force you to imagine, that is, to create. You cannot opt out, except by not reading.

I think this kind of writing started with Shakespeare. That does not mean that I would deny there is imagination-stirring indistinctness in medieval literature – in Chaucer's *Troilus and Criseyde*, for example. Of course there is. All written texts require interpretation and are, to that extent, indistinct. But with Shakespeare something new happened. An enormous influx of figurative writing transformed his language – an epi-

demic of metaphor and simile that spread through all its tissues. Whether that could have happened in any language other than English is a question too knotty to enter on here. All we can be sure of is that it did not, and it may be that English alone, being uninflected, and without gendered nouns, had the pliancy for a writer like Shakespeare to develop his figurative mode in. Metaphor, like rhyme, is a way of connecting things contrary to reason. So is simile. So when writing is dense with metaphor and simile, as it is in Shakespeare, the imagination has to keep fitting things together that rational thought would keep apart. It has, that is, to keep ingeniously fabricating distinctness – or whatever approximation to distinctness it decides to settle for – out of indistinctness. It is often said that Shakespeare took up where Marlowe left off, and could not have written his plays without Marlowe's example. But Marlowe is actually a completely different kind of writer, much more wooden and solid and distinct than Shakespeare for all his flamboyance. Shakespeare's superior indistinctness can easily be seen if we compare the way Marlowe's Jew, Barabas, and Shakespeare's Jew, Shylock, talk about their wealth. Here is Barabas:

> Bags of fiery opals, sapphires, amethysts,
> Jacinth, hard topaz, grass-green emeralds,
> Beauteous rubies, sparkling diamonds . . .
>
> [I i 25–7]

And so on. Pretty good, you will say. Yes, it is. But it is not very indistinct, so the imagination has not much to do. You can easily picture bags of jewels. Of course, even Marlowe's lines are beyond the reach of visual arts like painting or photography. You cannot paint grass-green emeralds, except by some ponderous device like juxtaposing painted grass and painted emeralds, whereas language can merge the two in a flash. Painting

cannot manage metaphor, which is the gateway to the subconscious, and that hugely limits it by comparison with literature. True, there is Surrealist painting, but it is static and deliberate, and quite unlike the flickering, inconsequential nature of thought. However, with all due credit to Marlowe's jewels, compare Shakespeare's Shylock when he hears that his daughter (who has run off with her lover, taking some of her father's gold and jewels with her) is living it up in Genoa and has exchanged a ring for a monkey.

> Thou torturest me Tubal, – it was my turquoise, I had it of Leah when I was a bachelor: I would not have given it for a wilderness of monkeys. [III i 112]

Marlowe could never have written that. Quite apart from the human depth, the indistinctness is what stamps it as Shakespeare's. 'A wilderness of monkeys', the lightning phrase with which Shylock registers his wit, scorn and outrage, is unforgettable and unimaginable – or, rather, imaginable in an infinite number of ways. How do you imagine it? Are there trees and grass in the wilderness? Or just monkeys? Are they mixed monkeys, or all of one kind? With tails or without? Of what colour? What are they doing? Or are these questions too demanding? Is the impression you get much more fleeting, much less distinguishable from the mere blur of total indistinctness? At all events, compared to 'grass-green emeralds', 'a wilderness of monkeys' is a wilderness of possibilities. We are tempted to say that it is a 'vivid' phrase, and it is understandable that we should want to use that word about it. But 'vivid' is often used to describe clear-cut effects, such as a bright pattern or colour composition, and Shakespeare's phrase is not vivid in that way, rather the opposite. It manages to be at once vivid and nebulous. It is brilliantly and unfathomably indistinct, which is why the imagination is gripped by it and cannot leave it alone.

That is true of Shakespeare's plays as a whole. Their indistinctness, stirring and challenging our imagination, makes them inexhaustible. He seems to have been capable of this almost from the start of his career, though as his imagination matured it came to dominate. The examples that follow, which, to save tedious introductions, I will list numerically, are cited in chronological order, insofar as that can be determined.

1) This is from *Richard III*. The Duke of Clarence is describing a nightmare in which he seemed to have gone down into the underworld and met the spirits of people he had killed.

> ... then came wandering by
> A shadow like an angel, with bright hair
> Dabbled in blood, and he squeaked out aloud
> 'Clarence is come, false, fleeting, perjured Clarence,
> That stabbed me in the field by Tewksbury.'
>
> [I iv 52–6]

How can a shadow be like an angel? Shadows are grey. And is it the shadow or the angel that has bright hair, or both? Is it a shadow with bright hair, in the shape of an angel? Or a shadow that (somehow) resembles an angel with bright hair? Then again, why does the shadow describe Clarence as 'fleeting', as if he, not the shadow, was just a passing shadow? And how does it squeak? Like a pig? Like a baby (though babies do not exactly squeak)?

The imagination is often compared to a set of interior senses. We seem to see things, touch things, hear things, and so on, inside our heads. This is a convenient analogy. But it is also misleading, because our real senses connect us to the outside world, and make it solid. But our interior senses are much less definite – more filmy and transposable, like senses in a dream. So they can respond, as they do in this passage, to something being both a shadow and an angel, both dull and bright, and it

218

is this latitude of the interior senses that Shakespearean indistinctness exploits.

2) This is from *Troilus and Cressida*, probably about ten years later than *Richard III*. The lovers must part and Troilus is saying goodbye.

> We two, that with so many thousand sighs
> Did buy each other, must poorly sell ourselves
> With the rude brevity and discharge of one.
> Injurious time now, with a robber's haste,
> Crams his rich thievery up, he knows not how,
> As many farewells as be stars in heaven,
> With distinct breath and consigned kisses to them,
> He fumbles up into a loose adieu,
> And scants us with a single famished kiss,
> Distasted with the salt of broken tears.
>
> [IV iv 41–50]

Flattened out, that would mean something like 'We don't have time to say goodbye properly.' But Troilus does not flatten out; he elaborates and fantasizes. He invents a culprit, Time, who is like a robber because he steals all the farewells and kisses the lovers ought, by rights, to have had time for – all the farewells they might have said, and all the kisses they might have kissed, in the future which is now not going to happen. This haul of unspoken words and unkissed kisses is the 'rich thievery' he crams into – well, not into a bag or sack but into a 'loose adieu'. Why 'loose'? How can a spoken word be 'loose'? Does it mean 'throwaway' or 'casual', or has it got the idea of loosening and parting in it too? The robber metaphor makes us expect not an 'adieu' but a bag or sack, and 'loose' makes it sound as if its mouth droops, perhaps because it is still empty, or because Time is in too much of a hurry to hold it properly, and 'fumbles'. None of this exists – no robber, no bag or sack, no

farewells or kisses. Indistinctness proliferates through the lines. The spread of the indistinctness will depend on how far we allow Troilus's fantasy figure to materialize, or not. If we configure him with our imagination fully switched on we can fancy him sweeping all the stars into his sack like some cataclysmic black hole. Or if we read less graphically the stars may stay beyond the edge of the text, with hardly a glint or gleam. The whole construct is nebulous and pliable. The 'broken' tears (so bitter that 'distasted' seems to spit them out) are the final indistinctness. 'Broken' is not a word we use of liquids. Are they broken like crushed pearls? Or like hailstones shattering on impact? Or like glittering, glassy shards, reflecting the lovers' faces, as they might be in a Donne poem? Or are 'broken' tears less use, like broken toys? Whichever you choose.

3) This is from *Othello*, a year or two later than *Troilus and Cressida*. Fooled by Iago into believing that his wife Desdemona is having an affair with Cassio, Othello reflects on his quandary with murderous rage.

> But there where I have garnered up my heart,
> Where either I must live or bear no life,
> The fountain from the which my current runs
> Or else dries up – to be discarded thence,
> Or keep it as a cistern for foul toads
> To knot and gender in! Turn thy complexion there,
> Patience, thou young and rose-lipped cherubin,
> Ay, here look grim as hell.

> [IV ii 57–64]

What is Othello thinking about? The answer seems to be Desdemona's genitals, or maybe a notional compound of her genitals and her heart and her love. At all events, he is maddened by the thought of someone or something else being in a part of her which he had thought private and special for him,

and which was the centre of his love and manhood. It is the indistinctness that makes the speech so tormented and hysterical. The indistinctness is there because Othello both cannot help but imagine, and cannot bear to imagine, what has happened. He thinks in metaphors to shield himself from a horrible, simple truth – 'Cassio has fucked my wife' – and he thinks in metaphors because the horrible simple truth, put like that, is inadequate to the monstrous betrayal of the wanting and cherishing and loving that the word 'wife' has meant for him up to now. So, as is likely to happen with metaphors, one thing turns into another in a mad sequence. There is a 'garner' – a wholesome, wheat-filled, sweet-smelling thing, where a heart could be safely left. Then it turns into a fountain, which dares to come a little closer to the genitals with their seeping fluids. Then it becomes a 'cistern', which could be wholesome too – a pure reservoir feeding the fountain – but which, in Othello's imagining, grows hideous, a pond swarming with reptiles. Where have the toads come from? Obviously toads would not figure in any rational account of his wife's infidelity. But, because he cannot bear, even now, to imagine anything as filthy as her and Cassio actually copulating, he has to replace them with creatures that can express his loathing and contempt but remain not recognizably them. 'Knot' is a dreadful word for him to utter, because it imagines the toads embracing and clinging, so that the searing image of Desdemona, perhaps with her legs wrapped round Cassio's back as they writhe and enjoy each other, is for an instant flashed before his consciousness. Then he hauls himself back from the brink of madness: 'Patience'. Where this figure comes from, like where the toads come from, is indistinct, though we can imagine plausible answers. Young, beautiful, sanctified, she (if it is a she) is what Desdemona was like before she fell. After the foulness of the cistern his mind turns, to cleanse itself, to where it is accustomed to turn for

pure images – to Desdemona, as she used to be, and perhaps the rosy lips are, momentarily, the lips of her vagina, clean and sweet as they used to be before it became a cistern. But the thought of those lips, and what has happened to them, convulses almost instantly back into fury. 'Ay, here look grim as hell.'

Well, that is one way of imagining it. Others will imagine differently. Either way it is indistinctness that stimulates our imaginings.

4) This is from Macbeth's soliloquy when he is contemplating whether to murder King Duncan, and fears the consequences.

> Besides, this Duncan
> Hath borne his faculties so meek, hath been
> So clear in his great office, that his virtues
> Will plead like angels, trumpet-tongued, against
> The deep damnation of his taking-off;
> And Pity, like a naked new-born babe,
> Striding the blast, or heaven's cherubins, horsed
> Upon the sightless couriers of the air,
> Shall blow the horrid deed in every eye,
> That tears shall drown the wind – I have no spur
> To prick the side of my intent, but only
> Vaulting ambition, which o'erleaps itself
> And falls on th'other –

[I vii 16–28]

The indistinctness here, like that in the *Othello* passage, seems meant to convey the half-formed thoughts of a mind in torment. But it is stranger. You could argue that, for the passage to come across with maximum impact – for it to seem breathtaking and sublime, as it does when you first hear or read it – it should remain half, or less than half, understood. It should flash past in a glorious blur of angels, trumpets, cherubins and gigantic naked babies, like young warriors stripped for combat.

It is when you try to understand it that the problems arise. The naked new-born babe 'striding' the blast seems at first to be walking triumphantly in a strong wind – an impossible thing for a new-born babe to do, of course, but the imagination tends to modify it so that it becomes a stalwart toddler with the wind whipping round him, representing the mighty power of helpless innocence, or some allegorical meaning of that kind. But this is all wrong, as a closer look at the passage reveals. 'Striding' means 'bestriding'. The naked baby is sitting astride a blast of wind, or perhaps sitting astride the trumpet-blast made by the trumpet-tongued angels. What makes it evident that the baby is straddling an air-current, as if on horseback, is the cherubins in the next line, for they too are 'horsed' on horses made of air – and horses that are blind ('sightless couriers') or maybe invisible, or both. 'Couriers', in fact, did not mean horses but horsemen – lightly armed skirmishers – so either Shakespeare is extending the word to mean 'horses' or we have to imagine the cherubins sitting on the shoulders of blind, airy horsemen, who are themselves sitting on airy horses. As we dismember it in this way the passage starts to seem comic – a cast of characters sitting energetically on nothing, jigging up and down on thin air – and it ends comically. Macbeth continues the horse-riding image when he turns his thoughts to himself. He has, he says, no spur to urge his (imaginary) horse on, instead he tries to take a flying leap into its saddle and jumps right over it, landing on the other side. It is a kind of clown's circus trick, like the car with wheels that fall off.

Of course it is not funny. It is a mind breaking up. A less daring writer than Shakespeare would have avoided the comic images and substituted something dignified – mighty steeds ridden by mighty figures. If we were to read the passage in the flash-forward way I suggested earlier, catching only vague, impressionistic images, it would have that kind of convention-

al dignity. And we may prefer to read it like that. But to try to make sense of the indistinctness, and uncover its comic potential, is to come closer to Shakespeare's art, because it does not evade the words he wrote. What seems to happen is that Macbeth wants to find, or Shakespeare wants to find for Macbeth, a sequence of images that will crush together elemental power (the winds), military power (trumpets, a cavalry charge), innocence (a new-born baby), holiness (cherubins), and something that will make people weep (dust or other particles blown in the eyes). This strange, indistinct passage of dramatic poetry is the result.

It is tempting to continue with examples of Shakespearean indistinctness, but we must move on. Once Shakespeare had happened, English literature would never be the same again. Even poets like Dryden who resolved to reject his figurative richness could not help being shaped by it, and poets for whom he was supreme – Milton, Keats, Tennyson – are drenched in it. As the indistinctness of a text increases, so the reader's imaginative effort has to intensify. In extreme cases the reader has to take on almost all the responsibility for giving the text meaning. Blake's 'The Sick Rose' is an example:

> O rose, thou art sick:
> The invisible worm
> That flies in the night,
> In the howling storm,
> Has found out thy bed
> Of crimson joy;
> And his dark secret love
> Does thy life destroy.

Most modern readers are likely to think of the 'worm' as phallic, but there are problems with that. Phalluses are not usually invisible, nor do they fly. Besides, in another version of the

poem Blake wrote not 'his' but 'her dark secret love', which seems to rule out a phallic interpretation. Another disadvantage of the phallic reading is that it seems to turn the poem into a warning against female unchastity, which is not what we should expect from Blake ('Sooner murder an infant in its cradle than nurse unacted desires'). 'Invisible' and 'howling storm' suggest that Macbeth's sightless couriers of the air may be somewhere in the poem's genealogy. That does not seem to help with interpretation much, though it might make us wonder whether, if the worm is on the side of the angels, the rose's solitary bed of joy may not be such a good thing after all. Perhaps it is ingrown and barren and needs to be exposed to the power of sexuality – if the worm is sexual. Blake's illustration for the poem, which shows a rose, with what appears to be a spirit trying to escape from it, and a caterpillar munching one of its leaves, seems inadequate to the meanings that his poem suggests. It supports the feeling that visual art, in its definiteness and solidity, cannot match the indistinctness of literature. None of this detracts, of course, from the poem's power. It is generally considered one of the greatest short lyrics in the language, and since there is no knowing what it is about that is a remarkable testimony to the imaginative potential of indistinctness, when carried so far as to approach the meaningless – or, rather, to approach the point where creating meaning has to be taken on entirely by the reader.

Another example of extreme indistinctness, which connects with Shakespeare's influence, occurs in Tennyson's *Maud*. This is Tennyson's most Shakespearean poem. He called it a 'little *Hamlet*' and its plot – the feud, the dance, the duel, the flight – is from *Romeo and Juliet*. The poem's way of representing a mind on the edge of madness clearly derives from a study of Shakespeare's tragic heroes and their strange, unaccountable images. At one point the maddened lover, unable to sleep, or

drive Maud's 'cold and clear-cut face' out of his mind, tells how he got out of bed and went into the dark garden:

> Listening now to the tide in its broad-flung shipwrecking roar,
> Now to the scream of a maddened beach dragged down by the
>     wave,
> Walked in a wintry wind by a ghastly glimmer, and found
> The shining daffodil dead, and Orion low in his grave.
>
> [98–101]

The shining daffodil, like Othello's toads, seems to come from nowhere. There is no mention of a daffodil, or even of a garden, in the poem up to this point. It is possible that it seemed to come from nowhere for Tennyson, as well as for us. Like the male sex of Blake's worm, it was a second thought. The trial edition of *Maud* reads 'sweet Narcissus' for 'shining daffodil'. Because it is reasonless and inexplicable, the shining daffodil stimulates creative reading. Is it a real daffodil or imaginary? It would be less puzzling if Tennyson had written 'A shining daffodil' rather than 'The shining daffodil'. Then we should know, or at any rate have a better reason for thinking, that it was just something growing in his garden. The definite article makes it sound like something we all ought to recognize – like 'the moon', say, or 'the constellation of Orion', which is what comes up next in the line. The alternative reading 'sweet Narcissus' seems to refer to something of that kind (though, as a matter of fact, it is equally perplexing in the context). Then again, how can the daffodil be both 'shining' and 'dead'? Dead daffodils are limp and dull. But perhaps (like Shakespeare's 'shadow like an angel with bright hair') this shining, dead daffodil is only in the mind. Or is it a real daffodil that was once shining and is now dead? In the previous stanza the lover describes Maud's face, coming and going in his dream, as 'Pale with the golden beam of an eyelash dead on the cheek'. Is that where the brightness and yellowness and deadness of the daffodil enter his mind

from? All these questions will have different answers for different readers, and it is because the daffodil's reasons for being in the text are indistinct that such questions arise at all.

A third example (chosen, like these others, simply because I like it, for examples are infinite) is from Matthew Arnold's 'To a Gipsy Child by the Sea-Shore'. Arnold wrote this after seeing a sad-looking child when he was on holiday on the Isle of Man, and it turns into a poem about the roots of human sadness. Among these, for Arnold as for many care-worn Victorians, loss of religious faith featured prominently, robbing humans of the divine certainties they once possessed, and making them like fallen angels (or rather, as he writes, 'lost' angels, which sounds more bewildered and disoriented than 'fallen').

> Ah! Not the nectarous poppy lovers use,
> Not daily labour's dull, Lethean spring,
> Oblivion in lost angels can infuse
> Of the soil'd glory, and trailing wing.
>
> [53–6]

The Shakespearean lines that were clearly somewhere in Arnold's subconscious when he wrote this come from *Othello*, and are spoken by Iago when he sees that his plot to poison Othello's mind against Desdemona is working:

> Not poppy, nor mandragora,
> Nor all the drowsy syrups of the world
> Shall ever medicine thee to that sweet sleep
> Which thou owedst yesterday.
>
> [III viii 330–33]

The contexts are bizarrely different, yet there seems no doubt about the echo, which is not just verbal ('Not . . . poppy . . . Not'; 'Not poppy . . . Nor') but encompasses the whole subject of irretrievable, unforgettable loss. Arnold's lost angels are not in Shakespeare, though, nor are the haunting indistinctnesses

of his last line. Reading it, almost everyone (I suppose) must think of a wounded bird. Beyond that, however, all the details are for us to invent. How badly wounded? What sort of bird? Does 'soil'd' make us imagine dust – or blood – on feathers? Does the 'trailing' wing suggest that the bird is somehow frantically managing to struggle along? Then again, it is not a bird but an angel, so we have to reach an imaginative accommodation – something between a bird and an angel – much as we had to do with Shakespeare's 'shadow like an angel' from *Richard III*. Arnold's bird-image stirs feelings of pain and helpless sympathy more acutely than the Iago speech that was his starting point, but the extent of those feelings, and how far the image emerges from indistinctness, will vary endlessly with different readers.

At its furthest extreme, poetic indistinctness becomes nonsense verse. Actually 'nonsense verse' is an unfortunately disparaging label for a kind of poetry which, to judge from the very few people who have succeeded with it, is arguably harder to write than sense-verse. English nonsense-verse writing virtually begins and ends with Lewis Carroll and Edward Lear, both of whom went in for nonsense verse because they were (by the standards of their day) sexually unacceptable. Lear was gay; Carroll liked little girls with very few clothes on. Civilization, at the time, condemned and outlawed such preferences, which meant that, for Carroll and Lear, civilization did not make sense. Hence the appeal of nonsense. Their poetic masterpieces – Carroll's *Jabberwocky* and Lear's *Jumblies* – are far from nonsensical if nonsense is equated with pointlessness. The Jumblies evidently satirize Western quest-literature from Jason and the Argonauts through the Holy Grail stories to – in our own day – space travel. Like the heroes of these stories the Jumblies brave menacing terrains – the 'Torrible Zone' and 'the hills of the Chankly Bore' – and their vehicle is daringly frail – a sieve. The

things they bring back – a 'useful Cart', 'a hive of silvery Bees', 'a lovely Monkey with lollipop paws' – are quite as desirable in their way as the wonders most real questers acquire. Carroll's *Jabberwocky* has a slightly different target. It parodies the vast genre of Western chivalric literature – going back, in English, to *Beowulf* – that describes warriors fighting monsters or each other. By ending with a stanza identical to its first it intimates that monster-slaying achieves nothing.

> 'Twas brillig, and the slithy toves
> Did gyre and gimble in the wabe;
> All mimsy were the borogoves,
> And the mome raths outgrabe.
>
> Beware the Jabberwock, my son!
> The jaws that bite, the claws that catch!
> Beware the Jubjub bird, and shun
> The frumious Bandersnatch!
>
> He took his vorpal sword in hand:
> Long time the manxome foe he sought –
> So rested he by the Tumtum tree,
> And stood awhile in thought.
>
> And as in uffish thought he stood,
> The Jabberwock, with eyes of flame,
> Came wiffling through the tulgey wood
> And burbled as it came!
>
> One, two! One, two! And through and through
> The vorpal blade went snicker-snack!
> He left it dead, and with its head
> He went galumphing back.
>
> 'And hast thou slain the Jabberwock?
> Come to my arms, my beamish boy!
> O frabjous day! Callooh! Callay!'
> He chortled in his joy.

> 'Twas brillig, and the slithy toves,
> Did gyre and gimble in the wabe;
> All mimsy were the borogoves,
> And the mome raths outgrabe.

The expressiveness of this is evident, and it is also evident that it could not have been achieved in ordinary language. If we compare Othello's 'cistern for foul toads/ To knot and gender in' with Carroll's 'slithy toves/ Did gyre and gimble in the wabe', we can see that Carroll has taken a step closer than Shakespeare to the maelstrom of unvoiceable, indistinct feelings we all have inside us. That real words, and the logical, distinct categories they represent, have to be left behind as we read Carroll, means that an avenue has been opened to the flux of the unconscious. What the Jabberwock is actually like remains indistinct. It wiffles and burbles and has flaming eyes and a head that can be cut off. But beyond that we know nothing about it. This is true of all the monsters that the Jabberwock parodies, from Grendel in *Beowulf* to Tolkien's Smaug. Their indistinctness is what makes them monsters. Grendel seems to be a shape-changer – sometimes big enough to snatch thirty men from the mead-hall, or devour a fully grown warrior, sometimes close enough to human size for Beowulf to tear his arm off. Grendel is called a *mearcstapa*, which means literally a stepper along the boundary, or, less literally, 'a wanderer in the waste borderland' (the translation offered in Klaeber's edition), and this means that he remains on the border of our consciousness and that we dare not allow him closer.

The poet who anticipated Carroll's way of writing most extensively was Spenser, whose epic *The Faerie Queene* deals, like *Jabberwocky*, with warriors and monsters, and is, like *Jabberwocky*, though on a grander scale, a glittering quarry of odd spellings and unaccountable word-forms. Inevitably this mists it in indistinctness, and it is meant to. Spenser saw, like

Carroll, that only a weird, new language could fit his weird, new world. Taking us into the questionable terrain of allegory, where nothing is what it seems, he also takes us across a language-barrier, so that coming back to the real world and talking about his poem in normal language is like coming back from a foreign holiday and trying to describe what we have seen and heard. A stanza will be enough to illustrate the language of Spenser-land. This one is about the myth of Phaeton, who came to grief when he tried to drive the chariot of the sun:

> As when the firie-mouthed steeds, which drew
> The Sunnes bright wayne to Phaetons decay,
> Soone as they did the monstrous Scorpion vew
> With ugly craples crawling in their way,
> The dreadfull sight did them so sore affray,
> That their well-knowen courses they forwent,
> And leading th'ever-burning lampe astray,
> This lower world nigh all to ashes brent,
> And left their scorched path yet in the firmament.
>
> [v viii 40]

Unlike *Jabberwocky* this is not funny, because Spenser is not aiming at parody, but there is the same dependence on malformed words and coinages. 'Craples', for example, is a coinage – that is, it had never occurred in the language until this moment – and a coinage is the ultimate indistinctness, since the reader cannot possibly have any idea what it means, beyond the noise it makes and the sense of the words around it. 'Craples' sound like 'grapples', which may suggest they are claws, but what they look like and how ugly they are is for us to decide.

The examples of Carroll and Spenser remind us that poetry is not just, as Matthew Arnold said, a criticism of life, but a criticism of language. It renews language, rescuing it from the shallow grave of day-to-day talk. Words like 'slithy' or 'craples' bear out Ted Hughes's claim that the language of poetry is 'organi-

cally linked to the vast system of root-meanings and related associations, deep in the subsoil of psychological life'. Poets have always known what Victorian nonsense-poetry rediscovered. Blake's 'the forests of the night' or Keats's 'Much have I travelled in the realms of gold' have as little to do with any strict, ascertainable meaning as 'All mimsy were the borogoves'. Women poets, who have had to re-make male language for their own use, have found nonsense especially serviceable. Emily Dickinson, for example, persistently arms her poems with nonsense phrases – 'The doom's electric moccasin' or 'Like rain it sounded till it curved'. Modernist poets were also drawn to nonsense in their crusade to shake off the old poetic meanings. When T. S. Eliot writes (in 'Ash-Wednesday', lines 42–5):

> Lady, three white leopards sat under a juniper-tree
> In the cool of the day, having fed to satiety
> On my legs my heart my liver and that which had been contained
> In the hollow round of my skull.

it is statelier nonsense than Carroll's, but escapes sense with equal success. Scholars have struggled to find a plausible explanation for the three white leopards. Elijah sits under a juniper tree in I Kings 19, but there are no leopards. Jakob Grimm's story 'The Juniper Tree', sometimes invoked as Eliot's source, has no leopards either. Leopards in medieval literature can symbolize the pleasures of the flesh, but they are not white. Whether Eliot's leopards devoured their victim in the order he mentions – legs first, brain last – and whether, if so, this is significant, we cannot tell. Nor do we know how serious Eliot is being. His mention, a few lines later, of 'the indigestible portions/ Which the leopards reject' sounds like a joke, but we cannot be sure. The fact that the speaker has been eaten, but is still speaking, may mean he has not really been eaten, only

metaphorically. So perhaps the leopards are metaphorical too. We must decide whether to see them as emblems – three white leopards couchant, maybe, as in a heraldic device – or real animals, or something in between. We do not know the identity of the 'Lady' addressed either, and there is nothing in the rest of the poem to clarify it. So we must do our best to fabricate some sort of identity for her too. It is the nature of Eliot's poetry to stimulate and excite readers long before they understand what it means – if they ever do – and that is because, as this excerpt illustrates, it is constructed out of resonant and alluring indistinctness, like nonsense-verse.

However, the examples I have used so far may seem complicated and unusual and, consequently, altogether too conveniently supportive of my case. Surely, you may protest, multiple-choice questions, of the kind I have been proposing, are not raised by *all* literary texts. Surely some texts are just simple. Yes, they are. But even simple texts require reader-creativity, and precisely because they are simple the reader may be unaware of what he or she is having to supply. The indistinctness may, for instance, relate to matters of space and distance that we automatically construe in our own way, without even thinking that someone else might read them differently. Here is a simple poem by Tennyson, called 'The Eagle', which illustrates this:

> He clasps the crag with crooked hands;
> Close to the sun, in lonely lands,
> Ringed with the azure world, he stands.
>
> The wrinkled sea beneath him crawls;
> He watches from his mountain walls,
> And like a thunderbolt, he falls.

From talking to students about this poem I have found that the word nearly everyone reacts to most enthusiastically is 'wrin-

kled' in the fourth line. People agree that it gives a sudden, actual sense of how high up the eagle is, and they often compare it to the sea seen from a passenger jet as it comes down through the clouds. But the eye-catching impact of that one word is, in a way, deceptive, because it tends to conceal something indistinct about spatial relationships in the poem which, if you question readers further, they turn out to be subliminally aware of. For the answer to the question 'How high up is the eagle?' is not as simple as it looks, and the phrase that disturbs its simplicity is 'Close to the sun' in the second line. That phrase suggests something way beyond normal eagle height, and so, for that matter, does 'Ringed with the azure world'. The effort of these phrases – and of 'in lonely lands' – is to push the eagle as far away from our experience as possible, and to make it something not quite natural – something other than an ordinary bird of prey stationed at ordinary bird-of-prey height within the earth's atmosphere. A trace of this promotion of the eagle to a remoteness and grandeur beyond common eagle scope lingers in the thunderbolt simile in the last line. These suggestions play against the simple, real-world, passenger-jet vividness of 'wrinkled', so that in effect there are two sets of indications about the eagle's height in the poem, one life-size and one immeasurably greater. The friction between the two sets is what suffuses the poem with indistinctness.

All writers have to be interested in spatial effects, but Tennyson was particularly keen, so he is useful for illustrating the strange, indistinct sense of a space inside our heads that we get from reading. In his poem 'Will', for instance, he imagines a lonely desert-traveller toiling through 'immeasurable sand' beneath a blazing sky, while ahead of him:

> Sown in a wrinkle of the monstrous hill,
> The city sparkles like a grain of salt.

It takes a moment to adjust to that simile, and the adjustment consists of expanding the confines of your inner space until you are far enough away from the city for it to look like a grain of salt. This is the kind of movement that makes reading feel creative, and the experience has the indistinctness that similes always impel. For a city, its white buildings glittering in the sun, and a grain of salt, which, of course, has no buildings, both press themselves on the imagination, so that reading the simile requires a rapid alternation or flickering between the two.

How Tennyson manages to make the city seem far away is in this case obvious – he just diminishes its size. But his spatial play is often more ingenious. An example is the waterfalls seen by Ulysses' sailors as they approach the land of the lotos-eaters:

> . . . like a downward smoke, the slender stream
> Along the cliff to fall and pause and fall did seem.
> A land of streams! Some, like a downward smoke,
> Slow-dropping veils of thinnest lawn, did go;
> And some through wavering lights and shadows broke,
> Rolling a slumbrous sheet of foam below.

How does Tennyson make the waterfalls seem so far away? The first answer that comes to mind is that he makes them fall very slowly and gently, as they obviously would not if you were close to them. The hesitant 'fall and pause and fall' slows them up so much they actually stop, and likening them to smoke takes away all their urgency and weight, even while it is supposed to be signifying the perpetual fog of spray caused by the mass of displaced water. 'Slumbrous sheet' makes the concussion of their impact lethargic and dreamlike. But just as decisive in creating distance as the slowing-down, and less obvious, is the quiet. There is not a whisper in the lines. We are so far away that the thunder of the torrents is silenced – as quiet as smoke or a dropped veil. The most sonorous poet in the language gets his distancing effect by deafening us, almost without our noticing it.

Using the inner sense of hearing to get an inner visual effect of distance can be matched in Housman's poem 'Tell me not here', which is about remembered countryside pleasures:

> On russet floors, by waters idle,
>   The pine lets fall its cone;
> The cuckoo shouts all day at nothing
>   In leafy dells alone . . .

'Shouts' operates as a space-word as well as a sound-word, because to shout is to try to make yourself heard across space. So 'shouts', together with 'at nothing', surrounds the cuckoo with emptiness. 'Shouts' is suggestive in other ways. Shouting all day at nothing seems futile, or demented, as a bird-call does not. This cuckoo is evidently not just an item of pleasant reminiscence. Its behaviour is too strange and agitated for that. It may symbolize nature's senselessness – brutal and meaningless despite its beauty. But how much meaning it carries, and what kind of meaning, remains indistinct. The plural 'dells' is unexpected too, and adds to the spatial expansion. A cuckoo may be in a dell but it cannot be in dells. Or is it 'nothing' that is in the dells? 'Dells' opens up innumerable echoing spaces around the cuckoo, spaces in which its shout is heard though it may not actually be present.

The spatial examples I have used so far all represent things that are supposed really to exist – an eagle, a city, waterfalls, a cuckoo. They are real in the worlds of the poems, and we re-create them inside our heads, making use of whatever indistinct indications we can find. But in my final example of poetic space the thing represented does not exist, and the poet depicts himself going through the process of creating it inside his head as a reader normally has to do. This is in Keats's 'Ode on a Grecian Urn' – a poem that can be read, on one level, as a plea for the superiority of the inner senses ('Heard melodies are sweet, but

those unheard/ Are sweeter'). The poet, looking at the people depicted on the urn, imagines the town they must have come from.

> Who are these coming to the sacrifice?
>   To what green altar, O mysterious priest,
> Lead'st thou that heifer lowing at the skies,
>   And all her silken flanks with garlands dressed?
> What little town by river or sea shore,
>   Or mountain-built with peaceful citadel,
>     Is emptied of this folk, this pious morn?
> And, little town, thy streets for evermore,
>   Will silent be; and not a soul to tell
>     Why thou art desolate, can e'er return.

As the unanswered questions indicate, this stanza is about indistinctness, and about trying to make indistinctness distinct, as readers of literature do. Though the town remains unknown, it starts to acquire features – a citadel, streets. Of course, there is no town. The figures depicted on the urn are just figures depicted on an urn. They have not come from anywhere. The poet imagines they must have come from a town, then he starts imagining the town, and his thoughts stray further and further from the real. The streets will not be silent for evermore, because there are no streets. No 'soul' can return because there are no souls, just painted figures. Coming back to the town to tell it why it is desolate is impossible, because no one ever left it, and it does not exist anyway. But against these peremptory denials Keats's lines build an alternative town, indistinct, imaginary and indestructible. This town is just as real as Simon in *Lord of the Flies*, or any fictional character. It exists where everything we read about exists, in our mind. The fact that it has never existed beyond that makes it more wholly ours. We create and possess it, rescuing it from nothingness.

True, it is not as distinct as a town we actually see. Our inner

senses, which operate in our imagination, and which words stimulate, vary in their distinctness, sight being, with most people, the most distinct. But none of them is as distinct as our real, outer senses. If they start to become as distinct, we call it hallucination, which is a morbid condition, and reading does not normally produce it. As we noted in Chapter 3, language belongs to a younger part of the brain than vision, and is correspondingly less powerfully developed, so that, for example, it is impossible to describe a face in words with a certainty that it will be recognized, whereas a photograph will effect this instantly. The same goes for the other senses. No words could communicate a symphony as accurately as an orchestral performance can. With touch, taste and smell, words become even more inadequate. Imagine trying to describe the grade of sandpaper you need for some specialized job in words – whereas the fingers can pick it out unerringly. Even Proust could not have described the taste of a madeleine so that someone who had never tasted one could tell it from other cakes.

All this might seem to be to language's disadvantage. However, it is precisely this indistinctness in language that, as we have seen, literature exploits. From the viewpoint of activating the reader's imagination, it is an asset for words not to be fixed and definite like pictures. Sights, sounds, smells, tastes and textures in literature are all indefinite compared to photographs or symphony concerts, but this means that they are reader-adjustable. As we read, we draw on our personal memory-store of sights, sounds, smells, tastes and textures, and this adds to our sense that the text belongs to us. For example, when Keats in 'The Eve of St Agnes' describes Madeline slipping out of her clothes, and standing 'Half-hidden, like a mermaid in sea-weed', the feeling of cold and slipperiness would not come across if we had never touched seaweed ourselves. When she 'unclasps her warmed jewels', we know,

even if we have never felt warmed jewels, what warmth and what jewels feel like, and putting the two together in our imagination we can register how warm her body must be for it to warm her jewels despite the chill of the room. Golding in his novel *Pincher Martin* depicts the sole survivor of a torpedoed warship starving on a barren rock in mid-Atlantic and, fumbling through his pockets, finding the wrapper from a bar of chocolate:

> He unfolded the paper with great care: but there was nothing left inside. He put his face close to the glittering paper and squinted at it. In one crease there was a single brown grain. He put out his tongue and took the grain. The chocolate stung with a piercing sweetness, momentary and agonizing, and was gone.

The pain of this comes from the brilliance of Golding's writing, but the actual taste of chocolate is not there and could not seem to be unless we had tasted chocolate ourselves. So too with smell. No author (so far as I know) has written about the smell of flowering privet as evocatively as Michael Frayn in the opening paragraphs of *Spies*. But if you have never smelt privet flowers yourself, it will be just words. He supplies the evocation, you supply the smell.

I apologize if all this seems obvious. But literature's ability to capitalize on language's disabilities does not seem always to have been recognized. That language cannot communicate meaning fully and finally is sometimes spoken of as a shortcoming, making language less useful than it might have been, whereas in fact this very inability to communicate fully and finally is a condition of literature's existence. The indistinctness of our inner senses – even inner sight and inner hearing – means that writers can, with extreme rapidity, propel us along endless trails of sensory imagination. In Milton's *Comus*, for example, the young heroine, lost in a dark wood, and frightened, starts to panic:

> A thousand fantasies
> Begin to throng into my memory
> Of calling shapes, and beckoning shadows dire,
> And airy tongues that syllable men's names
> On sands, and shores, and desert wildernesses.
>
> [204–8]

The word 'syllable' powerfully appeals to our (well, my) inner hearing, but not in a way that I can ultimately account for. 'Syllable' makes it sound as if these ghost voices are pronouncing the names very slowly and carefully, and somehow tonelessly, like a machine, and perhaps with more sibilants than the names might otherwise be expected to contain. But none of this can be substantiated. It is all personal – which is my point. 'Syllable' activates our inner hearing, but what we hear will depend on our individual imagination. There is another brief but limitless effect of this kind in Philip Larkin's 'An Arundel Tomb'. Larkin imagines how the stone effigies of the earl and countess have lain, side by side, as the centuries passed:

> Snow fell, undated. Light
> Each summer thronged the glass. A bright
> Litter of birdcalls strewed the same
> Bone-riddled ground. And up the paths
> The endless altered people came . . .
>
> [26–30]

'Altered' is inexhaustibly indistinct, and, as a result, inexhaustibly suggestive. How the appearance of visitors to Chichester cathedral would alter, how their clothes and their voices and their language would change, in the course of six hundred years, would take six hundred years to describe. Larkin's line launches us on endless imagining, and the endlessness – the impossibility of conceiving it – carries with it a sense of bewilderment that matches what Larkin's earl and countess feel. As they lie there watching the unaccountable new

kinds of people come and go, their sense of themselves as people diminishes ('The endless altered people came/ Washing at their identity' is how the stanza goes on). So the indistinctness of 'altered' sets us thinking not only about the history of English costume and language and manners, but also about the growing alarm of two watchers trapped on a stone, and not quite able to take in what is happening to the human race.

The imaginative advantages that indistinctness offers outbid distinctness so thoroughly that some of literature's most famous effects are entirely dependent on the fuzziness and nebulousness of our inner senses. Caliban's reassurance to the shipwrecked mariners in *The Tempest* is a case in point:

> Be not afeard, the isle is full of noises,
> Sounds, and sweet airs, that give delight, and hurt not.
> Sometimes a thousand twangling instruments
> Will hum about mine ears; and sometimes voices
> That, if I then had wak'd after long sleep,
> Will make me sleep again; and then, in dreaming,
> The clouds methought would open and show riches
> Ready to drop upon me, that, when I wak'd,
> I cried to dream again.

[III ii 144–52]

Nothing is distinct here. Definition is carefully avoided at every point, and you can imagine how crass any attempt to reverse that would seem. A film director, for example, anxious not to bore his audience with old-fashioned blank verse, might decide to enliven the speech with modern technological enhancements. Ethereal music might provide tasteful back-up to Caliban's description of what he hears, and diaphanous golden showers might simulate the 'riches'. There is plenty of precedent for such improvements. In the Burton-and-Taylor film of Marlowe's *Dr Faustus*, when Faustus, maddened with fear, and about to be dragged to hell by devils, screams 'See,

see, where Christ's blood streams in the firmament', the camera obligingly tracks upwards to show a large splodge of red in the sky. What such effects do is to cancel, at a stroke, language's inexhaustible reserves of indistinctness, and simultaneously cripple the audience's imaginations. The power of Caliban's speech is inseparable from its vagueness, and readers or hearers must convert this into their own fleeting and questionable inner sensations. It is hard to imagine a 'twangling' that is also a 'hum', but we must find some way of registering those words on our inner senses. So, too, with the pointedly indefinite 'noises', 'sounds' and 'voices'. And what sort of 'riches' are about to drop from the clouds? The sense we get of rapid, shadowy meanings is characteristically Shakespearean. It is true that indistinctness has a special purpose in this speech, for it adds to Caliban's pathos that he can only stumblingly express his brief glimpses of happiness. But, as we have seen, indistinctness is standard for Shakespeare, and integral to his power.

How we read, and how we give meanings to the indistinctness of what we read, is affected by what we have read in the past. Our past reading becomes part of our imagination, and that is what we read with. Since every reader's record of reading is different, this means that every reader brings a new imagination to each book or poem. It also means that every reader makes new connections between texts, and puts together, in the course of time, personal networks of association. This is another way in which what we read seems to be our creation. It seems to belong to us because we assemble our own literary canon, held together by our preferences. The networks of association we build up will not depend on spotting allusions or echoes, though sometimes we may notice these, but on imaginative connections that may exist only for us. This, of course, makes the subject rather hard to write about, since I

can only give an example of connections that occur to me. However, that does not differentiate it very much from the rest of this chapter, and, so far as I can tell from questioning friends and students, my connections are no more arbitrary than other people's. The example of an imaginative nexus I have in mind brings together the ideas of birds and darkness. A starting point might be Macbeth's meditation before the murder of Banquo:

> Light thickens, and the crow
> Makes wing to the rooky wood;
> Good things of day begin to droop and drowse,
> Whiles night's black agents to their preys do rouse . . .
>
> [III ii 50–53]

This, as usual, is indistinct, because it is not clear whether the crow is one of night's black agents or a good thing of day. Going home to roost at nightfall suggests it might be good, but its blackness is against it. *Macbeth* has other dark birds besides the crow – 'The raven himself is hoarse'; 'I heard the owl scream' – and the bird-darkness fans out (it seems to me) through English literature. It extends, for example, to George Eliot's Casaubon, who sits in the dark researching into the solar deities, and whose frigid wooing of Dorothea is like 'the cawing of an amorous rook'. It extends to Dickens's *Bleak House* where, at nightfall, Snagsby the law-stationer 'sees a crow, who is out late, skim westward' to Lincoln's Inn Fields, home of Mr Tulkinghorn, who is certainly not a good thing of day. Dickens was so saturated in Shakespeare that he probably did not know whether he was echoing him here or not. Ted Hughes's *Crow* eventually added its own dark doings to the network, but many poets had anticipated him. Young Milton, writing Shakespearean pastiche in *Comus*, introduces one of the weirdest dark birds when Comus commends the cadences of the Lady's song, 'At every fall smoothing the raven down/ Of darkness, till it

243

smiled'. A smiling raven? Or is it 'darkness' that smiles, and what would that look like? Then, later in the 17th century, come Henry Vaughan's night-birds, 'poisonous, subtle fowls', and, with the Romantics, Keats's nightingale ('Darkling, I listen'), which brings thoughts of death, and echoes Milton's nightingale that 'sings darkling' (which Keats marked in his copy of Milton), and Eliot's nightingales in 'Sweeney among the Nightingales', whose droppings ('liquid siftings') bespatter and congeal on Agamemnon's 'stiff, dishonoured shroud', and Hardy's decrepit Darkling Thrush, singing its inexplicable song of joy in a deathly landscape. Owls and bats join the network – owls with their 'long halloos, and screams' that Wordsworth's death-struck boy blows mimic hootings to across the dark lake; bats from Bacon ('Suspicions amongst thoughts are like bats amongst birds, they ever fly by twilight'), through to Bram Stoker's Dracula going head-first down a wall in bat shape. And the largest collection of death-birds is, to end where we began, Shakespeare's *The Phoenix and the Turtle*, which excludes the owl ('shrieking harbinger') from the mourners, but admits the swan, famous for its 'defunctive music', and a sexually-indistinct corvine:

> And thou treble-dated crow,
> That thy sable gender makest,
> With the breath thou giv'st and takest,
> 'Mongst our mourners shalt thou go.

When you talk to other readers you soon find that networks of this kind are commonplace. 'What it reminds me of . . .', they will say, and you are given a glimpse of some quite new set of connections. I am not suggesting that this is deeply significant, or that important literary truths will emerge from our individual, imaginative hooks-and-eyes. On the contrary, it is precisely because these networks are arbitrary and personal, precisely

because they are not like some mathematical theorem where everyone is on common ground, that they can play such a vital role in strengthening our sense of self. They make literature an internal thing, special to us. The fact that we can learn poems, or bits of prose, by heart is also crucial here, and it distinguishes literature from all the other arts. Of course, we can hum tunes, or play them over inside our heads, but it is not the same as going to a performance. We can remember pictures, perhaps quite vividly, but it will hardly make us never want to see them again. But learn a poem by heart, and you have it for ever. You never again have to consult a text. You can say it over to yourself in the small hours. It is yours. The equivalent would be lugging *The Kiss* home from the Musée Rodin, or strolling out of the Frick with Vermeer's *Girl Interrupted at Her Music* and, cumbersome though it might be to get through the door, Gainsborough's *Walk in St James's Park*. With literature we can commit these thefts shamelessly and as often as we choose. Indeed, it is better even than that, because supposing you did get the *Girl Interrupted at Her Music* home, you could never make her part of you. You could not take her into yourself, so that her beauty became yours. But with literature you can. Once its words are lodged in your mind they are indistinguishable from the way you think.

A last point. Because the previous chapter, which was about ideas, mainly used examples from prose, and this one, which is about imagination, mainly uses examples from poetry, it might seem that I am saying poetry does not have ideas. But of course I am not. The prose/poetry division is hard to operate anyway. A lot of what, for me, is poetry (the *Lord of the Flies* passage about Simon's body, for example) is written in prose, and a lot of verse is prosaic. But whatever definition of poetry you find acceptable, poetry can transmit ideas, and always has done. Sometimes its ideas seem relatively straightforward. For exam-

ple, John Donne's advice, 'Doubt wisely'. Or, going back in time, the resolve of the doomed warrior in the Old English poem *The Battle of Maldon*, when fighting against impossible odds:

> Hige sceal þe heardra, heorte þe cenre,
> mod sceal þe mare, þe ure maegen lytlað

– which is not really translatable into modern English, as we do not have enough alliterating words, but means something like 'Thought must be more resolute, courage more keen, will-power greater, as our strength lessens.' Or, going back further still, Aeneas's words to his followers in the midst of disaster: *forsan et haec olim meminisse iuvabit*, which translates, very roughly, 'One day we'll laugh at all this', or, more staidly, 'Perhaps it will one day be a joy to recall even this distress.' All of these are ideas strong enough to live by. And, though they seem straightforward when quoted out of context, they are all, when you put them back into the poems where they belong, charged with emotion. This is characteristic of poetic ideas. Poetic ideas do not tell you what the truth is, they make you feel what it would be like to know it. Because they make you feel as well as think, you can appropriate them, grow into them, adopt them as your own. When Larkin writes:

> If I were called in
> To construct a religion
> I should make use of water.

the power of the idea resides in its not being specific, so we can adapt it to our needs. Transparent and ordinary, water stands for freedom, not coercion. A glass of water, as Larkin writes, allows 'any-angled light' to 'congregate endlessly'. Auden's great poem 'Lullaby' is not specific either:

> Lay your sleeping head, my love,
> Human on my faithless arm;
> Time and fevers burn away
> Individual beauty from
> Thoughtful children, and the grave
> Proves the child ephemeral:
> But in my arms till break of day
> Let the living creature lie,
> Mortal, guilty, but to me
> The entirely beautiful.

Presumably it was written with a male lover in mind, but you cannot tell. It speaks to all lovers in their 'ordinary swoon'. It tells us what we all know: that beauty dies, that we want love to last for ever, and that it will not. But it enlarges us, because its emotional charge allows us to feel with it, and take on its wise and kind resignation as our own. So it contributes to that sense of personal ownership which, I have been arguing, is literature's unique gift.

And Shakepeare? Well, Shakespeare, of course, has more ideas than any other writer, and people used to construct anthologies of his wise and thoughtful bits, though it is no longer a fashionable thing to do. If I had to choose one single Shakespearean thought to cling to when all else fails it would not be from any of the great plays or major characters but from Parolles in *All's Well that Ends Well*. Parolles is an army officer but also a coward and a braggart. His name indicates that he is just made of words (as, for that matter, are Shakespeare's plays). The upstanding young officers who are his comrades-in-arms see through him and play a trick on him. They make him believe he has been captured by enemy soldiers and is about to be tortured. Blindfolded and terrified, he blurts out everything they want to hear. Then they take off his blindfold and disgrace and derision burst upon him. Left alone at last, humiliated and ruined, he decides to survive in spite of every-

thing: 'simply the thing I am/ Shall make me live'. That thought may be useful for all of us in the end, and it is a different thought for each of us, because each of us must read 'the thing I am' in a different way.

# Afterword

I have argued that there are no absolute values in the arts. We cannot call other people's aesthetic choices 'mistaken' or 'incorrect', however much we happen not to like them. Or, rather, we cannot do so rationally. Current research into brain function, which aims to discover what 'normal' aesthetic responses are, cannot alter this situation, because it has no way of deciding whether one response is better or worse than another. We might condemn other people's aesthetic choices on the grounds that they are likely to lead to undesirable behaviour. But causal links between aesthetic choices and behaviour cannot be demonstrated. Alternatively we might condemn them on the grounds that they arouse feelings inferior to our own feelings when we confront 'genuine' artworks. However, this claim would be irrational, both because other people's feelings are inaccessible to us, and because there is no criterion for deciding which feelings have universal value, as opposed to value just for us.

But if artistic value comes down simply to a welter of personal preferences, then how, someone sceptical of my position might ask, do acknowledged 'great' artists come to be so acknowledged? How can we account for the growth – and, for that matter, the decline – of worldwide artistic reputations? How could an artist acquire global fame if his or her work did not enshrine some sort of universal value, even though we may be unable to identify exactly what it is?

It is helpful, I think, in answering these questions to make a comparison with fashions in other areas of life. Why fashions change, and what determines the direction in which they change, are difficult questions, but they have received close attention from theorists in recent years. Stanley Lieberson, in his book *A Matter of Taste*, concludes from a study of, among other things, fashion in the choice of first names for children, that there are two major influences on taste, internal mechanisms of change and external social forces. He cites Howard Becker's *Art Worlds*, which draws attention to the central role of groups in generating artistic innovation, and also John H. Mueller's *The American Symphony Orchestra: A Social History of Musical Taste*, based on the programmes of music played by American orchestras over the period 1875–1950, which traces the decline in popularity of six composers – Schumann, Berlioz, Mendelssohn, Schubert, Liszt and Rubinstein.

Lieberson treats fashion as one of the internal mechanisms of change which, once set in motion, will generate new preferences indefinitely without the addition of any external influence. But he also recognizes the importance of a factor like class-imitation – the process whereby upper-class fashions are imitated by the lower, so exerting a perpetual pressure on the upper classes to innovate. Studies like Lieberson's do not, of course, assume any intrinsic 'value' in one fashion rather than another. When we say that someone has good taste and someone else has not, all we really mean, as Lieberson sees it, is that we like or dislike their choice – of clothing, for example – within the context of the choices currently available. But studies of taste, though making no assumptions about value, may be able to identify social factors in any particular period that influence the direction of change. An article Lieberson refers to by Edward Tenner, about fashion in men's hats, will allow us to make a comparison with changes in artistic taste in roughly the same time span.

Tenner notes the massive decline in the popularity of men's felt hats with brims in the period after the Second World War. Before the war men of all classes wore such hats as a matter of course, as photographs of New York depression-era breadlines or London homeless shelters illustrate. But after the war the felt hat disappeared, and it has been replaced in our era by the baseball cap, which is worn universally by males, most of whom have never played baseball and are not built to excel in it.

The social factors that might be invoked to explain this change would include the growth of informality, as evidenced, say, by the increasing use of nicknames in the workplace, and the prestige of America as a world superpower. If we were to seek a change in artistic taste traceable to the same social factors, we might instance the decline in reputation of the once celebrated Victorian painter of classical scenes, Sir Lawrence Alma-Tadema, and the rise to world-stature of Jackson Pollock the American Abstract Expressionist. Alma-Tadema's meticulously executed canvases bespeak the appeal of elegant lifestyles and the social cachet of a classical education. By contrast Pollock, putting his canvas on the floor and dribbling paint onto it from a can, represents proletarian informality, and his global reputation is a symptom of American cultural dominance. America, as a superpower, had to have a world-class painter, just as it had to win the space-race and conquer the world with soft drinks, chewing gum and baseball caps. To deduce from this that Pollock was an intrinsically better painter than Alma-Tadema would be like claiming that baseball caps are intrinsically better than felt hats with brims, and enshrine absolute, universal, eternal values that felt hats with brims lack. Similarly, to claim that we have 'progressed' in artistic discernment because we now prefer Pollock to Alma-Tadema would be like claiming that the worldwide dissemination of baseball caps is a sign of our improved insight in matters of headgear.

Again, the argument, often met with, that avant-garde artistic taste is 'proved right' when posterity accepts it, would, applied to our hat-example, mean that baseball caps were always truly and essentially superior to felt hats with brims, though this was evident only to a gifted minority of baseball fans, whose superior taste has now been vindicated.

I hope the above will not be taken to mean that I believe Alma-Tadema a better painter than Pollock, or vice versa, or that anyone who derives spiritual rapture from either artist (or, for that matter, from baseball caps, as no doubt some small boys do) is wrong to do so. If it is asked how, in this relativist world, one decides which artists or writers or musicians to pay attention to, my own view is that Dr Johnson's argument carries weight:

> What mankind have long possessed they have often examined and compared: and if they persist to value the possession, it is because frequent comparisons have confirmed opinion in its favour.

In other words, if you stick to the canon you are less likely to waste your time.

There is, however, a field of human activity in which results can be evaluated, and progress measured, with more certainty than in the arts. Science, so the French sociologist Emile Durkheim maintains, has replaced not only the arts but also religion as the locus of truth:

> Philosophers have often speculated that, beyond the bounds of human understanding, there is a kind of universal and impersonal understanding in which individual minds seek to participate by mystical means; well, this kind of understanding exists, and it exists not in any transcendent world but in this world itself. It exists in the world of science, or at least that is where it progressively realizes itself, and it constitutes the ultimate source of logical vitality to which individual human rationality can attain.

The truths of science are verifiable, and the progress of science can be measured in many fields from heart-transplant surgery to nuclear fission. From its earliest days Western science has restricted itself to answerable questions, and has scrupulously observed rules of proof and evidence, as the arts have not. Consequently 'scientific truth' means something definite, whereas 'artistic truth' is a nebulous concept. It is true to say, for example, that the earth goes round the sun, whereas to claim that Pollock is a better painter than Alma-Tadema, or vice versa, is not a verifiable proposition but an opinion, and this would be so even if it were an opinion that very many people, or possibly all living people, shared.

Does this mean that the arts have no access to truth? Art-lovers have often strenuously denied such an imputation. Schopenhauer maintained that art was a form of knowledge, giving intuitive, direct access to metaphysical truths, 'the permanent, essential forms of the world and all its phenomena'. The philosopher Hans-Georg Gadamer has called art 'a transformation into the true'; the painter Piet Mondrian contended that abstract art revealed 'the true content of reality' and 'the great hidden laws of nature'; Jeanette Winterson refers to 'the huge truth of a Picasso', and so on. What are we to make of such claims? Obviously they are different from the claims to truth that science makes, since they are not verifiable, and it is unfortunate that the way they are phrased sometimes obscures this difference. It would be impossible to prove that a Picasso was any more 'true' than, say, a washing machine or a packet of crisps. 'The permanent, essential forms of the world and all its phenomena', as an atomic physicist would understand the phrase, would bear no relation to what Schopenhauer meant by it, and what Schopenhauer meant by it would seem to most people nowadays merely fanciful. Claims about the 'truth' of art are statements of personal belief, akin to professions of reli-

gious faith, and since they are not subject to verification or falsification they cannot have the same kind of authority as claims that are.

However, a more serious objection to claims that art is 'true' is that they are restrictive and limiting. Though their aim seems to be to aggrandize art, they in fact diminish it. Science's concentration on truth is reductive, in that every true answer displaces innumerable false ones. Science's progress is at the expense of its past mistakes, which cease to have any scientific interest, and become merely part of the history of science. Art does not operate in this way. There are no false answers in art, because there are no true answers, and the past matters because the present does not displace it. Since art must accommodate all personal tastes and choices (at least, according to the definition of a work of art that I have offered), it is as illimitable as humanity, and as extensive as the imagination. The aim of science, by contrast, is to find solutions that are unaffected by taste or choice, and which consequently eliminate the human element altogether. In this respect, art is infinite, whereas science is bounded. But art is infinite only because, and so long as, it does not allow truth-claims. Once truth-claims are admitted – the claim, for instance, that Picasso is more 'true' than some other painter – the terrain of what can be counted as 'real' art shrinks, and is subjected to policing, instead of being as lawless and inventive as human intelligence.

That the arts are enjoyable to those who enjoy them is a fact that it may seem I have not emphasized enough in this book. If I have not done so, it is partly because it is obvious, and partly because being enjoyable does not distinguish the arts from a vast range of other human activities. Proofs that the arts are somehow higher or better than these other activities do not seem to be available. But recommending the arts simply as forms of enjoyment does not seem very attractive either. Kevin

Melchionne, in an article called 'The Idea of Aesthetic Health', has argued that the 'aesthetically healthy' are people who seek new and more refined experiences in the arts as in other areas. They will see the world as 'a field of possible sources of satisfaction'. Signs of their aesthetic health will include, according to Melchionne, their ability to discriminate between fine wines and their liking for exotic foods, as well as for 'complicated novels, foreign films, and strange sculptural installations'. The aesthetically healthy person will be a 'gourmand', as well as an art-lover, with a 'finely honed but voracious aesthetic appetite', and will be 'on the lookout for new spices and produce in order to concoct new recipes'. As will be seen, Melchionne accepts consumerism and luxury as unquestioned goods, and reduces the arts, and everything else in life, to the elegant piggishness of an in-flight magazine. Defences of the arts purely in terms of enjoyment always run this risk. On the other hand, to spiritualize the arts, and imagine that they can aspire to the significance of a religion, is (or so I have argued in Chapter 5), a delusion.

My more hopeful answer to the question 'What good are the arts?' comes at the end of Chapter 5 in the section on the arts in prison. There is evidence that active participation in artwork can engender redemptive self-respect in those who feel excluded from society. This may be the result of gaining admittance to an activity that enjoys social and cultural prestige. But it seems also to reflect the fact that standards of achievement in art are internal and self-judged, and allow for a sense of personal fulfilment that may be difficult to gain in standard academic subjects. The difficulty prisoners meet with when they try to pursue their artistic interests after release is a consequence, I have argued, of our inadequate support for art in the community, which stems from a belief in ideals of excellence, as reflected in Arts Council policy. The contention that the money available for the arts should be reserved for 'quality institu-

tions' such as the Royal Opera House, rather than being spread through the whole community, automatically relegates the public to the role of passive art-worshippers. It is not a decision that would be countenanced in any other area. The proposal, for example, that the money available for education should in future be spent only on the supremely gifted would immediately arouse opposition.

The idea that the arts are things that happen in 'quality institutions' seems to be essentially competitive. It puts 'achievement' in the arts on a level with national sporting triumphs or scientific breakthroughs. This triumphalist view of art seems to be related to the notion that high-quality artworks are 'monuments' to the human spirit. The earliest occurrence I have come across of this formulation is in Rousseau's *Discourse on the Sciences and the Arts*, where Rousseau urges that the arts and sciences should be left to geniuses, and that ordinary people should not be encouraged to play any part in them, because geniuses alone can 'raise monuments to the glory of the human mind'. It is not clear whom the monuments are intended for. But since human art is appreciated only by humans, Rousseau's suggestion effectively turns art into a pretext for the human race to glorify itself, which, given its long-term assumption of superiority to other species, is an incitement it hardly needs. Besides, if art is to be regarded as a collection of monuments it casts the majority of people in the drab and secondary role of monument-visitors, and negates the possibility of participation in art as a redemptive activity. It is worth adding, perhaps, that Rousseau himself seems not to have believed in his 'monument' idea, since he spends the rest of the essay saying that the arts and sciences make people effeminate, dissolute and depraved, and that men were better off without them, when they lived in rustic simplicity and ignorance.

Views of art as extolling the 'glory' of the human mind or

spirit tend to envisage art as inducing rapture or ecstasy, and these states are, like religion, escapes from the rational. In the second part of this book, dealing with literature, my emphasis is on literature's thought-content, which connects it with rationality. I claim that literature is the only art capable of reasoning, and the only art that can criticize. Advocates of contemporary conceptual art might, I am aware, dispute both claims, pointing out that it embodies concepts, as its name implies, and that these can be critical of present-day society and culture. However, conceptual art's ability to embody concepts is, I would contend, open to question. Language is the medium that we have evolved for embodying concepts, and the usual ingredients of conceptual art – objects, noises, light effects – cannot replicate this function. The catalogues and explanatory essays that accompany conceptual art's installations often claim that they 'explore' concepts. We are told, for example, that a stack of plastic recycling boxes 'explores the idea of the self-organizing power of the city'. A collection of hotel bills and travel tickets 'explores the relationship between the symbolic and the real'. A series of five trampolines 'explores personal memory and identity'. These claims are all taken from the catalogue of the 2004 Liverpool Biennial, and they are clearly not sustainable. Their use of 'explores' could, at best, mean only 'might possibly stir some vague thoughts about'. Only language can explore concepts – it cannot be done by plastic boxes, travel tickets or trampolines. Even to formulate concepts requires language, as the catalogue author's commentary demonstrates.

The aura of seriousness with which conceptual art surrounds itself is in this respect misleading. It has more in common than its proponents are willing to concede with the instant, sound-bite culture that they frown on. Another exhibit at the Liverpool Biennial was a maze made out of cotton. It occupied a whole gallery, and was said to 'evoke the historical suffering of

slavery'. In fact, reading even a short article on the subject of Liverpool and the slave trade would tell you more about the historical suffering of slavery than a cotton maze. But reading is comparatively arduous, whereas wandering round a cotton maze is just the kind of slipshod, superficial substitute for knowledge and understanding that conceptual art's advocates imagine themselves struggling against. The artwork that most effectively evoked the suffering of slavery was a work of litera-ture, Harriet Beecher Stowe's antislavery novel *Uncle Tom's Cabin*, which spoke to the conscience of a nation and helped change the course of history. Tolstoy in *What Is Art?* preferred it to Shakespeare, and it is worth instancing here since it illus-trates literature's ability to activate intelligence and feeling towards a practical end – the abolition of slavery – to a degree far beyond that so far evidenced by any work of conceptual art.

By contrast with Stowe's novel, conceptual art is calculatedly exclusive. It professes its eagerness to reach out into the streets and engage the public, but cannot resist signalling its superior-ity even while doing so. During the Liverpool Biennial, posters and badges depicting a naked female breast and a female crotch with pubic hair, designed by Yoko Ono, were distributed around the city, and caused great offence, particularly to mothers with young children. The many who phoned to com-plain would, we may assume, be regarded by the organizers as existing on a level of sophistication and emancipation far below their own. The brochures and catalogues accompanying the Liverpool Biennial also deliberately excluded the majority by using the inaccessible language customary in such publications. 'The artists propose to claim the ontogenesis of community . . .'; 'It is as though a case of digital drift is nudging the homo-genizing synchronization of the global art market into a synco-pated beat of local sounds . . .'– whoever framed these sentences was evidently not concerned with conveying thought to a wide

readership or, indeed, with thinking at all. Their function, and the function of all the 'explanatory' material in the brochures and catalogues, was to exclude the general public.

It is true that the emphasis I have given to literature's thought-content omits literature's power to yield other kinds of pleasure – emotional, comic, romantic, and so on. But its thought-content distinguishes it most markedly, I believe, from other arts. Thought-content makes it critical and self-critical as no other art is. Thought drives satire, and literature's satirical powers, wielded by, say, a Jonathan Swift, would make short work of Kevin Melchionne's aesthetic gluttons or Rousseau's monuments to human vanity. Swift satirized conceptual art, long before it was invented, in Book 3 of *Gulliver's Travels* where the sages of Balnibarbi forbid the use of language and communicate by holding up objects which they rummage for in huge bundles, carried on their backs. Whereas conceptual art is incapable of the clarity that argument requires, literature, I have argued, is an area of persistent contentiousness and contradiction, so that to read literature is to be forced continually to assess and discriminate between alternative personalities, opinions and world-views. The flexibility and range of thought available in literature seem particularly important at a historical moment when our own world-view in the West is being sharply challenged.

Read and remembered, literature becomes part of your own mind. It is unfortunate, in this respect, that current methods of school and university examination, based on projects and course-work, discourage memorizing, and reward, instead, a pupil's or student's ability to download information from the Internet. The boredom and lack of inner resources among the young, instanced towards the end of Chapter 6, which impels them to vacate their own minds with the help of alcohol and drugs, may relate to this educational change.

Literature's indistinctness (as Chapter 7 argues) makes reading creative, and gives readers a sense of possession, even of authorship. The detainee at Deerholt young offenders' institution who exclaims, after reading *Lord of the Flies*, 'I've got a massive imagination', speaks for all readers. Literature does not make you a better person, though it may help you to criticize what you are. But it enlarges your mind, and it gives you thoughts, words and rhythms that will last you for life.

# Postscript

People disagreed about this book even more violently than I expected. My belief that preferences in art are just preferences, and nothing more, infuriated some readers, while to others it seemed plainly true – just what they had always felt. The disagreement seems to go very deep, and is hard to account for. It is almost as if, on this question, human beings divide into two irreconcilable groups. Those who believe in personal taste think it obvious that things are valuable only insofar as someone values them. It is the act of valuing that confers value. But for their opponents some things, notably works of art, have intrinsic, eternal and universal value. Even if the human race died out, 'true' works of art would still be valuable, though there would be no one left to value them.

Reviewers who believe in absolute values of this sort understandably disliked the book. But in their haste to condemn it they sometimes, it seemed to me, misrepresented or evaded its arguments, possibly because I had not made them clear enough. This worried me, especially as several of them were writers whose work I held in high regard, and in this postscript I shall try to meet some of their objections. The book's most contentious passage proved to be my definition of a work of art as 'anything that anyone has ever considered a work of art, though it may be a work of art only for that one person'. On this, ex-Tory MP George Walden wrote in the *Sunday Telegraph*:

The fatuity of this definition is revealed simply by substituting 'Napoleon' for 'a work of art'. To say that anyone who has ever considered himself to be Napoleon is Napoleon, if only to himself, doesn't get you very far. That way lies the madhouse.

Walden was evidently pleased with his logical coup, and when, a week later, he gave the book a second adverse notice on the Radio 4 programme *Saturday Review*, he repeated the Napoleon analogy. Book programmes are nerve-racking things to listen to if you happen to be the author on trial, and I admit to a moment of uncharitable glee when Walden was shouted down by his fellow panellists. They could see, as he could not, that he had failed to distinguish between a matter of fact and a matter of opinion. That Napoleon was Napoleon is a fact no one bothers to argue about, whereas what makes something a work of art has proved endlessly disputable.

My attempt at a definition angered others because it seemed disrespectful to the artistic community, who alone should have the right to decide what are and what are not works of art. On the Radio 4 programme *Start the Week*, Ekow Eshun, Director of the Institute of Contemporary Arts, was outraged by the audacity of my suggestion, and though it was hard to tell, in the flurry of debate, quite what counter-argument he wished to present, it seemed to amount to a claim that those who belonged to the art-world, like himself, were uniquely fitted to identify works of art. My intention had certainly not been to upset Ekow, whom I like and admire. But the difficulty, as I see it, is to find convincing arguments with which to oppose someone whose idea of a work of art differs from your own. Supposing this other person thinks that – say – a tin of excrement is a work of art. I can set out my criteria for a work of art, which exclude a tin of excrement. He will then set out his, which include it. Where do we go from here? There are no facts or certainties to appeal to. We are both in an area of pure opin-

ion. All I can say is: 'Well, it is not a work of art for me, though it evidently is for you' – and that is the impasse that my attempt at a definition tried to formulate. It would not help to counter (as George Walden suggests) 'Well, you are mad if you think it a work of art', for your opponent might reply, with equal lack of cogency, 'You're mad if you don't.' Nor would it help to say, 'Well, I am head of the ICA, and I have decided it is not a work of art,' for the other person might not share your respect for officialdom.

Terry Eagleton, a critic of deservedly high repute, reviewing the book in the New Statesman, challenged my subjective approach from another angle. He agreed with me that anything can be a work of art - what makes it a work of art is that it is regarded as a work of art. But he distrusted the free-for-all conclusions I drew.

> Carey, however, concludes from this that art is just a subjective matter. He does not see that saying 'This is what I call a work of art' is possible only if I already have a concept of art; and this concept, like any other, is not private but public. He is, in fact, an old-fashioned Cartesian dualist, of the sort that almost every eminent philosopher from Ludwig Wittgenstein onwards has had fun demolishing. He believes that experience is inherently private, that the consciousness of others is inaccessible to us. Perhaps he has not heard of language – or indeed art. What else is art but the public sharing of intensely personal experience?

In fact, immediately after suggesting that a work of art is anything anyone has ever considered a work of art, I wrote 'Further, the reasons for considering anything a work of art will be as various as the variety of human beings.' Eagleton's eye must have skipped over this. At all events, by saying that the concept of art is 'public', he implies that it is one about which there is consensus. Nothing, of course, could be further from the truth – nor (as my imagined dialogue with the admirer of a

tin of excrement, above, tries to show) is there, so far as I can see, any hope of ever reaching such a consensus. The world is full of 'public' concepts – liberty, justice, sin – about which there is endless disagreement, as Eagleton must have noticed.

He is right to say that I believe the consciousness of other people is inaccessible to us. But this does not mean I subscribe to a Cartesian soul-body distinction, or to the ghost-in-the-machine idea of human make-up that Gilbert Ryle and others have mocked. All I contend is that everyone has a mental and emotional life, and that to have access to that life in someone else you would have to become the other person, which is impossible. Does Eagleton really believe he can think with someone else's mind, feel with someone else's feelings? If so, he should let us know how it is done – or perhaps he should not, for it would be a terrible weapon in the hands of the secret police, a recipe for cracking open another human being, which is the dream of every brutal and bungling torturer the world over.

As for his trust that language and art give us access to someone else's 'intensely personal experience', it seems to me naïve – a version of the old idea that a work of art is a sort of parcel in which the artist wraps up his feelings and sends them out into the world so that readers or viewers can unwrap them and feel exactly as the artist felt. A lifetime's experience of the endlessly divergent feelings and interpretations that artworks elicit in students and academics should surely have cured him of this illusion. The fact that other people's feelings are inaccessible is, as readers will realize, vital to my argument about evaluation. You cannot say, for example, 'What I feel when I listen to Mozart is more valuable than what you feel when you listen to whatever trash gives you pleasure' – and you cannot say this because what another person feels is not accessible. My chapter on science included a critique of Edward O. Wilson's recipe for

entering another consciousness, and I was disappointed that Eagleton, while insisting he can enter another person's consciousness, overlooked this.

An exceptionally long and thoughtful review was John Banville's in the *Irish Times*. But it, too, took exception to my definition of a work of art, and it was accompanied by a picture of the ruins of the New York twin towers. The caption read:

> According to Prof. John Carey, 'a work of art is anything that anyone has ever considered a work of art'. Composer Karlheinz Stockhausen declared the attacks on the twin towers a work of art on a stupendous scale – by Prof Carey's definition therefore 9/11 must be considered a work of art.

Well, no. The caption faithfully reproduces what Banville says in his review, but it is untrue. My definition continues 'though it may be a work of art only for that one person'. Banville sweeps this aside, but it is in fact crucial. By my definition 9/11 must be considered a work of art for, and only for, Karlheinz Stockhausen. I imagine most people would find his identification abhorrent, as I do. But if Stockhausen says it is a work of art for him then there is no escaping the conclusion that it is a work of art for him.

Erik Tarloff in *Prospect* magazine took yet another tack. Unlike Walden, Eagleton and Banville, he concedes that my definition is 'logically indisputable', but complains that 'it sheds no light'. I freely confess that it is tautological. However, I do not agree that that prevents it from shedding light. If, as is the case, it seeks to replace and undermine the enormous number of pretentious and prescriptive definitions that have been dreamed up over the centuries, then it does shed light, because it seeks to show that such definitions are useless, and that hopes of reaching consensus are vain – that there is, indeed, no escape from tautology. Rather in the same way, if I were asked to define the word 'funny', I might say 'Anything is funny that

strikes someone as funny.' This, too, is tautological. But it cannot, in my view, be replaced by anything less tautological. To replace it you would have to argue that some things are necessarily and by their nature funny (or not funny). I do not believe that this would be a rational enterprise. You could of course argue that those who laugh at certain things (death, say, or religion) are wrong to find them funny. But they would still be funny for the laughers, otherwise they would not laugh.

Given my comments on her thoughts about art, Jeanette Winterson had more cause than most to be angered by the book, and she was. In her *Times* review she wrote:

> I am not neutral, not simply because I am cited in his book as 'superior', 'elitist' and 'barely sane', but because he was present when I explained to more than a thousand students how I had escaped from a life of poverty, got myself to Oxford, become a writer, and all because of the power of art. My text was simple: if art could do that for a working-class girl whose father could not read, art is neither remote nor a luxury.

This is a remarkable passage. For one thing, few people, surely, would have selected as a crowning tribute to the power of art the fact that it had allowed Jeanette Winterson to climb up the social scale. More surprising, though, is her claim that she lectured to 'more than a thousand students'. The event she refers to was the 2004 Hillary Lecture, which she gave in the Gulbenkian Lecture Theatre in Oxford's St Cross Building, and the capacity of this theatre is 240. However, though the inaccuracy is blatant, I do not think Winterson was being dishonest. The vision of herself lecturing, or preaching ('My text was simple'), to a great multitude seems, rather, to be a facet of her apostolic stance. It is quite believable that in her mind's eye she saw more than a thousand students – they were there on a spiritual plane, though not in fact. Whether this counts as 'barely sane' is really irrelevant. It is more important to relate it to her

belief in art as an alternative religion – the theme of her lecture and of her review – and to the distorting and self-aggrandizing effects that belief can encourage.

'The title *What Good are the Arts?*', she writes, 'seems as idiotic to me as asking "What good is food?"'. This is strongly in the gospel tradition. It was Jesus who said 'Man cannot live by bread alone, but by every word that proceeds from the mouth of God.' But there are objections to transposing religion's claims to art, as Winterson does. In a world that contains millions of starving people, it is offensive to proclaim that art is as necessary as food. Only a lifetime of three square meals a day could foster so foolish a fancy. Christ's words, on the other hand, are serious (whether you believe in them or not). He offers the starving not art but eternal life. Of course, Winterson is not alone in her religiosity. Art-worshippers often declare that people without art are not 'truly alive' – that their souls have died for lack of spiritual nourishment, just as their bodies would without food. But in fact there are hosts of pursuits, from abseiling to zoology, that enrich the lives of their devotees, and for art-lovers to suppose such people are dead inside is impertinent.

Winterson believes that art, like religion, makes you a better person. 'Like religion art offers an alternative value system, it asks us to see differently, think differently, challenging ourselves and the way we live.' Challenging herself is not something we see Winterson doing, however, nor even allowing herself a moment of self-doubt. In reality a religion such as Christianity, with its strict ethical code and its insistence on the subjugation of the self, is entirely unlike art, which has no unified ethic, and which often generates not self-abasement but self-esteem, as Winterson shows.

A curious feature of several reviews is that they assume I hate art. It is as if the reviewers cannot get their heads round the idea

that someone might want to take a cool, rational look at the claims made for art, while at the same time enjoying art galleries, classical music, and so forth. In his attack on the book in the *Times Higher Educational Supplement*, Charles Saumarez Smith, Director of the National Gallery, writes 'It turns out that what Carey likes is popular art'. You might have supposed that my admiration in the book's second half for writers like Bacon and Browne, who are hardly popular favourites, would have given Saumarez Smith second thoughts about this. But anger seems to have blurred his vision. He writes:

Carey starts with a statement that no one would have understood the concept of art before the late eighteenth century. 'You might say that the question "What is a work of art?" could not have been asked before the late eighteenth century, because until then no works of art existed'. This is characteristic of his intellectual method. It sounds smart. But it suggests that he has perhaps not heard of Leonardo or Raphael or Michalangelo.

Seemingly Saumarez Smith did not notice that on page 135 of my book I use the example of Leonardo's *Last Supper*, and its partial destruction in the seventeenth century, to show that the religion of art as we know it did not exist at that time. The sentence of mine he quotes is, in my text, immediately followed by others, which explain it: 'I do not mean that objects we now regard as works of art did not exist before that date. Of course they did. But they were not regarded as works of art in our sense.' Had Saumarez Smith included that, it would have spoilt the point he wanted to score, so he omitted it. However, to counter my argument he would need to demonstrate that Leonardo, Raphael and Michelangelo regarded works of art as we do in the twenty-first century, and he shows no sign of being able to do so.

Finally, a frequent complaint among reviewers was that the second half of my book, which makes claims for the superiori-

ty of literature, contradicts the first, which denies absolute standards. I did my best to guard against this accusation at the start of the second half:

> Just in case anyone should seize on these claims as inconsistent with the relativist cast of the first half of my book, let me emphasize that all the judgments made in this part, including the judgment of what 'literature' is, are inevitably subjective.

Perhaps this should have been printed in block capitals, for as things turned out several reviewers just ignored it, and concluded that the book was (as Sam Leith put it in the *Daily Telegraph*) 'broken-backed'. Personally I do not see any contradiction. What is contradictory about saying, 'Look, there are no absolute standards. We do not live in a universe that contains such things. But these works of literature are what have meant most to me – even more than music, painting and the other arts – and I'll try to explain why. Of course, you may not be persuaded, and there's nothing wrong with that. But there's a chance that, if you give them a try, you'll get pleasure from them as I have.' Where's the contradiction?

Anyway, that's what I was trying to say in the second half of the book, and at the end of this grumbling postscript it's a pleasure to thank all those who got the point and liked it. Most of the reviewers – thank heavens – were in this category, and there were also many jubilant readers who wrote letters or came up to me at literary festivals. What was heartening about their enthusiasm was that they felt liberated by the book. They eagerly denounced so-called masterpieces that had left them cold, and cried up their less august preferences, without feeling ashamed or afraid or ignorant or inferior. They had come into their own. I especially remember one lady who cornered me at the Hay-on-Wye Festival. She quite liked art, she said, but what she really loved was gardening, and she thought it – here she

looked round nervously, and lowered her voice – 'more, well, philosophical than art'. Then she quoted, in a sweetly cadenced voice, two of my favourite lines from Wordsworth:

> To me the meanest flower that blows can give
> Thoughts that do often lie too deep for tears.

I said: 'I wish I had put that in my book.' And now I have.

# Bibliography

Adorno, Theodor W., 'Culture Industry Reconsidered', *New German Critique* vi (Fall 1975)

– and Horkheimer, Max, 'The Culture Industry: Enlightenment as Mass Deception', in *Dialectic of Enlightenment*, trans. John Cumming (London: Allen Lane, Verso, 1979), 120–67.

Alexander, Peter, *Shakespeare* (London: Oxford University Press, 1964)

Anderson, Richard L., *Calliope's Sisters: A Comparative Study of Philosophies of Art* (Englewood Cliffs, NJ: Prentice Hall, 1990)

Atwood, Margaret, *Oryx and Crake* (London: Bloomsbury, 2003)

Bailey, Anthony, *A View of Delft: Vermeer Then and Now* (London: Chatto and Windus, 2002)

Barnett, Homer G., *Innovations: The Basis of Cultural Change* (New York and London: McGraw-Hill, 1953)

Barzun, Jacques, *The Use and Abuse of Art* (Princeton: Princeton University Press, 1975)

Baudelaire, Charles, *The Painter of Modern Life and Other Essays*, ed. and trans. Jonathan Mayne (London: Phaidon Press, 1964)

Bazin, Germain, *The Museum Age*, trans. J van Nuis Cahill (New York: Universe Books, 1967)

Beardsley, Monroe C., *Aesthetics: Problems in the Philosophy of Criticism* (Hackett, Indianapolis, Cambridge: 2nd edn, 1981)

Becker, Howard S., *Art Worlds* (Berkeley: University of California Press, 1982)

Bell, Clive, *Art*, ed. J. B. Bullen (Oxford: Oxford University Press, 1989)

Benjamin, Walter, 'The Work of Art in the Age of Mechanical

Reproduction' in *Illuminations*, ed. Hannah Arendt, trans. Harry Zohn (London: Cape, 1970), 219–54

*Beowulf and the Fight at Finnsburg*, ed. Fr. Klaeber (Boston: D. C. Heath and Company, 3rd edn, 1950)

Berenson, B., *Aesthetics and History* (London: Constable, 1950)

Berger, John, *Ways of Seeing* (London: BBC and Penguin Books, 1972)

Berlyne, D. E., *Aesthetics and Psychobiology* (New York: Appleton-Century-Crofts, 1971)

Bernstein, J. M., ed., *The Culture Industry: Selected Essays on Mass Culture* (London: Routledge and Kegan Paul, 1991)

Bloom, Allan, *The Closing of the American Mind* (New York: Simon and Schuster, 1987)

Bourdieu, Pierre, *Distinction: A Social Critique of the Judgement of Taste*, trans. Richard Nice (London: Routledge and Kegan Paul, 1984)

Bourguignon, Erika, 'Dreams and Altered States of Consciousness in Anthropological Research', in F. K. L. Hsu, ed., *Psychological Anthropology* (Cambridge, Mass.: Schenkman, 2nd edn, 1972)

Buford, Bill, *Among the Thugs* (London: Secker and Warburg, 1991)

Cabanac, Michel, 'Emotion and Phylogeny', *Journal of Consciousness Studies*, vi 6–7 (June–July 1999)

Čapek, Karel, *In Praise of Newspapers and Other Essays on the Margins of Literature*, trans. M. and R. Weatherall (London: George Allen and Unwin Ltd, 1951)

Carey, John, ed., *John Donne* (Oxford and New York, Oxford University Press, The Oxford Authors, 1990)

– ed., *The Faber Book of Utopias* (London: Faber and Faber, 1999)

Carroll, Noel, *A Philosophy of Mass Art* (Oxford: Oxford University Press, 1998)

Coetzee, J. M., *Stranger Shores: Essays 1986–1999* (London: Secker and Warburg, 2001)

Collingwood, Robin George, *The Principles of Art* (Oxford: Clarendon Press, 1938)

Danto, Arthur C., 'The Art World', *The Journal of Philosophy*, lxi 19 (1964).

– *The Transfiguration of the Commonplace: A Philosophy of Art* (Cambridge, Mass.: Harvard University Press, 1981)

– *After the End of Art: Contemporary Art and the Pale of History* (Princeton, NJ: Princeton University Press, 1997)

Davidson, Ian, *Voltaire in Exile* (London: Atlantic Books, 2004)

Dawkins, Richard, *A Devil's Chaplain: Selected Essays*, ed. Latha Menon (London: Weidenfeld and Nicolson, 2003)

Dewey, John, *Art as Experience* (London: Allen and Unwin, 1934)

Dickinson, Emily, *The Poems of Emily Dickinson*, ed. Thomas H. Johnson (Cambridge, Mass.: The Belknap Press of Harvard University, 1955)

Dissanayake, Ellen, *What Is Art For?* (Seattle and London: University of Washington Press, 1988)

– *Art And Intimacy: How the Arts Began* (Seattle and London: University of Washington Press, 2000)

Drummond, John, *Tainted by Experience: A Life in the Arts* (London: Faber and Faber, 2001)

Dunbar, Robin, *The Human Story: A New History of Mankind's Evolution* (London: Faber and Faber, 2004)

Duncan, Carol, *The Aesthetics of Power: Essays in Critical Art History* (Cambridge: Cambridge University Press, 1993)

– *Civilizing Rituals: Inside Public Art Museums* (London and New York: Routledge and Kegan Paul, 1995)

Durkheim, Emile, *The Evolution of Educational Thought: Lectures on the Formation and Development of Secondary Education in France*, trans. Peter Collins (London: Routledge and Kegan Paul, 1977)

Ehrenzweig, Anton, *The Hidden Order of Art: A Study in the Psychology of Artistic Imagination* (1967; London: Weidenfeld and Nicolson, 1993)

Eisner, Elliot W., *The Arts and the Creation of Mind* (New Haven and London: Yale University Press, 2002)

Elias, Norbert, *The Civilizing Process: The History of Manners and State Formation and Civilization*, trans. Edmund Jephcott (Oxford: Blackwells, 1994)

Ellis, R. D., 'The Dance Form of the Eyes', *Journal of Consciousness Studies*, vi 6–7 (June–July 1999)

Freeland, Cynthia, *But Is It Art? An Introduction to Art Theory* (Oxford: Oxford University Press, 2001)

Gadamer, Hans-Georg, *Truth and Method*, translation ed. Garrett

Barden and John Cumming (London: Sheed and Ward Ltd, 1975)

Gardner, Howard, *The Arts and Human Development: A Psychological Study of the Artistic Process* (New York, London, Sydney, Toronto: John Wiley and Sons, 1973)

Gascoigne, Bamber, *The Christians* (London, Toronto, Sydney, New York: Granada Publishing, 1980)

Getty, J. Paul, *As I See It* (London: W. H. Allen, 1976)

Glover, Jonathan, *What Sort of People Should There Be? Genetic Engineering, Brain Control, and their Impact on Our Future World* (London: Penguin Books, 1984)

Greenberg, Clement, *Collected Essays and Criticism*, ed. John O'Brian (Chicago: Chicago University Press, 1986)

Hakewill, George, *An Apologie of the Power and Providence of God in the Government of the World* (Oxford: John Lichfield and William Turner, 1627)

Hanson, Karen, 'Dressing Down, Dressing Up: the Philosophic Fear of Fashion', *Hypatia* v 2 (Summer 1990), Indiana University Press

Harrington, C. Lee, and Denise D. Bielby, *Soap Fans: Pursuing Pleasure and Making Meaning in Everyday Life* (Philadelphia: Temple University Press, 1995)

Harth, Erich, 'The Emergence of Art and Language in the Human Brain', *Journal of Consciousness Studies* vi 6–7 (June–July 1999)

Hartman, Geoffrey, *Scars of the Spirit: The Struggle against Inauthenticity* (London: Palgrave, Macmillan, 2002)

Heaney, Seamus, *Death of a Naturalist* (London: Faber and Faber, 1966)

– *Crediting Poetry* (London: Faber and Faber, 1995)

– *Finders Keepers: Selected Prose 1971–2001* (London: Faber and Faber, 2002)

Hegel, Georg Wilhelm Friedrich, *The Philopsophy of Fine Art*, trans. F. B. P. Osmaston (London: G. Bell and Sons Ltd, 1920)

Hewison, Robert, *Culture and Consensus: England, Art and Politics since 1940* (London: Methuen, revised edn, 1997)

Hibberd, Dominic, *Wilfred Owen* (London: Weidenfeld and Nicolson, 2002)

Hobson, Dorothy, *Crossroads: The Drama of a Soap Opera* (London: Methuen, 1982)

Holland, R. F., *Against Empiricism: On Education, Epistemology and Value* (Oxford: Blackwells, 1980)

Horsley, Sebastian, 'Burn, Baby, Burn . . . This Is the Best Work of Art for Years', *The Times*, 27 May 2004, T2, 7

Hughes, Robert, *The Shock of the New: Art and the Century of Change* (London: Thames and Hudson, updated and enlarged edn, 1991)

Hughes, Ted, ed., *By Heart: 101 Poems to Remember* (London: Faber and Faber, 1997)

Hume, David, 'Of the Standard of Taste', from *Essays Moral, Political and Literary*, ed. Eugene F. Miller (Indianapolis: Liberty Fund, revised edn, 1987)

Humphrey, Nicholas, 'Cave Art, Autism, and the Evolution of the Human Mind', *Journal of Consciousness Studies*, vi 6–7 (June–July 1999)

*Including the Arts: The Route to Basic and Key Skills in Prisons* (London: Standing Committee for Art in Prisons and Bar None Books, 2001)

James, William, *The Varieties of Religious Experience* (Cambridge, Mass.: Harvard University Press, 2002)

Jameson, Fredric, *Postmodernism; or, The Cultural Logic of Late Capitalism* (London: Verso, 1991)

Jamison, Kay Redfield, *Touched with Fire: Manic Depressive Illness and the Artistic Temperament* (London: Free Press, 1994)

– *An Unquiet Mind* (London: Picador, 1997)

Jankowski, William, and Fischer, Edward, 'A Cross-Cultural Perspective on Romantic Love', *Ethnology* xxxi 2 (1992)

Johnson, Samuel, *Johnson on Shakespeare*, ed. Walter Raleigh (London: Henry Froude, 1908)

Kandinsky, Wassily, *Concerning the Spiritual in Art and Painting in Particular*, trans. Francis Golffing, Michael Harrison and Ferdinand Ostertag (Roxbury, Mass.: Halliday Lithograph Corp., 1955)

Kant, Immanuel, *Critique of Judgment*, trans. J. H. Bernard (New York: Hafner Publishing Company, 1951)

Kaplan, Abraham, 'The Aesthetics of Popular Arts', in *Modern Culture and the Arts*, ed. James B. Hall and Barry Ulanov (New York: McGraw Hill, 2nd edn, 1972)

Korsmeyer, Carolyn, ed., *Aesthetics: The Big Questions* (Oxford: Blackwell, 1998)

Kreitler, Hans and Shulamith, *Psychology of the Arts* (Durham, NC: Duke University Press, 1972)

Langer, Susanne, *Feeling and Form: A Theory of Art Developed from Philosophy in a New Key* (London: Routledge and Kegan Paul, 1953)

Laski, Marghanita, *Ecstasy: A Study of Some Secular and Religious Experiences* (London: The Cresset Press, 1961)

– *Everyday Ecstasy* (London: Thames and Hudson, 1980)

Lewis-Williams, David, *The Mind in the Cave: Consciousness and the Origins of Art* (London: Thames and Hudson, 2002)

Lieberson, Stanley, *A Matter of Taste* (London and New Haven: Yale University Press, 2000)

MacGregor, Neil, *The Perpetual Present: The Idea of Art for All*: The Romanes Lecture 2002 (Bodleian MS Eng. C 7027, ff. 263–76)

Manguel, Alberto, *Reading Pictures* (London: Bloomsbury, 2001)

May, Rollo, *Power and Innocence: A Search for the Sources of Violence* (London: Souvenir Press, 1974)

McLuhan, Marshall, *Understanding Media: The Extensions of Man* (London: Routledge and Kegan Paul, 1964)

– and Bruce R. Powers, *The Global Village: Transformations in World Life and Media in the 21st Century* (New York: Oxford University Press, 1989)

Midgley, Carol, 'In Prison? Take It As Read', *The Times*, 17 December 2003, 11–12

Milton, John, *Complete Shorter Poems*, ed. John Carey (London and New York: Longmans, 2nd edn, 1997)

Mueller, John H., *The American Symphony Orchestra: A Social History of Musical Taste* (London: Calder, 1958)

Murdoch, Iris, *The Sovereignty of Good* (London: Routledge and Kegan Paul, 1991)

Nussbaum, Martha C., *Love's Knowledge: Essays on Philosophy and Literature* (New York and Oxford: Oxford University Press, 1990)

Ortega y Gasset, José, *The Dehumanization of Art, and Other Essays in Art, Culture and Literature* (Princeton: Princeton University Press, 1968)

Osborne, Harold, *Aesthetics and Art Theory: An Historical Introduction* (London: Longmans, 1968)

Palmer, Frank, *Literature and Moral Understanding: A Philosophical Essay on Ethics, Aesthetics, Education and Culture* (Oxford: Clarendon Press, 1992)

Perrett, D. J., K. A. May and S. Yoshikawa, 'Facial Shape and Judgements of Female Attractiveness', *Nature* ccclxviii (1994), 239–42.

Phillips, Adam, *Houdini's Box: On the Arts of Escape* (London: Faber and Faber, 2001)

Pierre, DBC, 'Bittersweet Symphonies', *Guardian*, 27 February 2004

Postman, Neil, *Technopoly: The Surrender of Culture to Technology* (New York: Vintage Books, 1993)

Purves, Libby, 'Behind Bards', *The Times*, 11 February 2004, 13.

Ramachandran, V. S., and William Hirstein, 'The Science of Art: A Neurological Theory of Aesthetic Experience', *Journal of Consciousness Studies*, vi 6–7 (June–July 1999)

Ricks, Christopher, *Dylan's Visions of Sin* (London: Viking/Penguin, 2004)

Rose, Jonathan, *The Intellectual Life of the British Working Classes* (New Haven and London: Yale University Press, 2001)

Rousseau, Jean-Jacques, *Basic Political Writings*, ed. D. A. Cress with an introduction by Peter Gay (Indianapolis, Cambridge: Hacket Publishing Company, 1987)

Ruskin, John, 'The Crown of Wild Olive', in *The Works of John Ruskin*, vol. 18, ed. E. T. Cook and Alexander Wedderburn (London: George Allen, 1905)

Sacks, Oliver W., *The Man Who Mistook His Wife for a Hat* (London: Duckworth, 1985)

Sartre, Jean-Paul, *What Is Literature?*, trans. Bernard Frechtman (London: Methuen, 1967)

Schopenhauer, Arthur, *The World as Will and Idea*, trans. R. B. Haldane and John Kemp (London: Kegan Paul, Trench, Trubner and Co. Ltd, 2nd edn, 1891)

Sennett, Richard, *Respect: The Formation of Character in an Age of Inequality* (London: Allen Lane/ Penguin, 2003)

Shelley, P. B., *Complete Works* (London: Ernest Benn Ltd; New York: Charles Scribner's Sons, 1930)

Smets, Gerda, *Aesthetic Judgment and Arousal: An Experimental Contribution to Psycho-aesthetics* (Leuven: Leuven University Press, 1973)

Smith, Chris, *Creative Britain* (London: Faber and Faber, 1998)

Spotts, Frederic, *Hitler and the Power of Aesthetics* (London: Hutchinson, 2002)

Steiner, George, *In Bluebeard's Castle: Some Notes Towards the Re-Definition of Culture* (London: Faber and Faber, 1971)

Stern, Jane and Michael, *The Encyclopaedia of Bad Taste* (New York: Harper Collins, 1990)

Storr, Anthony, *Music and the Mind* (New York and Oxford: Free Press, Maxwell Macmillan International, 1992)

Suzuki, Daisetz T., *Zen and Japanese Culture* (Princeton, NJ: Princeton University Press, 1959)

Taft, R., 'A Psychological Assessment of Professional Actors and Related Professions', *Genetic Psychology Monographs*, lxiv (1961)

Tenner, Edward, 'Talking Through Our Hats', *Harvard Magazine*, xci (May–June 1989)

Tillman, Frank A., and Steven M. Cahn, *Philosophy of Art and Aesthetics from Plato to Wittgenstein* (New York, Evanston and London: Harper and Row, 1969)

Tolstoy, Leo, *What Is Art?*, trans. Aylmer Maude, ed. W. Gareth Jones (London: Bristol Classical Press, 1994)

Tusa, John, *Art Matters: Reflecting on Culture* (London: Methuen, 1999)

Van Lawick-Goodall, Jane, 'The Chimpanzee', in Vanne Goodall, ed., *The Quest for Man* (New York: Praeger Publishers, 1975)

Walker, Christopher, 'Nothing to Do and Nowhere to Go', *The Times*, 10 May 2004, 21

Weitz, Morris, *Philosophy of the Arts* (Cambridge, Mass.: Harvard University Press, 1950)

Wilson, Edward O., *Consilience: The Unity of Knowledge* (London: Little, Brown and Co., 1998)

Wimsatt, William K., and Monroe C. Beardsley, *The Verbal Icon: Studies in the Meaning of Poetry* (Lexington: University of Kentucky Press, 1954)

Winner, Ellen, 'Mute Those Claims: No Evidence (Yet) for a Causal

Link between Arts Study and Academic Achievement', *Journal of Aesthetic Education*, xxxiv (Fall–Winter 2000)

Winterson, Jeanette, *Art Objects: Essays on Ecstasy and Effrontery* (London: Jonathan Cape, 1995)

Woolf, Virginia, *The Moment and Other Essays* (London: Hogarth Press, 1947)

Zeki, Semir, *A Vision of the Brain* (Oxford: Blackwells, 1993)

– *Inner Vision: An Exploration of Art and the Brain* (Oxford: Oxford University Press, 1999)

# Notes

Items in the bibliography are referred to by the first word of the entry, plus a publication date if it is the first word of more than one entry.

### Introduction
ix *The arts, it is claimed*: see Hartman 155, Holland 73, Osborne 115, Storr 17, 145, Hegel i 11, Murdoch 83. *The Australian critic:* Hughes (1991) 270.

x *The most excellent*: Schopenhauer Book 3 Section 49. *Flaubert:* quoted in Bourdieu 576. *Greenberg:* see Greenberg i 12.

xi For the Dogaressa's table fork see Elias 55.

### ONE What is a work of art?
3 *Maritain*: see Tillman 479.

4 *Manzoni . . . Yves Klein*: see Hughes (1991) 382.

5 *Arp . . . Tzara*: see Hughes (1991) 61. *Orlan*: see Korsmeyer 161–3. *Barschak*: reported in *The Times*, 31 October 2003.

6 *Laurent Tailhade*: see Hibberd 134–5. *Breton . . . Burden*: see Hughes (1991) 267.

8 *rain dance*: see Van Lawick-Goodall 162–4. *Kant was in several respects*: for music see Kant 172–4, for the beautiful, 27, for the supersensible, 149, for charms and emotions, 58, for the morally good, 198–202, for scientists, 151–2, 161.

11 *C.W. Valentine*: Osborne 123.

12 *Hegel . . . teaches that*: for the Divine see Hegel i 9, for the Absolute, i 77, for higher reality, i 11, for Nature's inadequacy, i 40, for music, i 37, for the senses, i 52, for brides and bridegrooms, i

61, for the Chinese etc., i 101, for fettering passions, i 66.

13 *Schopenhauer, another beneficiary*: see Schopenhauer Book 3 Sections 34–39.

14 *golden section*: see Berlyne 228–30; Osborne 63-5.

15 *Meanwhile the attempts*: Osborne 10–11; Dewey 162.

16 *Picasso . . . Lichtenstein*: see Hughes (1991) 351, 366. *The critic who has examined*: the following paragraphs draw extensively on Danto (1964), (1981) and (1997). For Danto's 'essentialism' see (1997) 95; for the art-world, (1997) 165; for the candy bar, (1997) 185; for 'intended meaning', (1997) 165; for the painted necktie, (1981) 40; for 'demo-Christian aesthetics', (1981) 93; for the Manhattan telephone directory and literature, (1981) 136, 146; for the limit to what can be art, (1981) 22.

23 *Virginia Woolf*: Woolf 14.

24 *In music*: see Kreitler 279–80. *As for the question*: Kreitler 364-5.

25 *more weighty cultural critics*: see Hughes (1991) 111, and Hughes's speech to the Royal Academy of Arts reported in *The Times*, 3 June 2004, 10; Jameson 37.

26 *Marc Quinn's head*: see the *Evening Standard*, 3 July 2002, and *The Times*, 4 July 2002.

27 *Momart warehouse fire . . . Sebastian Horsley*: see *The Times*, 27 May 2004, 3, and *T2*, 7.

TWO Is 'high' art superior?

32 *The novelist Jeanette Winterson*: see Winterson 4–6, 93, 134, 74, 87, 72, 19, 144.

34 *As Ellen Dissanayake argues*: this and the following paragraphs draw on Dissanayake (1988), especially 55–9, 98–102, 109, 115–6, 172–87, 195.

35 *North American Eskimos*: see Anderson in Korsmeyer 19–33.

36 *romantic-sexual love*: see Dissanayake (2000) 49. *purpose of emotion*: see Wilson 123. *The only critic*: see Capek 20, 101, 130.

37 *We speak of the democratization*: from Capek's essay 'Instead of Criticism'. I am indebted to Dr Sarka Kuhnova of Charles University, Prague, for the translation.

38 *ethnographic survey*: Dissanayake (1988) 155 citing Bourguignon.

39 *Karen Hanson*: see Korsmeyer 59–72 and Baudelaire 32.

40 *The morning-glory*: Keorsmeyer 58–9, Suzuki 313–14.

41 *There is nothing mysterious*: Murdoch 85.

42 *I am looking*: Murdoch 82.

43 *Creative Britain*: see Smith 1–8, 15–16, 35–7.

44 *A far more intelligent*: this and the following paragraphs draw
extensively on Carroll. For 'middlebrow art' see Carroll 232, for
'highest achievement', 184, for the 'formulaic', 61–3, for 'difficul-
ty', 47, for emotions, 245-58, for Adorno and Horkheimer, 81, for
Benjamin, 130–31, for 'passivity', 33–8.

46 *Tusa believes in*: see Tusa 103, 131.

47 *R.D.Ellis*: Ellis 171.

48 *Winterson, championing*: Winterson 135.

50 *The Marxist critic*: see Adorno (1975) 12–19, (1997) 126–7. *Walter
Benjamin*: see Benjamin 223, 225, 230, 236–8, 242.

51 *The most celebrated*: see McLuhan (1964) 19, 85–8, 193, 334.

53 *Writing in 1936*: Collingwood 323.

55 *There are as many*: Hobson 135–6.

56 *False and elitist criticism*: see Hartman ix–xi, 155, 200, 233-5.

58 *insurance company . . . quality of life*: Glover 178, 162.

60 *Scottish Enlightenment philosopher*: see Hume 231, 241, 238–9,
247–9, 229.

61 *Voltaire . . . Tolstoy*: see Davidson 274–7 and Tolstoy 132–3.
*Darwin*: see Gardner 322. *Frederick the Great*: see Elias 11–12.

62 *Nashe . . . Greene*: see Alexander 52–7. *George Hakewill*: see
Hakewill 287. *Richard Dawkins*: see Dawkins 78–9.

THREE  Can science help?

65 *Edward O. Wilson*: for 'physical grounding' see Wilson 105, for
epigenetic rules, 164–213, for the arts, 235–49, for human nature,
251, for Smets, 255, for optimum female facial beauty, 256 and
Perrett.

69 *not true that Smets*: see Smets 24.

73 *universal rule or deep structure*: see Ramachandran 14.

74 *St Augustine*: Tillman 103–5.

75 *Fechner . . . behaviourist research*: see Berlyne 14–16.

76 *E. B. Tichener*: quoted in Berlyne 113. *Another advance*: see Berlyne
82. *The scientist who has tried*: the preceding and following para-

graphs draw on Berlyne 82–94, 125, 161, 255–8, 262–4.

78 *activities they do not classify as art*: Kreitler 358–63. *empathy*: Kreitler 257–8, 278–81.

79 *Cheap novels*: Kreitler 360. *colour-combinations*: Kreitler 98, 101. *When people are confronted*: Kreitler 119–20.

80 *But a scientist who does*: this and the following paragraphs refer to Zeki (1999) 9 (vision and language), 150 (facial recognition), 131 (abstract and figurative), 11 (knowledge of the world), 11, 32 (Williams . . . Constable), 21 (Great art can thus . . . ), 42 (festive occasion), 25–9 (Vermeer), 29–30 (Michelangelo), 50–54 (Cubism), 101–24 (Mondrian . . . Malevich), 116 (curves), 134–44 (Tinguely and Calder), 1 (unaddressed by neurology).

83 *Pavlov's laboratory*: see Berlyne 160.

84 *Vermeer's reputation*: see Bailey.

89 *Clive Bell*: see Bell 1, 6, 8, 32, 11, 21, 36 (the Chaldean lover).

92 *Edward O. Wilson argues*: see Wilson 127–30.

FOUR Do the arts make us better?

96 *Aristotle . . . Plato:* see Tillman 23–6, 43, 85–7.

97 *Hegel, typically*: see Hegel i 66. *Shelley's claim*: see Shelley vii 140. *Goethe . . . Hazlitt*: see Duncan 14–16. *Kingsley*: quoted in Gascoigne 305, from the Christian Socialist magazine *Politics and the People* (1848) i 1.

98 *Sir Robert Peel*: see MacGregor 270. *expert witnesses*: see Duncan 38–47.

99 *Lord Justice Coleridge*: see MacGregor 273. *Lord Napier*: see MacGregor 274.

100 *In America*: see Duncan 47–65.

101 *Summarizing the results*: see Kreitler 345, 357. *Elliot W. Eisner*: see Eisner xii, 38, 90–98, 252 and Winner.

103 *utopian writing*: for the utopias cited see Carey (1999) 38, 208, 264, 284.

104 *Leo Tolstoy*: see Tolstoy 51–2, 115, 67–8.

106 *Kenneth Clark*: quoted in Hewison 153.

108 *as Eisner puts it*: Eisner 10. *according to Palmer*: see Palmer 90, 213–7, 240.

109 *One of the fullest and most thoughtful*: see Gardner 98–106, 110-14,

169, 211, 229, 256–8, 295, 331 (and Taft), 345–6.

112 *Seamus Heaney*: see Heaney (2002) 5, 34, 45, 50, 68–9, 77, 188-9.

113 '*Personal Helicon*': Heaney (1966) 57.

115 *his Nobel Lecture*: Heaney (1995) 27–9.

117 *Bourdieu investigated*: see Bourdieu 6, 28, 35–56, 173, 183, 196, 323, 487.

121 *A less extensive . . . survey*: see Laski (1961) 9, 177–99 (triggers), 119–127 (totality expressions), 258–61, 276–7, 296 (Adamic ecstasies), 432, 526 and Laski (1980) 78–90, 136.

122 *Kandinsky*: quoted in Osborne 59.

126 *A curious footnote*: Laski (1980) 153 and Buford 88.

129 *Mr Justice Coleridge*: see MacGregor 273.

130 *John Paul Getty*: see Getty 173–4, 269–79.

133 *Imelda Marcos*: see Duncan 139.

FIVE  Can art be a religion?

135 *Plato . . . divinely inspired*: see Tillman 7–8.

136 *John Ruskin*: see Ruskin xviii 436.

137 *Jacques Barzun*: see Barzun 33. *Kandinsky*: see Kandinsky 24, 32, 44, 65–8, 74, 77.

138 *Robert Hughes . . . Clyfford Still*: see Hughes 313, 316.

139 *Duncan . . . Nochlin*: see Korsmayer 115, 314. *Bloomsbury aesthete Clive Bell*: see Bell 241–2, 247.

140 *Frederic Spotts's book*: this and the following paragraphs draw extensively on Spotts, particularly xi, 11–17 (lack of interest in warfare), 20 (Greek art), 23 (modernist painting), 33 and 218 (projects and art collection), 36 (Strength through Joy), 79 (enormous generosity), 87 (Bruckner's Fourth), 118 and 384 (attitude to bombing raids), 119 (planetary bacilli), 226–70 (Wagner), 317–76 (architecture).

144 *The classic study*: see Steiner 52, 63, 68–9, 71–2 (banal democracy of death), 73.

146 *Vienna Philharmonic*: see Drummond 152.

149 *Steiner doubts whether*: see Steiner 73–90.

150 *Robin Dunbar has recently listed*: see Dunbar 167–200.

152 *Among those . . . Dissanayake*: see Dissanayake (2000) xi, 8–13, 59, 118–20, 145, 154.

154 *Rollo May*: see May 90–94, 242–3.

155 *Richard Sennett*: see Sennett 1–23, 55–6. *In England, however*: this and the following paragraphs draw extensively on Hewison, especially xiv (shaping moral medium), 3–5, 43–6, 119 (W. E. Williams), 140 (John Harris), 249 (Palumbo), 259 (Gowrie), 251, 261 (Wilding Report), 310.

158 *A number of them have written of their experiences*: the following paragraphs draw on *Including the Arts: the Route to Basic and Key Skills in Prison*, published by the Home Office Standing Committee for Arts in Prison, 2001, on the Internet as *www.a4offenders.org.uk/new/sections/publications/pages/incarts.html*

160 *Libby Purves*: see *The Times* 11 February 2004, *T2* 13.

162 *J. M. Coetzee*: see Coetzee 9–11.

163 *The same question is raised*: see Rose 5, 43, 231–6, 275.

164 *Jack Henry Abbott*: for Abbott see *www.infoplease.com/ipa/A0901527.html*

165 *A more recent case in Sweden*: see Majgull Axelsson on *www.infopleaselahti.fi/kultturri/mukkula/axel.htm*

166 *Another group of people*: see Nick Wyke, 'From Prozac to Balzac', *The Times*, 11 October 2003, *Body & Soul*, 6–7.

SIX Literature and critical intelligence

The references I give in the text will, I hope allow readers to identify most of the passages cited in this and the following chapter. I have give references in the notes below only when that is not so.

174 *Jean-Paul Sartre*: see Sartre 17–18.

176 *Wordsworth*: see 'The Tables Turned', published in *Lyrical Ballads*, 1798.

177 *every flower . . . breathes*: from 'Lines Written in Early Spring' in *Lyrical Ballads*. *War and Peace*: trans. Rosemary Edmonds, Penguin, Harmondsworth, 1963, Book 2 Part 5 Chapter 9.

178 *Milton in a Latin poem*: see Milton 156. *The Magic Mountain*: trans. H. T. Lowe-Porter, Penguin, Harmondsworth, 1962, 113. *Howards End*: Chapter 5.

179 *The novelist DBC Pierre*: see *The Guardian*, 27 February 2004. *Walter Pater*: see Pater's *The Renaissance*, 'Leonardo da Vinci'. *Mrs Wititterly*: in *Nicholas Nickleby*, Chapter 21.

180 *Browning's . . . bishop*: see 'The Bishop Orders his Tomb at St Praxed's Church' in *Men and Women*.

182 *John Donne . . . diseases of the mind*: see Carey (1990) 156. *Religio Medici*: Part 1 Sections 3 and 6, Part 2 Sections 1 and 4.

185 *Rasselas*: Chapters 1, 11, 16, 18, 19, 29, 43.

187 *Gulliver's Travels*: Part 2 Chapters 3 and 6, Part 4 Chapters 8 and 9.

190 *Wordsworth*: see 'The Old Cumberland Beggar', 'The Ruined Cottage' (later in *The Excursion* Book 1), 'The Idiot Boy', 'Michael', 'Lines Left upon a Seat in a Yew Tree'.

191 *Persuasion*: Chapters 6 and 8.

192 *Sense and Sensibility*: Chapters 2 and 49. *Northanger Abbey*: Chapters 7 and 9.

193 *Blake*: see 'Proverbs of Hell' in The Marriage of Heaven and Hell'. *Middlemarch*: Chapters 5 and 42.

196 *Nostromo*: Part 1 Chapters 6 and 8, Part 2 Chapter 3, Part 3 Chapter 10.

197 *The Secret Agent*: Chapter 8.

198 *Daniel Deronda*: Book 2 Chapter 11.

199 *Lord Jim*: Chapter 45.

200 *Victory*: Part 4 Chapters 5, 13 and 14.

202 *Bacon*: 'Of Death' in *Essays*. *Browne*: see *Religio Medici* Part 1 Sections 40 and 44.

203 *Rasselas*: Chapter 35. *Gulliver's Travels . . . Struldbrugs*: Part 3 Chapter 10.

204 *Middlemarch . . . death*: Chapter 42. *so with love*: Bacon, *Essays*, 'Of Love', Browne, *Religio Medici*, Part 2 Section 9, Winterson 26, *Northanger Abbey*, Chapter 3.

207 *Wordsworth identified*: 'Tintern Abbey' 33–5.

208 *Paradise Lost*: iv 830.

SEVEN Creative reading: Literature and indistinctness

218 *squeaked out loud*: the Quartos read 'squeakt', some editors substitute the first Folio 'shriekt'. Ghosts 'squeak and gibber' in *Hamlet* I i 116.

230 *mearcstapa*: see *Beowulf* 103.

231 *Ted Hughes's claim*: see Hughes xv.

232 *Blake . . . Keats . . . Dickinson*: 'The Tiger', 'On First Looking into Chapman's Homer', Dickinson iii 859, 1098.

235 *land of the lotos-eaters*: 'The Lotos-Eaters' 8–13.

239 *Pincher Martin*: Chapter 6.

243–4 *other dark birds*: see *Macbeth* I v 39, II ii 16, *Middlemarch* Chapter 5, *Bleak House* Chapter 10, *Comus* 251–2, Vaughan 'The Proffer' 13–14, Keats 'Ode to a Nightingale', Milton 'Sonnet 1', Hardy 'The Darkling Thrush', Wordsworth 'There was a boy', Bacon 'Of Suspicion'.

246 *John Donne's advice*: in 'Satire 3' 77, see Carey (1990) 30. *The Battle of Maldon*: 312–13 *Aeneas's words*: Virgil, *Aeneid* i 203. *Larkin*: see 'Water' in *The Whitsun Weddings*.

247 *Parolles*: see *All's Well that Ends Well* IV viii 369–70.

### Afterword

250 *Stanley Lieberson*: see Lieberson 4, 76–8, 110–15.

252 *Dr Johnson's argument*: see Johnson 9–10. *Emile Durkheim maintains*: see Durkheim 341–2.

253 *Art-lovers have often strenuously denied*: see Schopenhauer and Mondrian in Osborne 56–65, Gadamer in Korsmeyer 91–7, Winterson 19. *Rousseau urges*: see Rousseau 4, 11, 16–20.

254–5 *Kevin Melchionne*: see Korsmeyer 98–103.

# Index

hunter-gatherer societies, 35–6, 39–40, 128, 152
Huxley, Aldous, 123, 124

Ice Age culture, 117
immortality, 147–9, 153
impotence, and violence, 154–5
*Including the Arts: The Route to Basic and Key Skills in Prisons*, 158–62
intentionalism, 19–22
international terrorism, and authenticity, 57
Inuit culture, 35, 153

James, William, 38
*Varieties of Religious Experience*, 124
Jameson, Fredric, 26
John Paul Getty Museum, 130, 132
Johnson, Samuel, 252
*Rasselas*, 185–7, 203, 211

Kandinsky, Wassily
*Concerning the Spiritual in Art*, 137–8
*Reminiscences*, 122–3
Kant, Immanuel, 8–12, 14, 42, 118
*Critique of Judgement*, 8
Kaplan, Abraham, 48
Keats, John
'The Eve of St Agnes', 238–9
'Ode on a Grecian Urn', 236–7
'Ode to a Nightingale', 244
King, Stephen: *The Green Mile*, 211
Kinglsey, Charles, 97–8
Klein, Yves, 4
Koestler, Arthur
Koestler Awards Scheme, 161
Koestler Trust, 161, 165
Kreitler, Hans and Shulamith, 77–80, 106
*Psychology of the Arts*, 24, 101

language, disintegration of, 154–5
Larkin, Philip
'An Arundel Tomb', 240–1
'Water', 246
Lear, Edward: *The Jumblies*, 228–9
Leith, Sam, 269
Leonardo da Vinci
*Lady with an Ermine*, 142
*Last Supper*, 135–6, 268
Lewes, G. H., 195
Lewis-Williams, David: *The Mind in the Cave*, 117
Lichtenstein, Roy, 16
Lieberson, Stanley: *A Matter of Taste*, 250
literacy, among young offenders, 210–11
literary moralizing, 181, 187
literature, 268–9
literature, definition of, 173–4
Liverpool Biennial (2004), 257–9
loneliness, and popular art, 35–6, 54
Loosley, Brian, 6–7, 10
love *see* romantic love
Lyell, Charles: *Principles of Geology*, 148

MacGregor, Neil, 99, 129
Magnetic Resonance Imaging (MRI), 75
Mailer, Norman: *In the Belly of the Beast*, 164
Malevich, K.: *Red Square*, 86–7
Mann, Thomas: *The Magic Mountain*, 178
Manzoni, Piero, 4
Marcos, Imelda, 133
Maritain, Jacques, 3
Marlowe, Christopher
*Dr Faustus*, 241–2
*The Jew of Malta*, 216–17
Marx, Karl, 104
May, Rollo: *Power and Innocence*, 154